Courtney,
Thank you
so much for
your support.
Appreciated more than
you will ever know.

Courtney,
Wishing you
continued blessings,
peace, and prosperity!
Karen

Dear Courtney —
May the words
in this book inspire
you to know
your value.
Warmly,
D. A.

To: Courtney
Thank you for your
support & we look
forward to hearing
about your success!

She's Got the Power

WOMEN BUILDING WEALTH THROUGH FINANCIAL LITERACY & SISTERHOOD

DR. ANGELA REDDIX & THE RR FUND SISTERS

ELG MANAGEMENT GROUP

Contents

Introduction

On October 24, 2021, I was on a plane returning to my quiet town in Hampton Roads, Virginia, from all the glitz and glam of Beverly Hills, California. Usually, just mentioning "red-eye" would lull me to sleep, but this trip was very different. My mind wouldn't stop racing with questions regarding what was next for me.

This trip to California was not my average business trip or family vacation. Oh no! It was a surreal experience. Just two months before the trip, I received a call from the CEO of Ebony Magazine informing me that I had been nominated and invited into the elite club of Ebony Power 100 Honorees. As a little girl, I remember waiting for the Ebony and Jet magazines to arrive in our mailbox, waiting to see who would grace the magazine cover. The Johnson family was like black royalty. The thought of being recognized by such an iconic brand was beyond my wildest dream. But to share this honor with greats such as Dr. Kizzmekia Corbett, Jada Pinkett Smith, Don Lemon, Tamron Hall, and Thasunda Brown Duckett was exhilarating.

After months of preparation, the weekend arrived, and it was nothing short of magical. The pre-award dinner on Friday, the red carpet on Saturday, and the gala. Breathtaking! Dr. Angela Reddix, Innovative Leader Award! This opportunity came to me because of my tireless effort to transform communities of poverty into communities of prosperity, through the promise of middle school girls. This was the work performed by the non-profit I formed in 2017, Envision Lead Grow (ELG).

Poverty is real in America. According to the 2021 Census Bureau Report, the 2021 national poverty rate was 12.8%; however, the childhood poverty rate was 16.9%. Breaking the cycle of poverty is critical as research shows that children raised in poverty are more likely to become teenage parents, become high school dropouts, participate in criminal activity, have difficulty obtaining employment, and are more likely to live in poverty as adults. (Ratcliffe & McKernan, 2010).

By 2020, the ELG program had touched the lives of 2,149 girls in 48 states. Teaching these girls to use the power of their minds and heart to create positive change in their communities through entrepreneurship. At age 12, our girl bosses learn to determine what makes their heart sing and translate that into a product or service. Our girls become "thousandaires" by the time they graduate high school. They learn to package the product or service, price the product or service, and create profit.

As I considered the conversations I had with various exceptional African American women and men during the Ebony Power 100 celebrations, I wondered about the future of ELG. How do we make the most impact with these girls? And I thought about the single greatest barrier to their growth, the female influence in their lives.

You see if these girls spent time in our program and had larger-than-life dreams they would develop have the courage to make those dreams come true. However, the female influence in their lives could only see a dream as big as a ring box. Well, that creates a roadblock to the success of our girl bosses.

The plane was silent as most passengers were in a deep sleep. I remember asking God to direct this movement. How do we get over the hump for a lasting life-changing movement for our girls? I looked out over the clouds as if I was getting closer and closer to God and saw a clear vision.

In fact, I saw clearly that if I was going to ensure success for these girls, I must help women see greater. I began reflecting on conversations I had with the ELG girls' female guardians. I thought about conversations with career women in my for-profit government contracting firm. I reflected on conversations with women in the community who were in high-level leadership positions. And then I played back some of the conversations with women who ran multi-million-dollar corporations. I found that discussion around family was something that flowed. I could discuss management and leadership, which seemed to be comfortable conversations. Even discussion about customer service or marketing appeared to be an interesting topic. But the moment I began talking about finances and wealth creation, I felt as if I were in an episode of Different Strokes, where Arnold would say, "What you talkin' 'bout, Willis?" Regardless of social and economic status, I found that money was not something that many women were comfortable discussing. That left me wondering why. As I researched, I found many theories to explain this dynamic.

- Lursadi and Mitchel (2011) identified there was a gap in knowledge for women.
- Holland (2015), a study conducted by Fidelity's Investment, found that money was taboo for women because they felt it was too personal and uncomfortable to discuss. The 'uncomfortable' topic women don't want to discuss (today.com) Women and Investing: 20 Years of Research and Statistics Summarized | The Motley Fool
- Merrill Lynch (2022) "Women and Financial Wellness: Beyond the Bottom Line" spoke to the life expectancy of women, the wage and wealth gap, and their lack of confidence and awkwardness when talking about money. Women and Financial Wellness: Beyond the Bottom Line - Age Wave
- Melicia Houston (2021) highlighted money's multifaceted nature with positive and negative associations. Money is perceived as an intensely private and emotional topic.
- Women And Money: Busting The Money Myths (forbes.com)

Driven by these various research findings, I decided to dig deeper, and found the magnitude of the wealth gap was even more alarming. According to Statista, only 13.5% of women make up the total number of American multi-millionaires and 11.9% of billionaires worldwide. Yet, women make up more than half of the U.S. population and control or influence 85% of consumer spending (Forbes 2019). The purchasing power of women in the U.S. ranges from $5 trillion to $15 trillion annually; women control $31.8 trillion of consumer spending worldwide. The total number of millionaires in the U.S. is 20.27 million, with 76% of the U.S. Millionaires white, 8% African American and 7% Hispanic. Now is the time for us as women, in particular women of color, to shift our mindset and take control of our financial status, allowing us to change the wealth status of future generations.

The BIG Idea

Just as Robert Baron's theory of Deliberate Practice would form the foundation for ELG, I wondered if this could be expanded to solve women's wealth knowledge gap. What if the model was the basis of creating a safe environment for women to deliberately practice becoming experts in wealth creation?

Deliberate practice requires eight (8) components.

- Intensity and focus
- Practice over time for a long time (10,000)
- Goal-based
- Self-assessed
- Mentor feedback
- Pre-work required
- Repetitive

If the original goal for ELG was 1,000 girls by 2020, and we were able to create a "thousandaire" mentality with over 2,469 girls.

How could we use that model and create a millionaire mindset with 1,000 women by 2030? This movement could generate a billion dollars if we could overcome the barriers for women.

So, the first step was to create a safe environment to have an experiential learning opportunity. No better place to begin than those whom I was in a close relationship with. I thought about college friends who had known me for over 30 years. Family members and relationships of women I have worked with professionally and in the community.

My goal was to create a club of 50 women to invest $10,000 and 10 women business owners with more significant resources to invest $50,000, for a combined total 1 million dollars. I socialized this idea with my first 10 people, and just like that, they were committed.

"Yes, we want to learn and grow!"

So I tested with a few business leaders, and they were in! Within two weeks, I had the commitment and enthusiasm for a million dollars. I must say that happened quicker than expected. So over the Christmas holiday, I was feverishly working to build the infrastructure to take this club concept and make it a reality.

I engaged two attorneys who specialized in this area, and the RR Fund was born on December 10, 2021. The initial membership of the RR Fund Club started with 53 members and 7 organizations. Within six months, there were rave reviews, and the word spread among friends and families of the group who expressed an interest in becoming a part of the Club. As a result, fifteen new members were added in July, taking the total membership to seventy-five75.

Of the seventy-five members, 90.48% are women of color. There are 41.27% business owners, 34.92% are millionaires, 73.02% are career professionals, and 61.91% C-Suite Executives. In addition, 79.37% are mothers, 58.73% are married, 17,46% are grandmothers, 92.06% are homeowners, and 100% are college educated. We have an eclectic group of women committed to empowering women and closing the wealth gap.

The RR Fund Investment Club meets monthly to provide a safe space to discuss financial concepts and act on those concepts.

Our mission is three-fold:

• **Educate:** Education provides a foundation and knowledge that no one can take away from us. Financial knowledge provides us with the security to establish and build a stable future for our families. The education of members is key to closing the knowledge gap through monthly book reading assignments, Industry experts' presentations to increase the wealth creation and financial knowledge of its members, reading financial reports and materials, and journaling their experience.

• **Activate:** Activation stimulates the brain to acknowledge and execute what is learned through education. When we start using the material, we sharpen our analytical and problem-solving skills, which helps the brain function smoothly and solidify the newly acquired knowledge by actively engaging with financial and wealth-creation instruments we encounter. Members are challenged to activate by identifying three actions from the items discussed in the meeting and through accountability check-ins each month. This Club is more than a conversation; it is about activation.

• **Evangelize:** To evangelize is spreading the financial knowledge and lessons learned to other ladies within the family and our community. This approach will help to close the gender wealth gap. One way to build generational wealth and legacy is through evangelizing the lessons learned during the Club meetings, through publications like the anthology. This creates the avenue to touch lives beyond our immediate circle.

Our Club meets on Sunday afternoons, and for 2 hours, we unapologetically discuss wealth strategies. Our topics include: financial stability, understanding the stock market, real estate, life Insurance (Term vs. Whole Life), tax strategies, retirement planning, and estate planning.

Preface

Our goal with this book is to normalize the conversation of money for women throughout the United States, particularly women of color. And I could not think of a better way to do this than to have normal women share their truth regarding their relationship with money. Throughout this first year, the ladies were asked to journal their experiences. What had they learned? What were their fears and doubts? Then, together we would conquer those. Twenty-five of our seventy-five members shared their feelings throughout the pages of this anthology. Not only did they share the vulnerability of this taboo topic, but they also shared beautiful pictures that describe their journey.

You will see that money is far more than a currency to make purchases; there is a psychological component to the view of money. The status that it creates and how we value ourselves. In these stories, you will learn how great-grandmothers impacted the lens through which we view money. The conversations we hear from our elementary teachers impact our view of its value and the power of media. Yes, that comes out in almost 50% of the stories.

The ladies answered these nine questions.

1. Who are you?

2. When you were a little girl, what was the indication of wealth?

3. As an adult, how do you define wealth?

4. What does it mean to know your number?

5. How would you describe your relationship with money?

6. Why did you take the leap and join the Club?

7. What has been your most significant "ah-ha" moment?

8. Based on what you have learned, what would you tell your 20-year-old self?

9. The word that defines your attitude regarding wealth now.... And why.

And finally the authors challenged the readers with an action.

I pray that these stories allow you to see that the almighty dollar is powerful on so many levels. The principles we teach by the things we say and do, leave an impression on a young mind that makes the difference in the ability to have a "rich" existence. Full circle, yes, if I am going to impact little girls' lives, we must start with opening the minds and hearts of the women in their lives. She's got the power to break the cycle of poverty for herself and for generations who will follow.

Presenting, the ladies of RR Fund Anthology: *She's Got the Power: Women Building Wealth through Financial Literacy & Sisterhood*

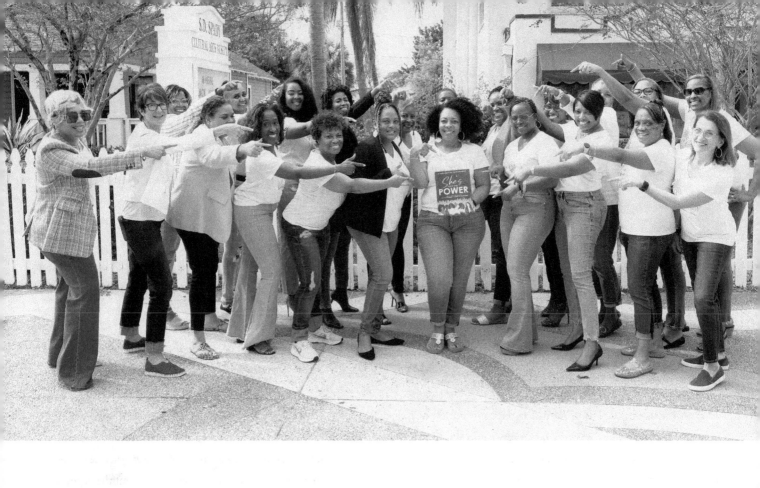

Dr. Angela D. Reddix

I am perfection! Yes, that's a bold statement and one that life has taught me to reimagine. Yes, I am perfection! The perfect textile blend of the burlap of my childhood, the wool of my young adulthood, and the fine silk of my womanhood. Yes, I am perfection as I embrace the various textures that took me from little Angie to Angela and, finally, Dr. Angela.

Born Angela Vernine Dyson, so much about my life was determined by the name on my birth certificate. I find it amazing that as teenagers and high school sweethearts, my mother and father had the vision to give my name such profound meaning. "Angela" means angelic, a messenger of God. After some research, I learned the name Angela was ranked in the Top 10 names of my generation. So yes, at birth, I was destined to hit the charts. My middle name, Vernine, has a meaning that I did not completely embrace until I was naming my first child 26 years ago. The depth of thought behind the name didn't resonate with me until I worked to reconcile my identity. "Vernine" represents the blending of two brilliant minds and souls who created me. My father, Vernon Uzzell, is a serial entrepreneur raised by my grandparents, George and Vernice, who were also successful entrepreneurs – entrepreneurship runs in my blood.

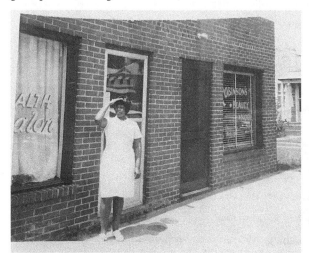

Grandma Vernice was a trailblazer who owned a physical therapy spa servicing local disabled veterans.

The second part of my middle name, "ine," represents my mother, Thomasine, who was named after her dear uncle, Thomas. Many people describe my mother as smart, resilient, strong, creative, faith-centered, and loyal to her family. For many years, she was an incredible businesswoman in a Fortune 500 firm, which speaks to her impeccable business acumen. These characteristics were passed down to me. Oh yes, it's clear that I "get it from my mama."

It is not lost on me that my mother, at the tender age of 18, had the control to name me whatever she wanted to. Yet, she deliberately gave me a piece of my father and grandmother in my name AND was humble enough to make their names the first half of my middle name. I really didn't understand or embrace the depth of that act until I lived 5 decades on this earth.

My last name, my mother and father never married, so I retained my mother's family's name, Dyson. And oh, how that name has been an incredible badge of honor throughout my life. It represents the God-given village that raised me. My Grandmother Olivia's wisdom and love seeped into every fiber of my body and inspired me to achieve excellence. Holding her hands, sitting on her lap (even as an adult), and playing in her hair felt like home. Growing up with nine aunts and uncles and a boatload of cousins continue to make up my village.

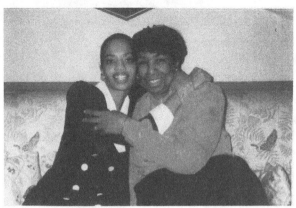

Grandma Olivia continues to be my guardian angel guiding my direction on a daily basis.

The village continued to impress upon me that success was not an option. It was expected that I would attend college, as my parents, aunts, and uncles had done, and I did. James Madison University was my number 1 choice. Some would say it was because of its strong reputation as a state school. I know it was where I was destined to be because a young man from the Washington D.C Metropolitan area was there. God knew that my perfect soul mate would be standing in front of my freshman dorm at the exact moment that my grandmother, mother, soon-to-be stepfather, and my high school boyfriend arrived on campus. Pete Reddix would be there in his Omega Psi Phi Fraternity t-shirt, waiting to move me into my dorm room. I left JMU in four years with a business degree and my Omega man. Twenty-nine years ago, I added Reddix to my name. That name represented a legacy of longstanding marriage. My mother and father-in-law, Carl and Dianne, had been together since they were teenagers. When I met them, they had been married for over 20 years. I watched them together and was in awe of their PDA (public display of affection). I had not seen much of that growing up. My mother-in-law" was a loving and fierce protector of her husband and children.

My example of a strong loving couple was my husband's father and mother, Carl and Dianne Reddix.

Dianne was indeed the Proverbs 31 woman – virtuous in every way. I made mental notes to apply to my future marriage. As a candle burned to represent her during our wedding and Yolanda's Adams "Just a Prayer Away" played in the background, I vowed to love her son and our future children and protect their well-being as she had demonstrated.

I feel nothing but pride whenever I am referred to as "Mrs. Reddix," especially when interacting as the mother of Anyssa, Ahmon, and Ayla. It is an incredible accomplishment to offer my three children the best of the Dyson and Reddix combination.

My yearning to continuously learn took me to the level of Dr. Reddix. Before creating a vision board was a norm, I had mapped out my life plan as a teenager. Yes, a doctorate was on my list of accomplishments. It's funny what an impression family and friends can make on children. At the time of developing my life plan, I only knew of one other person who had achieved that terminal degree, my Aunt Sandra. She was such a significant figure in my life, and her educational aspirations made an indelible impression on my young mind. I must say that this was the biggest challenge I had ever faced. EVER! As I walked across the stage with my Aunt Sandra, my children, and my husband watching, I was so proud of US. I may have been doing the reading, researching, and writing, but my family sacrificed for almost 4 years to allow me to reach this goal. When I hear "Dr. Reddix" or "Dr. Angela," my immediate instinct is to say, "when lf, "girl honor the journey. Honor the sacrifice. There is POWER in your perfect name".

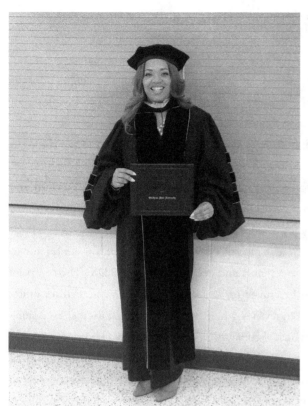

The day I became Dr. Angela D. Reddix. Obtaining my Ph.D. from Oklahoma State University was a milestone that opened my mind to new possibilities.

Who am I? Dr. Angela Vernine Dyson Reddix is a perfect combination of my upbringing, my womanhood, and my ups and downs. I am perfectly designed by a perfect God. Even on my worst days, I am perfection because I AM HERE!

When I was a little girl, my indication of wealth had nothing to do with material things, but I associated wealth with having a two-parent household. It's true. In the early part of my life, I was raised in my grandmother's home. I was born in Liberty Park, a public housing community with many people in a small apartment. I do not remember anything there because I was so young, but I do remember the family moving up to a single-family home in Park Place. There were still a lot of people sharing one bathroom. My grandmother was the chief of the home, and all my aunts and uncles took on responsibilities to make the house a home. I did not realize what we didn't have because my grandmother was honestly a miracle worker. She could make a single piece of chicken stretch into a tasty meal. We were rich with love. In my classrooms, I don't remember many men head of households.

I would spend summers in Washington, D.C., with my Aunt Sandra and Uncle Sidney. In my mind, they were rich. They planned things together. I heard them discussing bills. Heck, it might have been about how they did not have enough money, but in my mind, the fact that they were discussing the bills as a couple made it seem like they were rich. We would take summer vacations. Never flying, but driving and occasionally making stops at McDonald's – they were rich. Very rarely did we stay in a hotel, but we would visit relatives. We were on family vacations, so they had to be rich.

My mother moved us to a city with one of the highest incomes in the Commonwealth of Virginia. She purchased a brand-new beautiful townhome as a 24-year-old single mother (the girl was freaking amazing). In my young mind, I never associated moving with being rich. However, everyone in our new school district seemed to have a father in the home. My classmates would talk about sitting down at the dinner table and talking to their dads. I thought everyone in the school was rich.

This school was probably 1% African American at the time. I became close friends with one of the few African American girls, Cara. She lived within walking distance of our luxurious townhome in an apartment. Cara's mother and father were so much fun. I spent most days after school and weekends with her family. Her father would cook and talk fondly about her mother and her two sisters. He was such a kind man. They were a military family and just the nicest people. I vividly remember them inviting my mother and me over for New Year's Eve party. They had cooked a feast, and there was good music playing and so much laughter. There were five of them in a 3-bedroom, 1-bathroom apartment. But you could not have told me that they were not rich. There was a mother and father in the household communicating and laughing. They were RICH.

As an adult, my meaning of wealth is not simply about the accumulation of dollars, but it is about the ability to demonstrate love with the money. It is seeing scarcity and then "moving up." It is watching the discipline my mother had with money and watching her demonstrate the choice to delay gratification to achieve something bigger in the future. It is watching her instill a work ethic in me and watching that payoff. It is experiencing my mother writing a check for my college education so that I never experienced the baggage of student loans. It was watching my mother save for my "life after college" so she could offer me the choice when the time came. I could have a wedding or a down payment on my first home. Yes, I chose the wedding of my dreams, and yes, I would do it again. It is the feeling of a two-parent household that made me say this is what I will fight for, EVEN when the times get tough, and my husband is as "sick of me"

as I am of him. Get over it. Together we have the power to impact generational wealth. My definition of wealth is Winning Economically by Advancing Love Throughout Humanity.

This is my dream- The Reddix 5. Anyssa, Pete, Angela, Ahmon, and Ayla.

I am blessed to have founded ARDX, a healthcare management and technology firm that has successfully completed over $200M in contracts for the Federal Government. I know this has only come because we have built into our model the necessity to be a positive contributor to our community from day one. It is biblically based. In Genesis 26:12, Isaac sowed into the land and reaped in the same year a hundredfold. It is incredible that during our 16 years in business, we have faced the biggest recession of my lifetime, the housing market crash, and a global pandemic, yet we continue to prosper. I am convinced it is because we continue to sow into the community.

I left a successful leadership role with a major government contractor to relocate back home to Virginia and decided to open ARDX. The company grew so quickly that I recruited my husband to support me in the back office. The company tripled in revenue year over year for the first decade. Everything happened so quickly, but I also knew that 45% of businesses failed within the first five years. In the company's first year, my husband and I met with our financial planner and asked what if the company goes under. What is our target number to achieve so that we can maintain our lifestyle, get these three kids through college, create an "after-college" fund for the kids, and retire? He ran a model for us and provided the "magic" number. Let me tell you that number was on my bathroom mirror, my wallet, my dashboard, and my journal EVERYWHERE to remind me of THE number to freedom. I prayed on that number. My husband and I talked about that number weekly. My finance VP understood that we were managing to that number. We lived way under our means because I was on a mission to reach that number by year 5. Why? Because 45% of businesses didn't make it past 5 years. We met that number by year 3. Once we met that number, I felt like I could breathe! I felt I had options! I felt I could say "yes" to contracts and "heck no" to others. I could walk away. Yes, we were beyond the first million-dollar contract by year 1, but that did not give us permission to spend like we had reached the million-dollar level. We were on a mission, and the key was something my mother taught me, not by simply her words, but her actions – live below your means! We ran our household with one income instead of two. Not because we didn't have it but because we had to delay gratification so we could live in peace in the future.

My relationship with money reminds me of something many IT departments will say. IT is most effective when it is invisible. Meaning the IT department is never called unless there is a problem or a need. That actually means things are working well. I have to say, there isn't a day as a business owner that there is no discussion about money. Any healthy organization monitors the financial performance of the company at least monthly. However, money is not an obsession for me. I recognize that it is a tool that allows access – access to tables, access to information, and access to resources. I constantly ask myself, " What will you do once you are at the tables, gaining information and resources?" My relationship with money, simply put, is to be a calling card that provides access to many.

This really is the basis of this club that I formed. It is simply to provide access to resources, people, and information that has allowed me to be successful. I pinch myself when I learn something new. I often wish that I could bring others into the room with me. It may not always be appropriate to bring them into the room, so I have intentionally created spaces where I can bring those resources to rooms that I create for other women.

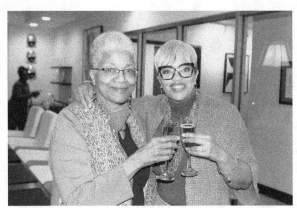

My mother and I toasting to reaching another major milestone. Her continued lessons in financial management provided the foundation that my children now continue to build upon.

I am amazed at the growth in the conversation in just 11 months. I am surprised at the transparency between the women who don't know each other but with whom I have had the great opportunity to grow in relationship. I am amazed at the level of questions and the ability of women to challenge one another. I am intrigued by the number of women who show up consistently committed to being sharpened. My biggest aha is that I started this thing, and no matter what, I must show up. I have been graced for 11 straight months to show up. Even in sickness, I gain enough strength to show up and give it my all. Even when juggling the schedules of busy high school students, this was my vision, and I must show up. I am committed to demonstrating what I hope will be emulated by the women in the club. That discipline to show up NO MATTER WHAT, has allowed me to become who I am today. That is the building block to WEALTH discipline without excuses.

When women show up, even when it is tough, we send a powerful message to the following generations. I try to put out in the world what I wish I had known as a young adult. I would tell my 20-year-old self that you CAN have it all! Just recognize that you may not have it all at one time. Life is an accumulation of experiences, not just a snapshot of the day. So, at the end of life, I would have vacations with my husband. It may not be every anniversary, but we will have those moments in the book of our life. I may not be at every soccer game or cheer event, but in the book of life, I will have many soccer game and cheer experiences to share with my children. In my book of life, I will have everything that I desire, it may not be every day, every month, or even every year, but I will be fully present at that moment as if that is the only time I will have that experience.

The word that defines wealth for me now is ministry. I believe we are all called to be a representation of God's goodness and possibilities. The accumulation of wealth provides an opportunity to be a blessing to others. I am reminded that others are watching, and with that comes a responsibility to demonstrate grace and compassion – to remind others that wealth takes faith and work.

Here are three actions I would recommend to begin building wealth.

1. Start with the end in mind. Imagine where you desire to be in a decade and plan the milestones to get there. Creating reasonable annual goals allows you to hold yourself accountable.

2. Identify a professional financial planner who has a client base on a higher level than where you are today. I always value having access to the knowledge of the people where I would like to be in the future, not where I was yesterday.

3. Create a circle of influence who are serious about reaching financial goals. Those individuals will begin to speak the same language regarding budgeting and investing. They will understand when you must delay today's gratification because your eyes are on a much greater prize in the future.

Andrea Boyd

I Am Andrea Boyd

Who are you? One simple question can invoke so many different emotions from the average person. It can make an unsure person sad, questioning their ability to be secure themselves. It can make others happy, knowing they have their answer down pat like it's written on the back of their hand. Some may go their entire life never knowing the answer. Through the journeys I've invoked in life, I can say that I now know my answer.

I am Andrea Boyd. I grew up middle class. I am a scared little girl that developed into someone who toughened up and stood strong for her surroundings. I have always been a sponge and could never learn enough information because there is always something new to learn, and it creates power and substance. At one point, I was whomever you wanted or needed me to be, whether it was always kind, genuine, or sincere, even if it made me a doormat many times in my life. I attribute that to being adopted and wanting to feel wanted by others. I am married, and I have two sons. I'm a woman of God who loves spending my winter month birthday on a trip with my friends. If you met me in real life, you would know I'm pretty outspoken. My words flow from my heart straight to my mouth. I love so deeply with everything I do that it's almost impossible for those around me not to be inspired by my passion after I'm done speaking to them.

Remember when I said I was adopted? My biological mother passed away in a motorcycle accident when I was seven months old. She was in the Navy during her accident, and because of this, I couldn't be adopted for the first two years of my life due to differing opinions on who would gain access to my mom's life insurance policy. I also had an inheritance waiting for me when I turned 17. Though I love my parents very, very much, money management was not something that was instilled within me growing up. I would not have known that my family ever struggled to pay bills if they did not verbally tell me. My mother was the first one in her family to go to college, and she became a teacher. My dad had a boat we could sleep in and would buy us new cars frequently. I had the latest toys and clothes; life was beautiful to me as a kid. I was always a daddy's girl, and my brother was definitely a momma's boy. My daddy was my entire world. We were so close in everything we did, my whole life changed forever when he passed away when I was 12. To this day, I still feel like a piece of me is missing. That piece is something a lot of adopted kids feel, but we'll get to that later. When I gained access to my inheritance, I spent it like crazy.

Anything my friends and I wanted, I bought. Buying the newest clothes, going on the best trips, what more could a teenager want? My mindset resembled Robin Leach's *Lifestyles of the Rich and Famous* if you're old enough to even remember that. This was my indication of wealth as a kid. Being able to buy what I wanted at my disposal. My inheritance was next to gone by the time I was 23 and a newly single mother. I had to take more time to budget my money wisely because I had a new life to take care of. That meant less room for splurging whenever I wanted to pick myself up.

The Ones Who Chose Me

The Parents

AJ- The Little Brother

The older I grew, the more my viewpoint on money changed. Younger me felt that treating yourself is like putting oil in a car. You need to do it at some point to keep moving. Fast money attracts you when you're younger, but as you get older, old or long, money is the goal—creating a Legacy. If anyone had asked me a few years ago what I define wealth as I would have told you it's having the funds to do and buy whatever I want. At this stage in my life, I define wealth as leaving a legacy for generations to come and understanding your net worth. Knowing when to turn down money is an essential key that everyone needs to know. Having the mindset that "all money isn't good money" will take you far in life without getting caught up in any financial ties that don't belong there.

For a long time, I resented money; I even resented the people who did not keep money for long. It came from watching my dad be a poor steward of money they received from working and for taking care of me and watching my mother be extra careful because of that lack of stewardship. In my mind, that money represented how people would put money over everything else important in their life. To this day, I have that love-hate relationship with money. When you're married, you move as one person, but there's no guarantee that your partner will have the same relationship with money as you. It's like a regular dance balancing checkbooks in a home. You could be the safest spender and only put money out for necessities, but if your partner does not share that same mindset, it won't balance. I believe that the difference in mindsets has factors such as age, culture, and upbringing. In my relationship, my husband is a frivolous spender. If the money is there for something he wants, he will spend it. The factors I mentioned also play a role because he is younger than me and from a different culture. In the eyes of banks and society, it does not matter who is the frivolous spender in the relationship or not. The women's net worth will be cut in half regardless.

My husband and I run a business together, and even though we share one banking account, his net worth is still worth more than mine. Understanding the principles of what the wealthy do now and not later in life makes a difference. Surrounding myself with like-minded people was a game changer in my transition with my mindset on money and wealth. You should never be the smartest person in the room. If you are, you're in the wrong room. Worrying about pleasing others and what they have to say is not a priority when you're trying to get your life together.

Trying to fit in will eventually leave you broke. Knowing how much it costs to function in this world is essential. You should know every number it costs to live your lifestyle off the top of your head. Understanding this as my net worth or number helped me realize that things are not set up in the world financially for women. According to the Bureau of Labor Statistics, in 2021, the median weekly earnings for wage and salary workers who usually worked full time were $998. Median earnings for women were $912, or 83.1% of men's earnings. If I could, I would tell my 20-year-old self to invest while I still had my inheritance before all the fun and games were over. Another thing I would tell my younger self is that many people put on a facade of being wealthy and aren't, so don't try to keep up with them.

Wealth, to me, is a balance of everything in my life working together for my good. All things working for me spiritually, financially, mentally, and emotionally are what living in wealth is. Seeing every area of my life prosper, along with those around me, motivate me to keep going. I would define prospering financially as having multiple income streams coming together to ensure my legacy will be acknowledged and supported. My mindset on money shifted when my life circumstances shifted. It wasn't just about me anymore; I had

a family that depended on me. When you make a creation and see that they look up to you in everything you do, it makes you not want to leave a bad imprint on their mind.

My most significant "ah-ha" moment would be learning about the difference between a man's and a woman's net worth. When looking at income disparity between different factors, such as race and gender, was knowledge in financial matters. This is the key. Knowing the different income-producing vehicles and how to operate them fills some gaps in how we play the game going forward. Will it instantly give us a moment where we can collect $200 and pass around the monopoly board? It most likely won't be instantly, but if we continue to implement and teach these practices to our youth while they are still young, we may play it as a real game of Life.

Now, I have some actions for you that I want every reader to take seriously. The first one is read. Read as much as you can. The saying may get old and played out, but knowledge is your key to success. Just like your overall health, your financial health requires love and attention. You usually go to the doctor when you're sick in hopes of them fixing the problem; financial advisors do the same for your financial health. Their guidance keeps you focused, driven, and oriented with a map for success. Second, know your numbers. Not only should you know them, but you truly understand them as well. You should know every dime it will take for you to survive and operate living your lifestyle. Knowing this will have you set straight on how much you need to earn weekly, monthly, and yearly while also giving you that insight into what you can spend on leisure things and activities. My number fluctuated as I got older because I took on more responsibility, but if I had known my number back when I was a young 20-something-year-old, it would have been a game changer much early on with my mindset on my finances. Third, get into new rooms. It may be comfortable to stay in rooms with people you've known your whole life, but you need to expand! Don't be complacent in comfort. When you are in your most uncomfortable positions, you grow in every aspect. You should never be the smartest in the room: if you currently are, it's time to adjust. There's always more to learn in life, and you can't learn more by staying in the same position for the rest of your life. Next is to give back to your community. Think about when you were in a position where you needed mentorship or something to motivate you to keep going. Be the person you would want to meet in times of need. To whom much is given, much is required. Also, understand that you must be able to receive because these two principles go hand-in-hand. Don't block your blessings because of your pride. That is a strong contender of things I would have liked to apply early on in life. Sometimes we can get so wrapped up in fitting an image or lifestyle that we see our peers living that we block our blessings trying to become someone we aren't. I see that more and more nowadays, with social media being a weighty influence in young people's lives.

Comparison is the thief of joy and can distract you from your goals and purpose. There was a time when I would compare my progress with those around me and wonder when my time would be coming. Little did I know, my time came shortly after. We can't be so caught up in keeping up with the Joneses while our lives pass us by in seconds. Spending our last dimes on beauty products and enhancements to look like other people we admire from afar will not help us financially, physically, or spiritually in the long run. If it doesn't make money, it honestly doesn't make sense. It's easy to fall down the rabbit hole of comparison when you see someone at a point in life that you strive to be, especially financially. Doing things to advance your situation and staying motivated toward your goals will get you further in life much faster than trying to be someone else.

The key to being wealthy is not spending all your money at once. This also ties into the cultural differences that I mentioned earlier. In the Black community, it is common to spend money as soon as it comes to buy things that will enhance their life temporarily and not for the long run. In the Jewish community, it is common to keep their dollars flowing in their community to keep their wealth up and not

to decrease it as a whole. Defining wealth, in my opinion, is generational and continuously flowing. How can wealth continue to flow if there is no work to keep money in the communities it comes from? Being more conscious of your spending, especially when you're young and do not have as many responsibilities to handle, starts with you. If you feel like you also came from a background where financial literacy was not taught to you in debt, make sure that that unknown factor ends with you. Teach financial literacy to your family, friends, neighbors, future family, and anyone you can think of. We often see wealthy people of today talk about how their family was wealthy and helped fund their business or taught them financial skills that helped make their business successful. This could be the case for many more people of all cultures and backgrounds if the teachings of spending money wisely and investing in important things are taught worldwide and not kept a secret.

One of the biggest things I would tell my younger self to do differently is not to splurge as much on myself and my friends (sorry if you guys are reading this). The only reason I say this is because I could have invested my inheritance so much sooner and seen a greater return on it. While I do feel that way, I don't regret it. The memories I spent going on trips and having those great times with my friends are near and dear to my heart to this day. The only difference between then and now is a shift in habits and mindset. The change starts with you, literally. I will leave you with this jewel to shift your perspective on money and how you see it fit for yourself and your future family. Don't continue being a people pleaser to fit in with those around you. Make your decisions wisely and use your discernment in every situation.

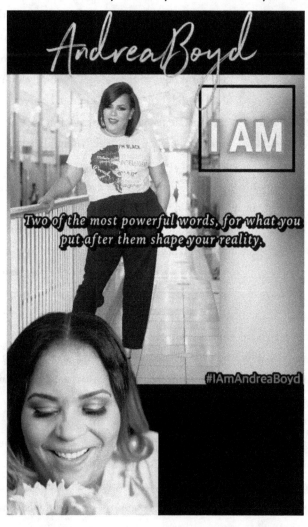

Charleta Harvey

Born and raised in Chocolate City -- Washington, DC for those unfamiliar, by a single-parent mom, I am grit when times get hard. I am a representation of possibility, despite humble roots. I am faith when the world says 'no.' Having stood at death's door and lived to tell about it, I am resilience personified. I am hope, even when all else seems lost. I AM BLESSED BEYOND MEASURE...in all the ways that matter. These blessings flow not because of money or material things but because of grace and mercy – even when I didn't deserve it. I am love after learning to love myself. I AM my ancestor's wildest dreams! But I didn't always see myself in this way. Through the gifts of time, maturity, and second chances — a million times over – I now understand how difficult it is to *see yourself* through the lens of possibility in times of challenge, especially a financial challenge.

When you lack vision for the future and can only fathom the burden and seeming finality of negative circumstances as they are, hope can be lost and new opportunities wasted. I now know that instead of focusing exclusively on *what is not*, there is far more value and strength to be found for the journey ahead in the place where the challenge likely first began...our minds and thoughts. Rather than looking at myself and my circumstances as *impossible*, I had to endeavor to see beyond the *now* and instead focus on new opportunities to learn, grow, do, and be. I had to, in the words of Vance K. Jackson, "identify my mountain(s) and study my climb." Knowledge is indeed power-- the more I get, the more powerful I become. What I also know to be true is that knowledge is infinitely more powerful when shared with others, that they too might be elevated in their understanding.

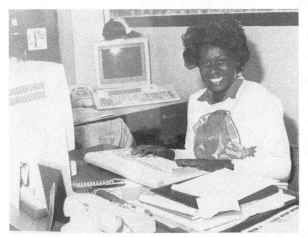

My mom LaQuatia at her job at the Washington Suburban Sanitary Commission (WSSC) where she worked for more than 30 years to provide for my siblings and I.

As a little girl, I can honestly say that I didn't understand my power – let alone the importance of having some measure of it, at least not beyond what my childlike fantasies about being a superhero gave me. Those "fantasies" allowed me to escape my environment in favor of a made-up one, to trade moments of lack & struggle for abundance, prosperity, and peace. I've since come to understand that power is about more than simply having control over others, one's self, or access to extensive resources – financial or otherwise, *it's about having choices*. Exercising the liberties of one's right to choose, anything really – to take it or leave it – without fear of consequence because simply knowing you *can* is empowering enough. It's everything. It's invaluable.

In childhood, the most powerful folks I "knew" were on television...they had the attention & admiration of people the world over, and they had money...*so they had choices*. The only people that came anywhere close to the folks on tv that I viewed as wealthy and thus powerful were the street-corner pharmacists – they always had wads of cash – they also had choices, albeit untenable ones...jail or death if something went left. I both admired and feared them. They led a dangerous lifestyle. But, that money provided for their families, something folks in the 'hood wanted and desperately needed.

The concept of wealth was very foreign to me. In the early years, we didn't discuss investments or the like. However, I remember overhearing my mom talk about contributions to her retirement plan. The conversations were about something she did rather than shared specific details about. I learned so much just by watching her, and I'm incredibly grateful! After she and my dad divorced, her role as a single parent required her to work extra hard – sometimes having two jobs at once. Because where I'm from, people were just trying to make it. Our everyday vernacular in the inner-city neighborhoods of northwest Washington, D.C., didn't include discussions of *wealth*. You were either *rich* or *poor*; there was virtually no middle ground. I didn't even fully understand what it meant to be middle class until I was nearly in my twenties! So, in my adolescence, it's safe to say that my mentality was one that (incorrectly) assumed money & wealth were the same. I didn't realize that *having money* didn't necessarily mean you were wealthy, only that you were likely – at least in those early days, *making it* a little better than most. But, in the words of my maternal great-grandmother, who worked for many years as a housekeeper – or domestic as they were once called, to make ends meet, without proper planning for the future, "We are all just one paycheck, one life catastrophe away from financial ruin and poverty."

As an adult, I define wealth in new and empowering ways. I understand it to be something far beyond dollars and cents, more than just a number – although the number certainly matters! Wealth is not just about having money in the bank; it's about keeping more than you spend and then using what you keep to save for a rainy day, invest, grow, and enjoy. For me, wealth is generational and knowledge-driven. It is also a consideration of and planning for how far the money made today can reach beyond tomorrow. It is seeds of legacy planted through the prospering of communities based upon an understanding that "to whom much is given, much is required." In this way, we are indeed blessed so that we can be a blessing to others. To be clear, the blessings are not handouts but instead a hand up in the form of advocacy, education, and philanthropy. My paternal great-grandmother was a strong model for "to whom much is given...". She was the 1st and only female – African American or otherwise, to own a general store in Gees Bend, AL. The only other store in the town was a co-op owned by a Caucasian man. As you can imagine, Black folk more often patronized my great-grandmother's store, and she used produce from her farm to help keep it stocked to meet their needs.

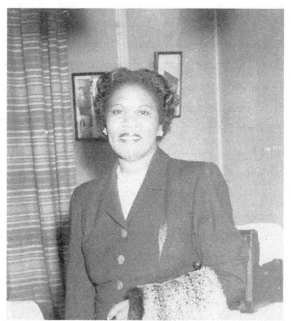

My maternal great-grandmother Cliffus McKinney, more affectionately known as Mama Tee. Despite her humble employment she was quite a sophisticated lady!

As we talk about wealth, we owe it to ourselves to clarify what that amounts to on an individual level. Different wants, needs, and life experiences can significantly influence one's opinion about what it means to be wealthy. Because you can't miss what you never had, for some, being wealthy can mean having enough to pay the bills with a bit left over for dinner and a movie once a month. For others, it comes down to being characterized as a millionaire, that is, until you look at the financial footprint, aka "the spend." Is this so-called millionaire being thrifty and considering the future or spending like there's no tomorrow, regardless of how uncertain it may be that the money will last? For still others, true wealth is directly correlated to *knowing your number*, i.e., the total dollar amount by which you could live out the rest of your days, even if you never worked another day in your life and maintain a quality of life at or above your current station—recognizing the importance of knowing this number means having and executing a plan to achieve it and, more importantly how to stay there without using credit of any kind. It means exercising the discipline to financially plan for twenty, thirty (or more) years from now; when the kids are gone, the job is done, and life 2.0 begins. And it starts with the wealth of mind.

They say you do better when you know better. I don't know that that is true for everyone, but I know that once you know differently, you are empowered to choose differently. I now recognize the things I could not fully understand or respect about money in my youth as deferred (but not denied) opportunities that can be fully leveraged now. I get to choose my attitude about money and thus my relationship with it. I get to decide if I control its flow or if it controls me. Where it was once viewed as a tool for survival, I now honor it as an invaluable

resource, far more than simply a means to an end. I get to experience the elation at watching it grow, see it do good in the world, fund my fun, and provide for my family's needs and my children's future, among other things.

When I reflect upon the motivations behind my decision to join the *Club*, honestly, there were several. The short answer is that I joined because I believed in the vision of the investment club's Founder, Dr. Angela Reddix. On the surface, it truly does seem that *everything* she touches becomes gold without difficulty. In reality, I know that that is far from true. She is a very astute businesswoman; more than anything else, she has made our God above her purpose partner in every endeavor. Her undeniable success is the fruit of that partnership. She is walking in that...she is the epitome of that, and I wanted some of that for myself! The knowledgebase. The business prospects. The iron sharpening iron. And the ability to increase my financial literacy while building wealth alongside other like-minded women was also a powerful draw.

Plus, there was something about joining the *Club* that felt both inherently organic and *necessary* – particularly in this time of nationwide uprising in the face of social and racial injustice and women's inequity across a spectrum of concerns.

The Club is more than a moment; it's a movement that is going to have a lasting impact on the women coming behind us and on us as founding members.

As a woman of color, I was very fortunate to be able to meet the moment financially when it presented itself...the investment being significant as it was. Statistics related to wealth tell us that that is the exception and not the rule, as women of color tend to fall near the bottom of racial and ethnic demographic rankings. The female-powered *RR Fund Investment Club* endeavors to change that, one woman, one household at a time. Before I ever discussed club membership with my husband (which I did, by the way!), I realized that for me, joining simply was not an opportunity I could let pass me by. I did not regret my decision then; I do not regret my decision now.

My most significant "ah-ha" moment since joining the Club, truthfully, has not been anything so earth-shatteringly magnificent. There was no big WOW! But instead, it has been a collection of little things over time, the most impactful being a simple yet often overlooked truth...and it was life-changing. It is empowering in ways that have allowed me to fully lean into the club membership experience. And it was this: no matter where you are or what you've done in the past, be it miscalculations in money management, a lack of planning for the future, or something altogether different, it is never too late to get started *right where you are*. Baby steps matter nearly as much, if not more, than the larger ones taken after that because they develop our patient obedience. Our diligence. Our discipline.

Starting right where you are, taking baby steps toward enhanced financial security – or not – means the difference between "maybe" and "definitely" having the power and freedom of choice for your life...where you live, how you live, etc. Think about it this way, if you do nothing to make a change now, *maybe* one day things will miraculously get better, but that's not very realistic or productive. If, however, you decide to begin investing in yourself and your future – today, even while starting small – by creating an achievable financial plan that allows you to gain knowledge, increase your financial health AND build wealth over time, you'll *definitely* be the better for it! Beyond this, don't sweat the bumps in the road or discount the small triumphs along the way; getting *there* gives us a chance to meet ourselves and discover who we are amid the journey.

If I had the chance to go back in time and have a conversation with my 20-year-old self, I'm sure there would be much to talk about – LOL – oh, if I knew then what I know now! Thinking it through, two very important points come to mind:

1) don't be afraid to fail...failure is required for growth in both your personal & professional development;

2) how you "start" doesn't have to be how you finish...you can begin again – stronger, wiser, and empowered to become far more than you thought possible.

Then again, another point fills my mind...share and teach what you know and strive to never stop learning more; the positive ripple effect from this is infinite. Life is a magnificent classroom, and experience is your best teacher.

I come from a strong legacy of survivors who, though well-intentioned, could not possibly fathom the unintended impact of being singularly focused on just *making it*. On the one hand, it could be argued that they didn't have the luxury of doing anything different during those early days. And yet, at the risk of sounding critical of my kin, I'd argue the importance of focusing on the multi-dimensional climb from survivor to thriver. To be clear, I recognize that some life situations undoubtedly cause a survivor's instinct to kick in. However,

there's real value in harnessing and repurposing some of that survivor energy into a more intentional focus on developing a thriver's identity...to not just stand still waiting for the next *shoe to drop*, but to exhale and live.

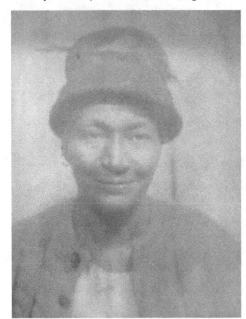

My paternal great-grandmother, Martha Mosely. She too was a sophisticated lady, as well as a well-respected entrepreneur — the first, I believe in my family.

Every decision we make in life indicates, at any given moment, how we see ourselves and what we believe is possible. Those decisions that build us up inspire hope and embrace opportunity; decisions that disrupt our productivity distract us from our God-given potential. This is especially true of our financial health. We can't just focus on today; we must also plan for the day after tomorrow, as well as unexpected life events that have the potential for catastrophic impact.

In life, we are responsible for how we show up in the world...whether our attitude portrays gratitude, lack, or narcissistic entitlement. Generally speaking, the same can be said about our attitude toward our finances. When we have monetary resources available not simply to meet our needs but to extend beyond them, there is – or at least should be – a healthy appreciation for its stability. Sometimes though, all you know is all there is...and when you know or have experienced continuous lack, it is tough to see beyond today. At the other end of the spectrum, the absolute extreme is narcissistic entitlement and the pursuit of excess for the sake of exploitative access. A posture for which I have zero respect. To be clear, I have no issue with people building wealth – I am, after all, building mine. But, what I do take issue with is the idea of building wealth exclusively for the purpose of greed. A person's prerogative is theirs alone; I just happen to think wealth is exponentially more powerful when used to do good in the world...above & beyond, tending to our own needs.

Thinking about these things as I consider my attitude regarding wealth over time, and notwithstanding my circumstances at any given moment, there is but one word that comes to mind – *OPTIONS*. I am grateful to know and understand that wealth creates options. It builds relationships. It solves (some, but not all) problems. Wealth innovates and empowers. And when respected and adequately leveraged, it can be an undeniable force for good, just as the Bible says in Ecclesiastes 10:19(KJV)..."money answereth all things."

While we are all born into different financial circumstances, some ideal, others less so, a shaky beginning does not have to be the end of possibility. We are all given the same 24 hours a day, and we each get to decide how & where we'll make the most of it. Commit to taking the time to cast the vision for your future wealth. And, as you do, consider the following:

Make a Financial Health & Wealth Wishlist.

Items on your list can include establishing a retirement account and making regular contributions. Building savings, paying off debt and achieving and maintaining a specific credit score. Be as detailed as you can about the goals connected to these activities to turn your wish list dreams into reality.

Identify the Assets and Obstacles that will Impact Your Wishlist - People. Thoughts. Behaviors.

When positive, these are assets that will support the achievement of things on your wishlist, getting you one step closer to financial health & wealth. However, when negative, these same things become obstacles that can detrimentally impact your progress.

Identify Your Wealth-Building Dream Team...Ask them for help and Expect Accountability.

You must commit to doing your part; your wealth allies can then come alongside you to do theirs. The members of your dream team should ideally be people who can lead you by example and have the proven knowledge & experience to help you get where you're trying to go.

NOTE: People with a more dire financial situation than yours cannot lead you to the promised land and thus don't qualify to be on your team! If anything, they will serve as nothing more than a distraction. Or worse, an obstacle that slows your progress. Team members should consider including a banker, an accountant, and a certified financial planner, in addition to your partner/spouse (if applicable).

Make a Wealth-Focused To Do List.

Before you can build sustainable wealth, you must establish or improve your overall financial health. To make it possible, here are a few suggestions for your wealth-focused to-do list:

Begin to believe that accumulating wealth is possible, change negative financial habits (ex., stop spending outside of budget), learn your money "flow" (i.e., the amount coming in & going out) – then control it instead of it controlling you, create a budget and stick to it, commit to learning something new about financial health and building wealth each month, reward yourself (with something small) when money milestones are achieved, *forgive yourself for not starting sooner*.

Most importantly, take the first step and get started now...no more excuses! Remember, consistency and accountability are a must.

Charmin Jacobs

Like many women, I tend to move into the space of what I do and what I've done when asked to share who I am. I'm a retired Naval Officer, a mother, a wife, a daughter, and an entrepreneur. Falling into titles and the things I do in those roles (well, I might add) made me feel valuable. It gave me the reason for my worthiness until now. It felt like I heard a different question, "Why are you?" I would begin defending my reason for being.

At this moment, I hear the question clearly. I have a new understanding. I have a new knowledge of WHO I am. Because of my relationship with Divinity, I can share the essence of who I am. At my core, I am a unique expression of a Loving Creator. I express through beauty—the beauty of my smile, the sparkle in my eyes, my curly hair. I express myself through generosity. My very nature is giving—giving freely to those within my circle of influence and reaching further all the time. I express myself through my strength and my resilience. I can hold on when life's wind is blowing and snap right back into place when I get knocked down. I express this through my resourcefulness, knowing there is always a way or another way and another way, and never giving up. I am a woman worthy of love because I offer it every day. I am like a tree: growing, learning, unconditional in my giving, paying attention, and swaying in the winds of change. That is who I am.

I think of my childhood as special. My formative years were in the south. The first eight years of my life were spent there in Woodbine, GA. There is something special about a southern experience, in my humble opinion. There I built a foundation for the rest of my life, and it was solid and easy to build upon.

I moved to Delaware and erected other aspects of my becoming, but always standing on my Georgia foundation. As a young girl, my indication of wealth was a comparison game. You know how we look at what we have and put it up against what those around us have. That's how I could tell who was wealthy and who was not, namely me.

It started with my car. Let's pause for a moment and acknowledge that I had a car! I've met so many friends who didn't have the same experience. I want to show gratitude for that. In high school, I drove a blue 1972 Datsun B210 with a rusted floor and a red pinstripe. I had a car! I was so proud of my car until I compared it to the vehicles of my classmates. They drove Porches, VW Jettas and Jeeps. New ones! This comparison let me know that they and their families were far wealthier than mine. They had pools in the backyards that resembled a resort-type atmosphere at their homes. We had an inflatable pool that sat on top of the grass. We had a great time, but it was undoubtedly my first indication of wealth.

As a woman who is also black, I now understand that comparison is the thief of all joy. I believe it was Mark Twain we can thank for that wisdom. There will always be someone with more than me. That someone else has more than I do doesn't determine or deter me from my wealth. That is an important knowledge to have. I chose to redefine wealth in my life which didn't include comparing myself or my position to anyone else.

I define wealth as freedom. It is that simple for me. Wealth is freedom—the freedom to own my time, set my agenda, and give myself a raise according to my decision to create something new. Wealth became the rhythm, and freedom was the song. Wealth, as I define it, choice and the freedom to choose is what I value about wealth more than anything else. When someone first asked me if I knew my

number, I was perplexed. Maybe I was a little apprehensive about finding out what my number was. What I discovered is that knowing my number is power. Knowing my number is fuel. Knowing my number gives me a canvas on which to create the life picture I wish to have. It's a starting point that encourages more creativity. I fully understood that I could not possibly know where I was going unless I knew where I was at that moment. Notice that I didn't say where I've been; where I have been no longer matters. Where I've been won't help me get to where I am going; only knowing where I am right now.

My GPS gave me the perfect understanding of this. Let's say you are going to drive to California. What are the two essential questions that the GPS is going to ask? Will it ask where you have been? Absolutely not!

It will ask:

1) where do you want to go?

2) what is your starting point?

Knowing those two pieces of information will give you step-by-step guidance to get there. So, knowing my number is just the starting point for when I get on the road and go to the place I wish to be. Knowing where you are right now is essential before you go anywhere.

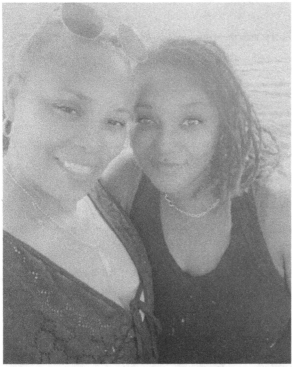

If there is WIFI, we can create income and enjoy traveling the world simultaneously. Laticia and Charmin are out sailing onboard a cruise ship.

The two words relationship and money in a sentence are interesting, and it conjures so many images. It is a connection, a link, an affiliation with something, someone, or someplace. How am I connected to money? How does money link me to other connections in my life? That is how I downloaded this question to give an output describing my relationship with money.

For me, money is a tool. It is something I utilize to provide solutions. It is a means, not a method—a means for delivering experiences, education, resources, and support for people and organizations that align with my life values. I don't think of money as anything more than the energy that I get to bring into my life. I love the balance that money offers. It epitomizes scales. I create it, and I spend it. I love that. I create more, and I spend more. I love to spend it, so I think of ways of creating it as a relationship that I enjoy.

I have a relationship (remember that word...connection, link, affiliation, bond) with Angela Reddix. I have had the privilege of knowing her for over a decade. I've watched her set goals and reach them. I've watched her raise a standard for leadership amongst black women. I've watched her design a system for teaching young women with Envision, Lead, Grow, LLC. Those aren't just words. She is a visionary. She leads by example in everything she does. And she allows others to join her in the beneficial experience of the growth of that vision. I trust that.

I was invited to the *Club*, so I didn't see it as a leap, and I recognized it as a commitment and chose to make it. My relationship with Angela had enough history for me to see her growth and to trust her ability to expand even further. Her servant leadership made it an easy decision. I aspire to be a servant leader of the same magnitude within my circle of influence. This decision was because of a relationship I found easy to make.

When I was a young girl, I loved to watch *Looney Tunes*. I particularly enjoyed the Roadrunner. I was fascinated by the incessant attempts by the Coyote to catch the Roadrunner. I almost felt sorry for the Coyote sometimes. He just didn't get it! He didn't give up, though. He kept waiting for his "eureka!" moment.

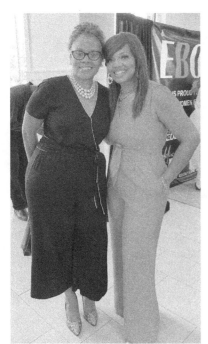

Relationships Matter! Angela and Charmin attending the Reddix Rules Fund Inaugural Cohort 1 Graduation Ceremony.

A friend of mine shares the acronym ATINIAH—All That I Need I Already Have, with me quite often. I think that was my most significant eureka moment, the moment I actually understood and knew that she was right. I am a retired Naval Officer who worked as a Civil Servant in the Federal government for several years. I left that line of service and chose full-time entrepreneurship. I came to understand that Black Wealth is not just a snippet rolling on the bottom of a CNN frame. It is not something that "others" have. It is not illusive, temporary, or fleeting. Black Wealth is a choice. It is a decision. The "aha" for me was the acronym ATINIAH! That was what moved me to go from being enlisted to becoming an officer in the military. That knowledge is what drove me from retirement to working in leadership to effect change in the federal government. That knowledge pushed me to full-time entrepreneurship and the creative space to make freedom my choice. I didn't need anything more—not another degree, not one more certification, not one more group to accept me in order to make that decision. I chose wealth because I knew that I could. Wealth is something I choose. Entrepreneurship is my path to success. Fully embracing the knowledge that I am ready, capable, and equipped to make a choice was the most significant "aha" for me.

I was 19 years old, almost 20 when I enlisted in the US Navy. I did so after a decision to leave college. I'd been given a full scholarship because of my basketball prowess and discovered that I wanted more, and basketball was a distraction to the more that I wanted. I left school, and with the encouragement of my cousin, I enlisted. I carried some doubts about my decision at times when I was younger. Today, I know I made the right choice.

I would say to my 20-year-old self...

Little Miss Ma'am, this is about you and your right to decide for yourself what you want for yourself. You are doing a great job. You don't have to wait to be great. You already are! You are already exceptional, worthy, valuable, and loved. You don't have to earn that. You are that! Everything you need is in you. Open and let it pour out. Get to know yourself and always grow yourself. Don't be afraid to dream, and don't ever stop dreaming!

There are angels riding on the wings of your dreams that would otherwise never fly. Your dreams are needed. Oh, and Sweetie, don't forget your sisters. They are watching you. Lift as you climb. That way, you will always have friends with you at the top. Your mountaintop experience is on the way. I'm so proud of you and the woman you are becoming.

I've shared with you what wealth looked like for me as a child, and as the adult I am now. I'm choosing. I'm always choosing. In every moment, we get to choose. The word that defines my wealth choice is RISE. When you think of the word rise, where does your mind go? for me, it tends to go up. I go up to growth. I go up in intensity. I go up by way of increase. I go up, sometimes, to climb. I go up to augmentation and make my life bigger. I love the word RISE. It has become an acrostic for my current wealth definition, meaning it is a word with four letters, but those four letters offer a doorway to access a deeper meaning for my life.

Respect: Respect yourself and others. I have a healthy respect for the experiences, education, and expertise of others. I don't know it all, but I also have a healthy respect for what I know and how I can connect with those who know what I do not.

Influence: Leadership is influence. Nothing more. Nothing less. We all have influence; therefore, regardless of your audience, you are a leader. Pay attention to where you are going.

Service: Serving others is a bridge to wealth. Therefore, servant leadership has a reciprocal effect on those who choose that mode of leading. You always have a critical mass of customers when you think from that vantage point because there will always be someone in need of service.

Excellence: I am always careful to point out what excellence is not. It is not superiority as with condescending behavior or belittling. Excellence is choosing quality. Quality is always preferred. Work on the quality of your service, product, and interactions, and then wealth becomes a byproduct that you will create more and more of because you chose excellence in the way you serve.

Make the decision to respect, influence, and serve others in excellence, and you can't help but be wealthy.

My mother, Marjorie L. Timmons, is my heavenly conductor orchestrating my dreams.

3 Daily Habits to Excellence

Journal Daily. Journaling is a way to remember. It's a way to see where you are and map out where you are going. When you plant a seed, you can't just dig it up the next day and yell at it, "Why haven't you grown yet?" You must give it time. Journaling allows you to see the growth from seed to seedling to the full-fledged forest on every page. You document your emotions along the way so that they feed you during the rough patches that are sure to come. When you wonder if any growth is possible, journaling reminds you of the places you've planted in the past that had tremendous growth so that you stay the course. I encourage you to write daily.

Meditate. Meditation allows you to connect with Spirit. Regardless of your spiritual practice, you must know that energy is greater than you. Connecting to your Source of energy enables you to move in the right direction. You will get inspired thoughts and the means to take inspired actions. Daily acting without connecting to that power source is like vacuuming your living room carpet without ever plugging in the vacuum. You might see the lines on the rug showing that you did the work but nothing to show for the work you've done.

Serve. Do something for someone else every day. This act will keep you in the space of appreciation and gratitude regardless of your station in life. Serving will remind you that you have something to give, no matter your condition. In that space, you will see your conditions change, and when your conditions change, so will your giving. But everyone can give/serve daily. I encourage you to do that cheerfully.

Connie Russell

As the twelfth jewel in my family, I always felt like I had to do or be 'extra' to be seen, heard, or even respected sometimes. Jewels were the name my parents gave my siblings and me. Even to this day, I am still considered 'baby girl' to my 11 siblings. Yep, nine girls and three boys; it was clear my parents did not watch the TV sitcom 'Eight is Enough,' but I assume watching the "Brady Bunch' at least twice gave them the idea that 12 was the perfect number of children to have together. For those of you who are post Generation X, you'll have to Google these TV sitcoms to get it. Being raised in such a large family, some may think it had to be challenging, and sometimes it was. But the truth is, I would not change one thing about it. As an adult, I realized just how amazing my parents were. The way my parents raised us, it was like they created their own 'playbook' for raising their own tribe. I like to think I had the best seat in the house growing up because I had the pleasure of observing the life 'chronicles' riding on the coattails of my older siblings...sorry guys! This front-row seat ignited the 'gutsy' Connie inside me.

All my siblings had a creative finesse and personality about them. So here I am, the youngest, trying to discover my 'finesse' since they were practically all taken from the other 11 siblings! Eventually, I discovered it, or shall I say 'them.' I recognize different talents I had; I like to think I captured a little piece of finesse from each of my jewel siblings. One of my creative 'finesse' talents was fashion. I loved designing and styling, especially hats! I remember watching my mother get dressed every Sunday morning, and when she topped off her assemble with her fabulous hat, it was as if she transformed into a powerful being (not that she wasn't already.) I also discovered my discerning skills in helping others learn in creative ways. I became really good at it, which was the catalyst for launching my training company. Fast forward, today I never stopped believing that, and it has made me the humble, strong, persevering CEO I am today.

As a little girl, I had no idea what the word 'wealth' meant. The words I was most familiar with in that context were poor or rich. I do not recall reading about wealth in the schoolbooks either. Even as a young adult working at a bank, the word wealth didn't come up...at least not around me. My grandmother owned two homes. She was a landlord and a homeowner. She owned land and a farm. Whenever I stayed during the summer months, I never had to wonder what I would eat, wear or live. I was always taken care of. That was wealth to me. As a teenager, my parents were homeowners, owned land, and bought me a car after graduation, and I never had to wonder what I would eat, wear or live. That was wealth to me. Wealth was having what I needed to survive, live, and grow. According to the Oxford Dictionary, wealth is defined as *an abundance of valuable possessions or money*. If this is the case, perhaps I was wealthy. What my grandparents and parents owned was an abundance of valuable possessions to me. As a teenager, I don't recall having an abundance of valuable possessions unless you consider my collection of New Edition & Mary J Blige memorabilia valuable. As the youngest of the tribe and always receiving my older sibling's secondhand clothing, I guess that could've been an indication of lacking wealth.

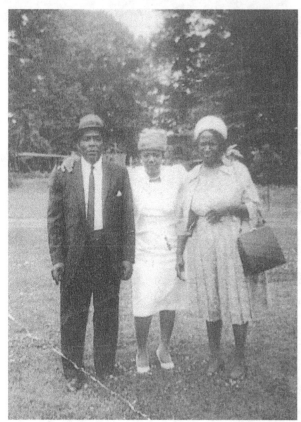

My parents taught me, just through their life examples alone, to always know I already have everything I need to get what I want.

Watching commercials and drama sitcoms showing flashy cars, celebrities wearing high-end fashion, etc., was what the world made me believe was wealth. Later reading about those same celebrities going broke while reading the tabloids at the grocery store would make me wonder how did that happen? Aren't they rich (wealthy)? I can laugh about it today, but as a teenager, the tabloids kept me in the know about what I thought being rich (wealthy) was. How could someone who appeared to live such a rich lifestyle lose it all? To my curiosity, I would soon learn what wealth meant while discovering entrepreneurship.

"It's all about the Benjamin's baby! Now... what y'all wanna do? Wanna be ballers? Shot-callers? Brawlers -- who be dippin' in the Benz wit the spoilers On the low from the Jake in the Taurus Tryin' to get my hands on some Grants like Horace. Yeah livin the raw deal, three-course meals Spaghetti, fettucini, and veal. But still, everything's real in the field. And what you can't have now, leave in your will."

That is how Puff Daddy and his squad so uniquely described wealth. To me, wealth is generational, created to give continuous value. As an adult, I discovered that wealth could have different meanings for everyone. To some people, money is not their everything. Every time I looked up the definition of wealth, it related to assets, money, valuable possessions, or property. It was tied to something physical. I believe in four types of wealth: Financial Wealth (money), Social Wealth (Status), Time Wealth (Freedom), and Physical Wealth (Health). Wealth is a state of mind. What good is it to anyone to have a large bank account and not be free to enjoy it? If I had to choose one type over the other, it would be Financial Wealth. I would choose financial wealth because I believe money gives me access to freedom. Freedom to buy me more time, take better care of myself, and position my social status. Financial wealth is my freedom ticket. Slowing down to reach one's financial goals is not an option for me.

Growing up, it was common in my circle of family and friends to hear people say, 'I got your number.' It didn't mean you literally knew their number; it meant they knew what you were up to. When used in another context, for example, being a businesswoman, it literally means I know your number, your financial numbers, that is. Years before becoming a business owner, I was asked a question by a wealthy business owner, "Connie, What is your number?" I had no idea what he was talking about. I didn't know if he was trying to school me on numerology or Scientology or if he wanted my phone number. So instead of looking even more confused, I simply positioned my poker face and replied, "I'm still working on it." I figured that answer could be applied to all three options. He smiled at me and sat down. I knew at that point he figured I had no idea what he was asking me, so he took the time to explain what he meant. Knowing my number is understanding what my income and expenses are and what is needed to live the lifestyle I desire. It always amazes me when someone explains something to you only to realize it is something you should already know. It bothered me that I didn't know 'my number' or didn't have people in my tribe who felt it was a conversation worth having. (Note: Always have friends smarter than you). But I knew I wanted to do something about it. Knowing my number equates to freedom, optimism, and faith. It means I know how much I need to earn to live the lifestyle I desire and position myself for generations after me. It means understanding how much I'm willing to sacrifice, grow and work to acquire such a lifestyle. It means having enough faith to believe the lifestyle I want to live is so conceivable. Once you know your number, it becomes your 'gamebook' for life. The roadmap to reach your ultimate goals and enjoy it along the way.

When I think about my relationship with money, one bible verse sums it up for me. It's 1 Corinthians 13:11 *"When I was a child, I spoke as a child, I understood as a child, I thought as a child: but when I became a man, I put away childish things."* (KJV). Growing up, we didn't have conversations about how money can work for you from a broader perspective. Money conversations around the kitchen table were reminders to save a percentage of your paycheck for personal expenses, contributing a percentage to the household, and contributing your ten percent to the church. Money was a teaching tool to help develop my independence and become a responsible adult. Things most parents want their children to learn before they leave the nest. Learning how money can work for you and how to invest it wasn't a common conversation growing up. So as far as I was concerned, my relationship with money was good. After all, I was giving a percentage to the church, paying my expenses, and keeping a roof over my head. That was my relationship and mindset with money before I 'got schooled.' How I thought about myself mirrored how I thought about money. I figured if I was making ends meet, I was doing okay and becoming content. Fast forward, as I grew up and was exposed to new lifestyles, careers, and higher education, I began to realize my relation-SHIFT with money started from the inside. It was then I began to understand I had to change my mindset. The more I worked on believing in my dreams; I began to look at money as a vehicle to take me to where I wanted to go rather than a band-aid to my problems. Developing my relationship with money didn't just increase my finances, but it increased my wellness and feelings of freedom. I no longer thought as a child; I grew up, and so did my mindset.

As women, we do not need to slow down for others to catch up. We've been slowed down for too long.

Before deciding to join, I didn't have to know too much about the program. I already knew it would be a valuable investment for me. I believe all things happen for a reason and joining the RR Fund Club was a journey that was pre-destined for me. Being in my fifth year of business was considered the year of discovering my CEO space. You discover a new you and realize how differently you see things. This meant putting away old ways of thinking to explore new ways of thinking and surrounding yourself with diverse individuals with similar growth mindsets. Growth has been my mantra for the past few years in all facets -Spiritual, Physical, Mental, and Financial. To grow successfully, it's important to connect with individuals demonstrating growth in whatever area your goal is aligned with. I'm in a season where I'm focusing on my financial wealth growth, and what better company of individuals to be part of than an all-female investment club? This club has all those components and more. There's something special about being in the company of like-minded individuals. You're reminded that you're not the only one facing certain obstacles in life, and the possibility of recovering is proven amongst such individuals. I joined the club because it was Angela Reddix's project! She is an individual who has not only demonstrated success, but she's an advocate for helping others reach their goals. Being the CEO of my life, my time is valuable and priceless. Joining this Club is worth the investment, and I expect tangible and intangible big returns!

My most significant "ah-ha" moment was realizing I did have enough money; I just wasn't managing it appropriately. For so long, I always thought I had to continue to earn more to manage my expense. When in reality, I only had to manage better. Discovering the true meaning of wealth will change your list of 'needs.' What I thought I needed, I later realized I didn't. Wants and needs don't always align at the same time. I later discovered that by applying new money management principles, I actually decreased my expenses and increased my income. The only thing that changed was my mindset.

If I could go back in time and talk to my 20-year-old self, the location would be on the beach, sipping an apple martini. Then I would begin to spill the 'tea' with her! The conversation would go something like this...

"So, this is what we've become. Did we do good? I'm not sure if anything I am about to share with you will make a difference in our future, but by chance, should it trigger and expand your mindset, I can only believe it will be for the better. That said, I will get this part out of the way...we are not married...yet. We had offers, and we declined them, but we will be fine. You will eventually learn to know your worth, and no longer accept mediocrity in any space in your life, and you'll be o.k. with it. Our relationship with God will become so amazing, but trust that it will take some work to get to that point. You'll experience seasons of doubt and insecurities but always bounce back. That's something I love about us; we are such survivors. You'll also experience fabulous ventures with wonderful friends and even have some memorable loves in your life. Our career of being a business owner will come to fruition in more ways than one; I'll keep that as a surprise! But as much as I would love to share more with you, I don't want to share too much that you have nothing to look forward to. Just know and believe that no matter what you go through in life, God has given you everything you need to win. I need you to believe it and act on it. Because I procrastinated so much out of doubt, I missed out on some amazing opportunities. But I'm making up for it now. But you don't have to; all you have to do is believe that you're capable of doing whatever your heart desires regardless of what others say, and I guarantee you will win. I want to leave you with a few jewels of the many things I have learned so far in life. 1)Always surround yourself with people who are smarter than you 2) Learn about investing and managing your money now! 3) Have at least three mentors (financial, spiritual, and business), and oh yeah, I almost forgot. 4) You're going to meet a really nice guy named Pete. You're not going to be interested in him romantically, but you will think he's nice. He was the one who got away! Learn to like him. He will be worth it, trust me!"

Although I believe all things happen for a reason, I also think that if some things were prevented, it would help many of us from losing valuable time in our lives, time that cannot be replaced.

#Abundance! This is my attitude regarding wealth. I've learned to appreciate everything I've been blessed with, and I try not to take anything for granted. I believe having an abundance of time, peace, and other things that complete one's life makes you wealthy. My attitude toward wealth is to use it as a tool to help me reach my purpose in life. I feel blessed to have discovered a career path that is rewarding financially, but more importantly, I believe it is my purpose in life and one that I enjoy. Planning my schedule each day is not a task for me. I enjoy working with my clients and getting to know them, their values, and their needs. My business not only helps my clients and employees achieve their financial goals but also helps them define their attitude regarding wealth. It feels good to have the privilege to pour into others, help them reach their personal goals, and define their attitude toward wealth.

I want everything and every person in my life to have value. Why am I sacrificing my time with it or them if it's not valuable to me? Period.

Everyone will have their personal wealth lessons and journey to experience. It's not always easy to get started in the right direction or even maintain your flow once you feel you understand achieving wealth. I've been there and still experience challenging times when I'm trying to stay focused on achieving wealth. Life just happens sometimes, and when it does, you'll find out that some things cannot be fixed. You will have to swallow your pride, dust yourself off, cock your hat to the side and keep it moving! I desire that my candid but humbling experiences have allowed you to examine yourself in the next phases of your wealth journey.

Here are a few Jewels that have helped me daily to continue to move forward with my wealth journey during all phases of my life. These jewels were either discovered along my journey through trials or were shared with me by a few wise people in my tribe. I challenge you to put these jewels into practice daily to help you further define your self-worth and develop your wealth mindset.

Jewel #1: Define Your Tribe. Your vibe attracts your tribe. You are the average of the five people you spend the most time with. Select your tribe wisely.

Jewel #2: Know Your Number. An overall understanding of your numbers places you in a far stronger position to make better decisions.

Jewel #3: Identify Three Mentors (Spiritual, Financial, Business). Mentorship is a two-way street. Identify mentors who can pour value into you to help you reach your goals, not waste your time.

Jewel #4: Embrace a Healthy Lifestyle. Your body will only do what your mind tells it to do. Take care of your mind.

Jewel #5: Learn & Practice Money Management & Investment. Being without is a choice.

Jewel #6: Discipline. Create rules to live your life to achieve the results you want.

Debora Clark

Fear paralyzed me, but determination made me soar. I am a survivor!

From being victimized, living daily with an auto-immune disease, and eventually being diagnosed with breast cancer, I always wanted to give up, but I survived. I also wanted to give up and throw in the towel regarding my lack of financial management. I went on an unpleasant journey where there were bumps in the road, and fear consumed me. If one unfortunate BIG thing happened, it could financially cripple me. While I survived, I didn't know I could thrive and be the best I could ever be.

Growing up as a military brat, I lived in a two-parent home until I was 14. Before then, there was not a need that I had that was not cared for; after my mom and stepfather divorced, things changed drastically. Our family had to leave our single-family home and move into a three-bedroom, roach-infested apartment. My mom did her best to raise her three children, but when you know better, you better. As a family, we never talked about finances, and saving and investing were foreign concepts; therefore, I never learned skills that were truly needed to be successful with money. Even when there were discussions with knowledgeable people in my young adult life, I still didn't manage my finances. I did not do better until I turned 50.

And it was not that I was unintelligent. I graduated from James Madison University with a Bachelor's degree in Office Administration. I followed with a Master's degree in Human Resources Administration from Central Michigan University. Today, I am a Human Resources Business Partner Senior Principal making a six-figure salary, but having a six-figure salary means nothing when making poor money choices. For most of my life, my money controlled me. I know now that money habits begin early in life. I didn't learn the importance of managing and growing money until it felt like time was running out.

In 2018, I made the decision to take control of my finances. Therefore, I added up all of my consumer debt. When I saw the number, I felt like drowning and couldn't breathe. I had over $78,000 in debt from purchasing what I wanted and not what I needed. Making purchases without thinking about my financial future and building wealth cost me time and money. Once the opportunity to join RR Fund Investment Group came along, I decided to invest in myself and my future.

When I was younger, my indication of wealth was depicted in shows like The Jeffersons or Diff'rent Strokes. George and Louise Jefferson "movin' up to the East side...to a deluxe apartment in the sky" or Willis and Arnold riding to school in a limousine indicated wealth for me. Additionally, seeing how movie stars and athletes lived with luxury cars and big houses indicated wealth. In the real world, I viewed wealth a little differently.

I wasn't able to live the comfortable life that I was accustomed to after the age of 14, so having friends whose parents could afford the latest and greatest clothes like Jordache jeans, K-Swiss, Chuck Taylors, bomber jackets, FUBU, and Members Only were indicators of wealth in my eyes. Their parents drove nice cars, lived in single-family homes, took summer vacations, could attend summer camp, belonged to Jack and Jill of America Inc., or were a debutante. A life that I dreamed of but didn't have. Even when it came to attending college, I didn't think that this was even a possibility for me. However, this dream did come true.

I always equated wealth to possessions that my friends and their families had. I also equated it to their opportunities and experiences growing up. Wealth gave them the power to do whatever they wanted. I knew that I wanted to have a life like their lives, but I didn't know

how I would get there. Even as an adult who has learned and grown, I defined wealth as an individual's or household assets, such as money in saving and investment accounts, minus debts like loans. As I have grown and learned more, it is much more than that. Today, I define wealth as being FREE, which is financially free. It is being able to manage my wealth, living a life where I can do whatever I want with my time, and living on my own terms. This means I don't have to worry about what is in my bank account, and I have assets that grow my net worth, like stocks, bonds, mutual funds, or real estate. Another way that I define wealth is that I am not institutionalized or handcuffed to "the man." That means that if a company or boss decides they no longer need my services, I have enough money to sustain my lifestyle for years to come; therefore, my paycheck is ONLY a bonus.

Frivolous spending and the inability to say NO, led me to accumulate over $78,000 of debt, which ultimately impeded my opportunities to build wealth.

As I get older, I realize wealth is not just about finances. It is about having psychological, spiritual, and emotional wealth. It is about my relationship with God, living a stress-free retirement, and overall peace of mind.

Periodically, I listen to a radio show called Dr. Laura. There are many times that Dr. Laura will ask a caller what they want their life to look like between now and until death. When I think about this question in my quiet times, my answer is that I want to live an abundant life where my finances do not control me. I am the driver, and the mission and destination are to build wealth.

In their book, The Millionaire Next Door, Thomas Stanley, and William Danko define your number as "...your age times your realized pretax annual household income from all sources except inheritances... divide by ten. This, less any inherited wealth, is what your net worth should be." I need to know my number, or my net worth, to make sound financial decisions and prepare for my future. When I know my number and work towards building my net worth, a sense of security comes over me. Not knowing my number early on in life, undue stress has occurred, and this has consumed me for many years. Taking on the challenge to know my number has been an eye-opener.

Early on in the RR Fund Investment Group, we were given the challenge of knowing our number. To calculate our number, we had to complete the steps in the book. After completing the calculation, I felt punched in the gut. I already knew that I was off a tremendous amount. Still, seeing the number and processing everything makes your mind hard. I am thousands of dollars off from where I should be. I knew this, but I had to face that I wasted time and money on my finances. I give myself an "F" on my financial report card, but I give myself an "A" for having the courage to find out my number and make the change to reach my financial goals. You can, too, by knowing your number. In fact, everyone should know their number!

My relationship with money is dysfunctional, complicated, and mixed with love and hate. I love making and having money, but I hate when I don't make wise choices with my finances. I am really not surprised by the relationship I have with money because the relationship formed early in life.

Growing up, the important lessons of saving, budgeting, investing, and staying out of debt were never topics of conversation in my household. When I had to take out student loans to get through college, I didn't think about the part about having to repay them. Reality hit when I received my first loan repayment bill. At the time, I was not making much money and paying towards the loan was one of the most unpleasant things I had to do. After paying back my student loans, one would think that I would have learned a valuable lesson about managing money and debt. Again, when you don't learn these valuable lessons early on, it can be hard to create good habits about managing money. Remember, financial management was like speaking a foreign language to me. It is complicated!

In my 20s, 30s, and 40s, I fumbled through life trying to manage my money. It wasn't until a cold winter night in February 2018, lying in my bed, that a voice in my head said, "YOU DO NOT HAVE ENOUGH MONEY to live comfortably in retirement." That night, I had to choose to change my relationship with money or continue living like I was – In debt and not building wealth.

I needed motivation because I felt like I was still a little stuck, so I read a couple of books. Zero Debt The Ultimate Guide to Financial Freedom by Lynnette Khalfani and The Total Money Makeover by Dave Ramsey. After reading these books, I added up over $78,000 worth of consumer debt. I sat in the middle of my bed, had a divorce party with my credit cards, cut them up, and closed all but one account. I paid off my debt in 25 months. If I didn't go on this journey, I would have never been able to be a part of the RR Fund Investment Group and have the opportunity to build my wealth and share my story.

I can't say that I don't still make some poor decisions, but I make way better choices about my finances than ever before. One step at a time, and you can change your finances too. Take the leap and go on the journey!

There is a saying that you don't know what you don't know, and one thing that I didn't realize is that only 13.5% of women make up the total number of American millionaires. And I am not in the 13.5 %, but I want to be. Therefore, there are five reasons why I joined the RR Fund Investment Group.

First, I joined because there is no generational wealth in my family. I will not suddenly become a millionaire overnight because a loved one left me an inheritance, so I am on my own. I needed a long-term strategy. Joining the group allows me to achieve financial stability and the chance to build wealth because my 401K will not grow to the level I need to live a comfortable retirement life.

Second, I joined to gain knowledge and confidence on how to build wealth. I wanted to have power over my money. I have fumbled through life, thinking I would suddenly be knowledgeable about investing. I have not become knowledgeable enough to invest and build wealth independently.

Third, having the opportunity to learn about growing wealth and building relationships with women from all walks of life who want to grow their money is not only an opportunity. It is a blessing and a gift. Without joining this group, I would never have had a million dollars to invest on my own. Collectively, it is nice to be in a group of like-minded women claiming their power and autonomy with their money. Build Wealth!

Forth, I am tired of stressing and living in fear that I will not be able to take care of myself when I retire. It is now or never that I really focus on growing my money.

Last, since there is no generational wealth, it is vital for me to build wealth to leave for my five nephews. Being a member of the RR Fund Investment Group will allow my wealth to grow, and hopefully passing on for generations.

March 27, 2022, is the day that I had an "AHA" moment about life insurance. On this day, Iris Nance from Famers Insurance spoke about life insurance. She gave the group a better understanding of the difference between term and permanent insurance. I was informed and surprised that you can leverage insurance by having wealth while still on this earth.

It was also a big surprise to learn that life insurance is the only product that can create a million-dollar estate out of thin air. Shocked! I was shocked to hear this as this must be one of the best-kept secrets in the world, or once again, I have NEVER sought to understand how life insurance worked. It was the latter.

I flashed back to my younger self during this session, and regret crept in. But I listened intently, and here are some of my greatest takeaways:

- You can build up cash value (like equity in a home) and access it at any time.

- You can accumulate cash, and your beneficiaries can receive the cash value tax-free when you pass away.

- With a permanent life insurance policy, you can supplement your retirement.

- You can add a rider for long-term care to care for medical needs.

- If you work for a company and have life insurance, it is not your own policy. When you leave the company, the policy doesn't go with you unless you convert the policy to your own. This I did know because I work in human resources. What I didn't realize

is that for any amount of life insurance over $50,000, my family would be responsible for paying taxes on this amount.

- Even living with an illness, you can obtain life insurance, and you just have to go through the process to find out what you can qualify for.

- Walt Disney and Doris Christopher from Pamper Chef started their companies by accessing money from their life insurance policies. I was amazed when I learned that Walt started Disney by taking a loan from his life insurance policy.

I hope that my "AHA" moment will encourage others to learn more about life insurance and act quickly so that they can take advance of a policy when needed. The best advice I can give someone is to obtain a policy early on in life. Waiting until you have medical issues, like me, can pose a challenge, but don't let this discourage you from getting a policy.

* * *

Knowing what I know now, there is so much that I would tell my 20-year-old self about life, especially when it comes to finances and living your dream. If I had to write a letter to my younger self, this is what I would say.

Dear Debora,

Life is going to be tough and not always fair, but you are resilient, a fighter, and a survivor. You can accomplish anything in life as long as you get out of your way.

When it comes to your finances, heal your relationship with yourself and money. Stay focused, gain knowledge about investing, be intentional about growing your wealth, and listen to people who give you great advice along the way.

Always know you are worthy and don't let anyone personally and professionally make you think that you are not worthy. Take the high road when you are faced with adversity.

Remember to take care of yourself. Wellness, self-care, and mental health should always be at the forefront of your mind. Never let this fall by the waist side because how you feel about yourself plays into how you make decisions regarding money.

Have a plan because having no plan is planning to fail. Stick to the plan as best as possible. If you fail, revise the plan and pick up and move forward.

Love, Me

Optimistic is the word that describes my attitude towards wealth today. It took a long time for me to get to the point where I can say that I am optimistic. I had to change my mindset and realize that in life, you take steps backward even after taking steps forward. Once I changed my mindset, I was confident and hopeful about my future. Believe it when you hear the saying that it isn't a sprint but a marathon!

Making positive life choices counterintuitive to how you were raised is a journey. When I decided to get out of debt and focus on building wealth, I knew that it would be a journey. I knew it wouldn't be an overnight success, and I had to want it more and focus intently on it like I did to be the first in my family to get a college degree.

What really motivated me and how I became optimistic was reading other people's stories. Knowing that others were in the same boat as me, that I didn't have to be embarrassed and ashamed, and that I had to meet where I was and get out of the hole helped me stay focused. Until my focus was developed, I would never have hope or confidence about my future and learning what I needed to know to build wealth.

Now, I am optimistic. I got out of debt, and without getting out of debt, I would have never been able to join the RR Fund Investment Group. This has been one of the best financial decisions that I made for myself.

It took me 50 years to go on this journey. The best advice I can give is not to walk in my past but walk in my present and future! Start your journey so that you can be optimistic too.

"When you wish someone joy, you wish them peace, love, prosperity, happiness... all the good things." –Maya Angelou

Once you have decided that you are ready to have power over your money, be financially free, know your number, and are prepared to win, I have a challenge for you. But you must be ready to gain knowledge, do the work, know that it will be hard, and be willing to fail. Before you start, I want you to look in your rearview mirror and tell yourself that your financial past is in the past. This is a new day, a new beginning, and I will shape my financial future. If you are ready, here we go, one step at a time.

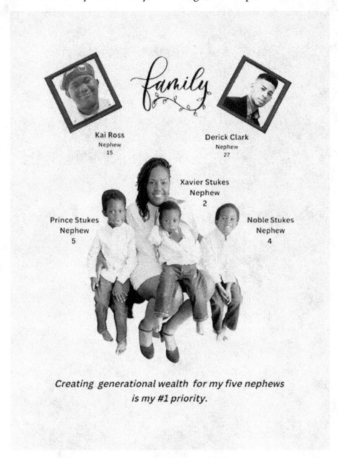

Kai Ross
Nephew
15

Derick Clark
Nephew
27

Xavier Stukes
Nephew
2

Prince Stukes
Nephew
5

Noble Stukes
Nephew
4

Creating generational wealth for my five nephews
is my #1 priority.

Action 1: Write down everything you owe your creditors (consumer debt only). List your smallest debt to the largest. Do not focus on the interest rate. Pay the first debt off and move to the next. Make a resolution that you will pay off all of your debt.

Action 2: For one month, track your spending. You may be surprised at how much money you spend on eating out or buying stuff you don't need. Make a resolution that before you purchase something, you will think if you really need it.

Action 3: Create a financial plan, as you need a snapshot of where you are today. Know what your assets, liabilities, and cash flows are.

Action 4: Know your number. Figure out what your net worth should be at your age. Your Number = (Current Income x Current Age/10) - Inheritances

Action 5: Educate yourself on financial options (e.g., stocks, bonds, mutual funds, and life insurance). We all know that knowledge is power, and the more you know, the better off you will be financially.

Suggested Readings: What Would the Rockefellers Do? How the Wealthy Get and Stay That Way, and How You Can Too by Garrett B. Gunderson, and The Millionaire Next Door by Thomas J. Stanley Ph.D., William D. Danko Ph.D.

As you go on this journey, you will make mistakes and fall back into old patterns, but if you stay on course, the rewards will be well worth it.

Faith Palmer

I am a Christ-following, Type A-problem solving, peacekeeping, planning, wife, mother, daughter, sister, and sister-friend. I grew up on the Peninsula in Hampton, Virginia. My sister and I were raised by a single mother who married and divorced in her teens. Looking back, I would certainly say we struggled financially, but at the moment, we did not lack anything that we needed. I'm not sure how my mother made ends meet but by God's provision. My name was given as a result of her having to totally rely on God. I only remember her having a Leggett credit card she reserved for school clothes, but everything else was out of pocket.

I started working as soon as I was old enough. Watching my mom through the years made me a very conservative and hesitant spender, but a 10% tithe was ingrained in me. Anything after went towards clothes and school expenses, and no funds were available for extraneous spending.

When I began thinking about college, I had no idea how that would be accomplished. My mother never talked about loans. I had scholarships that covered the first year but had no idea what would happen after that. Because my sister and I were first-generation college students, we lacked guidance. When it came time to apply for Financial Aid, I told my mother I was not returning to college for my sophomore year. I did not know much about the lending process, but I knew I did not like the sound of owing anyone for anything. I thought about leaving, working to save money, and returning to college. Still, I knew many friends and family members who said they would do the same but never returned.

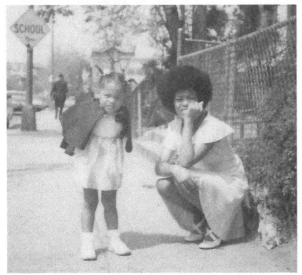

Me and my mother, Phyllis

After many conversations with my mother and prayer, I applied for a student loan. I attended a seminar where they stressed that others would not have access to funding until current loans were paid, so I vowed I would pay it back as soon as I graduated.

While on campus, the Financial Aid funding went directly to my account tuition and room and board accounts. When I moved off campus, I received a lump sum funding for room and board. I wrote a personal check for each monthly rent payment, stapled it to my calendar, and deducted the sum from my check registry. I also had a work-study job to help pay for other expenses. I remember watching my friends pay for cars and shopping every weekend and wondering how they were doing that. At the end of the semester, my sister, who received the same amount of Financial Aid, thought family members were sending me money because she didn't understand how I made the money stretch to the end of the school year.

I learned how easy it was to acquire a credit card in college. Our mailboxes were cluttered with offers, and all you had to do was sign on the dotted line. I eventually signed up for Fashion Bug and Mastercard credit cards. It was fun spending and not having to pay anything right away. Even then, I was very conservative, only using the cards for clothes

for social events, food, and extracurricular activities. I remember splurging on my first bottle of perfume – Estee Lauder Beautiful. I think that bottle lasted ten years because one squirt went a long way.

After college, I read a book by Suzie Orman, which opened my eyes to basic finance principles. I quickly paid off my outstanding credit card balances to put more toward my student loans. Before my husband and I got married, I pulled his credit report and made a plan to pay off his student loans, too.

As a little girl, wealth meant nice cars, houses, vacations, and being a Girl Scout. In elementary school, I watched my classmates attend Girl Scout meetings weekly dressed in uniforms. I couldn't join because we couldn't pay the dues or afford the vests, sweaters, skirts, patches, etc. When my daughter turned five, I helped to start a Girl Scout troop at my church and became a leader. She joined as a Daisy (first level) and ultimately completed her Gold Award as an Ambassador (final level) and is a lifetime member. Talk about living vicariously.

In my keepsakes, I have a high school project where we were tasked to create a book about our past, present, and future selves. We wrote chapter narratives that included photos from the past and magazine clippings to illustrate the future – this would be my first vision board of sorts. Here is an excerpt from the last chapter of that project:

After high school, I'll go to college, though I'm not sure which one yet. I plan to major in business administration with a concentration in accounting, so I might own my own business or accounting firm someday. ...Around twenty-two, I'll be ready to get married. Preferably a man in the military or with a bachelor's degree. After we're married, we will become financially stable and buy our own home. This is very important to me. Mainly because most of my life I've lived in an apartment, which hasn't been bad....We'll have our honeymoon in the Bahamas or Disney World.

We grew up in an apartment from age five until I went to college. We relied on public transportation but were fortunate enough to have most things within walking distance. The only vacation we took was the year my aunt received a huge bonus and took us to Disney World. So "wealth" meant I would have nice, affordable transportation and a roomy but comfortable home, and we would work hard but play harder on annual vacations. I married my college sweetheart, and we went to Disney World on our honeymoon and to Disneyland Paris on one of our European stops for our 25th wedding anniversary. Our daughter, serendipitously, works for Disney.

I love numbers, and math was my favorite subject in school. I thought briefly about becoming a teacher but quickly decided against it because I was told "business" was the way to make money. So that became my track in high school and my major in college.

I worked at a Fortune 100 company for 15 years and began working in education part-time when we relocated from Northern Virginia to North Carolina while maintaining my full-time job virtually. I eventually left corporate and became a full-time math instructor before moving into administration. This role was very impactful because I taught GED® students. Many of these learners were the first in their families to complete a high school equivalency. Ninety-nine percent of the students waited to take the math exam last because of fear of fractions, word problems, and the basic principle that letters and numbers do NOT go together! To this day, I remember the names of the teachers who had the most impact on my learning and their unique way of presenting the most convoluted information. Now it was my turn. Like the subject matter experts in the RR Fund, it was my job to break the math concepts down into bite-sized, edible pieces. Math would not stand in the way of them having a better future. I had the privilege of being a Generation Change Agent. God has a way of helping us fulfill seemingly forgotten desires.

As an adult, my definition of wealth has less to do with money and more with spiritual and emotional peace and happiness. We can all name traditionally wealthy people who can no longer enjoy their assets for one reason or another. I wholeheartedly believe that monetary wealth makes life easier to navigate; however, you do not live half a century without some perspective on what matters most in life.

To be clear, monetary wealth does offer a sense of security. Suppose there is a drastic change in your economic status due to job loss, serious illness, or some unforeseen devastation. In that case, there is security in knowing that you can maintain your livelihood. A good man leaves an inheritance to his children's children" (*New King James Bible*, Prov. 13.22). That is not possible without some accumulation of wealth.

My relationship with money has changed depending on my season of life. Early on, it was fear of the unknown. As I became more educated and utilized principles from experts such as Suzie Orman and Dave Ramsey, I felt more empowered and in control. I began to see money as a means to do what we are called to do. A Benefits Coordinator on my first professional job pulled me aside and told me to sign up for a 401K that day. She was a mature black woman who reminded me of my aunt, so I said, "yes, ma'am." I didn't realize it was illegal to make someone sign up for a retirement plan, but I'm glad she took the risk.

My husband and I met with a financial planner early in our marriage. That planner told us to open 529 plans for our children when they were very young. He said to contribute as much as possible, which would significantly impact them by the time they went to college. There were years when we could contribute a lot and others where we could not contribute anything at all, but we kept the accounts open. As a result, my daughter graduated college with no debt, and my son will do the same. I also learned early on that America was built on entrepreneurship, and our laws and tax system support this enterprise. Our assigned reading, *The Millionaire Next Door*,

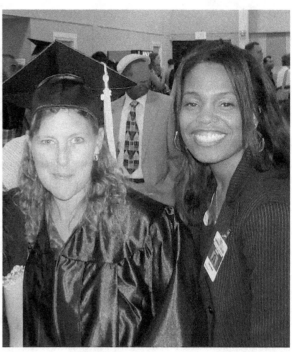

Student, Sherri, and me

reiterates this principle. I am a *parallel-preneur*. I have always had a side business (aka side hustle) for which I could claim tax deductions. My full-time career is in college administration, and I "hustle" as a real estate agent.

I decided to join the RR Fund club because I believe in the mission, objectives, and goals. I have known and respected the founder, Dr. Reddix, since college, and even then, she was a visionary. This was an opportunity to utilize funds to empower and elevate women with an emphasis on closing the gender and racial wealth gap. I had not heard of the concept but was now invited to participate. FOMO was setting in! This was also an opportunity to be educated, led by experts, and interface with women willing to share their wealth journeys. I did not know what to expect, but I knew it would be great. At the end of the first meeting, Dr. Reddix asked us to choose one word to describe how we felt, and *excited* was the only word to describe it. I knew this was an endeavor that I could stand behind. Especially hearing that the RR Fund strategy was to Educate, Activate and Evangelize. This would not just be for the core group; others would also be invited to participate at a later time.

The meetings are inspiring because there are women of all ages, races, and walks of life. The facilitators have incorporated training by subject matter experts (to include legal, investment fund, and insurance advisors), open discussions, and book studies to appeal to every learning style and provide the proper scaffolding when determining investment decisions. The facilitators led with transparency and ensured that a strong foundation was established before moving to the next topic. There is no expectation of expertise, and questions are encouraged.

One of my biggest Ah-Ha moments surrounded our discussion regarding insurance, an area I am least familiar with. Our guest speaker discussed the different types of insurance plans, including Term and Permanent/Whole Life policies, and the differences and benefits of each. One member of our cohort mentioned that she was able to fund her own business from the Whole Life policy that her father took out for her when she was a child. After that meeting, I did a lot of research and spoke with my insurance agent and tax advisor. It ultimately was not something we needed to add to our portfolio at this stage of our lives. However, I have told several people to evaluate the appropriateness of their personal situations.

Based on what I've learned since joining the RR Fund, I would tell my 20-year-old self to be more risk-tolerant. I've also shared this with my two 20-something-year-old children. I have always been a hesitant spender, heavily weighing sometimes the most minor purchases. There were things that I was overly cautious or reluctant to pursue because of the uncertainty –perhaps fear and remembering past struggles. Our economic system is built on the ebb and flow of the market, and what goes up must come down and vice versa. The

market rebounds, recorrects, and levels. I would say not to sweat the small stuff and live in the moment because tomorrow isn't promised. Oh, and I would invest in Apple and Amazon!

The word that defines my attitude regarding wealth now is Expectation. I expect that wealth will grow with proper planning and stewardship. Akin to leading or guiding your children or even employees/mentees, you must build the proper foundation, establish clear objectives and nurture the process. It won't always go as planned, and you might have to reset and sometimes just ride the ride.

I advise the reader to have uncomfortable conversations with experts about your financial goals if you haven't already. Be open and honest. It gets easier. Anything worth having is worth fighting for. Ask questions and do your research. You must be a lifelong learner. We're at the fortunate age where information is literally at our fingertips. Subscribe to podcasts. I also recommend reading our two book assignments, *The Millionaire Next Door* by Thomas Stanley and Williams Danko and *What Would the Rockefellers Do?* By Garrett Gunderson, which helps demonstrate the key characteristics of the wealthy. Finally, reach back. Whatever information you've learned from successes and failures, pass it on to others – your children, friends, other family members, and the next generation. Allow others to learn from your mistakes. When you know better, you do better.

Christian (Son), Brooke (Daughter), Brook (Husband) and me

Felicia Morris

Let me introduce myself. I am Felicia Denise Morris, middle daughter of the late George Durward Morris, Jr., and Carrie Elizabeth Morris Carter. Being the middle child meant that I was in the shadow of my older sister, Anna, also known affectionately to some as "Penny,"; and George III, some called him Candy. In case you wonder why Candy is a nickname for a boy, my mom thought that he was adorable as a baby, hence, the nickname, Candy. Well, back to being in the shadows, whenever I had to introduce myself to others in my area, I would say, "I am George and Carrie's daughter."

Most would say, "We didn't know they had another daughter; we only knew Penny.

Of course, I would say, "No, there is another one."

As we got older, it was George's (Candy) turn to introduce myself; people would say, "Oh, we knew Penny and George, but you are the second daughter." I felt even more deflated.

How can you know my brother, who is 22 months younger than me, before you knew I existed? As I got older, the moles on my face became even more prominent as they were on my mom's face. People would walk up to me without introduction and say, "I know who you are; you are Carrie's daughter."

I would walk away feeling proud and wearing that title as a badge of honor; I had arrived.

When I was a little girl, wealth meant a big house, lots of money, and endless shopping trips. You see, that is not how we lived. It was how the Morris' and Carter's lived. My mom remarried in 1983 after my father passed away in 1977, in a modest 3-bedroom house, with one bathroom.

My mom practically worked up to the day she passed and the only time we went shopping while I was growing up was to get school clothes or for Christmas. I didn't really care about the big house, money, or shopping until I saw someone at school who had something I wanted, which was rare. You see my mom did whatever it took to make us happy. We never were hungry; we had clothes, we usually had the hottest toy, and more importantly, once we ALL received our driver's licenses, my mom purchased each of us a used vehicle.

So, I never thought about wealth, but being wealthy was what I wanted to be one day. I didn't want to live from paycheck to paycheck. I didn't want to work a factory job coming home smelling like grease as my mother did. I wanted to go to the store and buy name-brand items, not the store brand as my mother did.

I wanted to go on trips without a budget. I wanted to buy that purse or that pair of shoes for my mother or me within reason without waiting for a sale. I wanted to feel like I had made it.

As an adult, my definition of wealth has been relative to me, how do I plan, how can I make my money work for me, how can I work less but still earn, and how can I pass this along to my family once I am gone? I want to have enough money, to have liquidity, and I want to invest in others. Now that I am planning for my retirement, and trust me, I have put away a small, I mean small, nest egg that I fear will not last during my remaining years after retirement.

I know my goal is to live comfortably after walking out of my job for that last time and retiring. I want to travel and see more of the world, not having to worry about whether I can survive after returning from a long trip, whether I will have enough money to survive when an unexpected financial event occurs, I will have to tighten my budget for food.

Therefore, I return to one of the definitions, planning. I have been planning for years for retirement day and am taking those aggressive steps to meet my financial security and wealth goals.

Knowing my number, my financial numbers...I often look at my credit score, income, expenses, and bank accounts. Let me start with my credit score, which has become my financial lifeline. The credit score helps me know how I am doing with my credit. My score spoke for me when I purchased a vehicle seven years ago.

Felicia is always in the middle and the mediator to this day!!!

I walked into a dealership, told the salesperson which vehicle I wanted, and I drove off with that vehicle without much stress. My income helps me sustain my livelihood. I couldn't pay my everyday expenses, eat, or have a place to live without my income. I try to keep my expenses manageable, but I want to have a comfortable life to at least twice a year. Pre-COVID, my expenses would change as I love to travel.

Reconciling my bank accounts is vital. I need to know to the penny what is happening in my accounts. With the potential for fraud and theft these days via cyber thefts, every penny is counted, and if I don't know what a charge is, trust me, I will question it. You can say I know my number, but what number I genuinely don't know is my net worth.

My relationship with money has been a love, hate, a liking back to I want to marry you. I can be frugal; I remember when my mom would give us an allowance which was sparse, I would make my money last until the next time. All the while, my brother would spend his without a second thought. I loved money.

I always knew I had to be careful, smart, and mindful of where my next dollar would come from. I knew working was how I would earn money. I got my first job at age 16 at McDonald's. However, where I had to go to work didn't make sense even at age 16 for what I earned. I had to drive 50 minutes to earn $3.35 an hour, to only work a couple of hours/lunch rush. I remember bravely walking into my boss' office after being told that I could go home for the second time after working only a couple of hours.

I asked, "Can I get more hours? I am driving way too far for this".

Her smug response was, "Do you want my hours?"

I walked out and never looked back; I hated money because I couldn't earn enough, and I knew that I had to be better to earn more. I decided that going to college to earn my degree would pay off so that I could earn more; I like money, even though I hadn't made much at that time.

After graduating from James Madison University, the first of my immediate family to graduate from college, I worked my way from being an Accounts Payable Clerk to Finance/ Human Resources Director. I attained my master's degree along the way from Averett University. I began to be engaged to money and after a long engagement, I am ready to marry money.

I took the leap and joined this financial club run by Angela Reddix. She was a Dyson when I met her at James Madison University in 1986. I have watched Angela grow and prosper with her business and her non-profit to mentor the next generation of young women.

Once I heard the pitch, I took a moment to think, but it was a no-brainer for me. I have run a small tax and bookkeeping business for over 20 years, usually taking vacations and enjoying the fruits of my labor by relaxing with friends. I have not been able to take my usual vacation since COVID, so I had saved and wanted to invest in my future retirement. I want to retire but still earn money without worrying about going back to work.

"Ah ha" moment, my most significant one, was when I purchased my house in 1996, 26 years ago. I knew that attaining wealth meant more than just earning money it meant purchasing power. Purchasing my home was a monumental task being a single black woman living on a modest salary. Although I had paid my bills on time, no one wanted to take a chance on my goal of home ownership until, one day, someone did. After having that "ah ha" moment, I just did not think about another until I joined this club. I thought, "Ah ha," the club would be a path to my living comfortably during retirement. Most will retire only to have to go back to work because one has not planned for the financial adjustments during retirement. My plan started the day I announced my retirement year in 2028, and I see a clear path to being a part of this investment club.

My pride and joy is gone but not forgotten! I miss my "mama", glad we did these things together...

I would tell my 20-year-old self; you don't have too many years, as you might think, to get it right. You will make mistakes, but you must learn from each one of them and move on. Stop focusing on surface changes, the inconsequential, the non-starting moments. Think about your future and how your life will be for you when your parents are gone, your life plans will change over time, and you will need to modify them. Think about how you will be happy, financially stable, and quite frankly independently wealthy on your own. Leave a legacy for your family even if you don't have a family of your own. I have told myself; you will be successful; although it is tough now being in college and not seeing the future yet, hang on and just keep plowing forward.

My one word for wealth…. Independence. My mother taught me early on how to be independent, take care of yourself, and never depend on anyone for your money, happiness, health, and power. My mother set me up to be powered by sending me to college to gain knowledge, as it's powerful when you can make informed and logical decisions based on consciousness. I am independent in every aspect of my life. I go to work without being told; I pay my bills without being told; I take care of myself. I pride myself on the independent black woman I have become, even with all the bumps, twists, and turns in the road getting here.

Let me help you get there with what I am planning by reflecting, reviewing, releasing, and revealing. Look back at your life, what have you done, what you did do wrong, and what can be done better. As I stated earlier, thinking about who I was, where my place was in life…I was a middle child that no one knew. I am reviewing when I should retire and how I will retire. Will I have the finances to retire comfortably? Since I didn't think I was at a comfortable stage to retire, how would I fix it? Join an investment club and pull some resources together to obtain that retirement goal. I released my feelings and became my own person once in college. I had to learn who I was, independent of my family, and make my own way. I can't reveal just yet where I stand with my true independence, but I know that I am on the right path.

Iris Conley Nance

I am a dreamer. I am a survivor. I am a champion despite my circumstances. I witnessed the struggle of my single mother, who had five children by the age of 22. She worked two and three jobs to keep the lights on and food on the table. The mere $35 a week she received in child support did not make a dent in what it took to sustain a 6-person household. The sheer exhaustion my mother endured from working multiple jobs made me realize early on that I wanted more. I prayed, please, Lord, allow me to only work ONE job, meet and marry the man who would treat me as the queen I was, and achieve the American dream of home ownership and have twins so I could have the number of children I desired on the first try. One and done! The ticket for me was higher education. As the oldest, I was the first to attend college. Although I qualified for a few grants, most were funded by working a full-time job. To say I was determined was an understatement. At the time, I was living on my own and had accumulated a few obligations. So, I would delay paying bills if it meant another semester successfully completed toward achieving my degree. I knew if I stayed true to the road I was traveling, my future would exceed more than I had envisioned. I am a witness that dreams can be achieved if you believe.

My father was the best indication of wealth that I can remember as a little girl. He and my mother had since divorced, and he remarried. We would visit him on designated weekends at his home in the country with a long gravel road, acreage, and farm animals. I was amazed that his home was big enough to not only accommodate his new wife and their three children but me and my sister as well, with additional rooms available for anyone else who came along. Where we resided with my mother, I shared a small bedroom with my two sisters, so my father's home was a mansion in my eyes. Another sign of wealth was the fact that my father and his wife had multiple cars. Most of the families in my neighborhood were lucky to have one reliable vehicle, as most depended on the transit system for transportation. My father was able to work one job and experience the American dream of home ownership, multiple vehicles, and family vacations. At the same time, my mother had to work 2-3 jobs just to stay afloat. Family vacations for us were nonexistent, and understandably so, with five children to take care of. When we initially started dating, I remember telling my husband I had never been to Disney. Because he had been several times, he was amazed that I had never got that experience. So as an adult, I was able to take advantage of the magical Disney experience with my boyfriend, now husband. And we made sure that this would be the same for our children.

As an adult, I define wealth as freedom. Freedom financially to do whatever I want, whenever I want, and however, I want. Wealth is not having a worry in the world about the cost and how it will affect me the next day, the next month, or the year after. Wealth is peace of mind, a feeling of calm with no worry about problems or difficulties. Wealth is knowing that no matter what happens in life, the car breaks down, children need assistance, investment opportunities too good to pass up, and the resources are readily accessible. Wealth is the ability to help others around you. Wealth is leaving a legacy for your family. More importantly, wealth is health. You can have all the money in the world, but if you are too sick to enjoy it, it means absolutely nothing. I remember this particular vacation on a cruise ship and seeing so many people requiring wheelchairs to navigate the vessel. And at that moment, I tried to visualize how much I would enjoy this trip if the situation were reversed. What if it were me in the wheelchair? How much of a burden would I be to my family if all they did was help me get situated and wheel me from one section of the ship to another? A better question is, how memorable would the trip be for them? I am so thankful for my health and strength. I can still run up a flight of stairs, walk a mile and not have to stop to catch

my breath, and I pay close attention to what I put in my body. And that, my friend, coupled with the ability to enjoy life to the fullest regardless of cost, is priceless!

Wall Street and Me

Knowing your numbers changes the game. I am still amazed at the answers I get from clients when I ask where they are financially. I would get more "I don't know" responses than you can ever imagine. As a business owner, I know all too well how you can get caught up in the day-to-day riggers taking care of your clients' needs and ignoring your own. Taking a hard look at the business finances after reading the recommended book "Profit First" by Mike Michalowicz helped me to understand the premise of putting aside the profit first before paying bills. Yes, for years, like a lot of business owners, I paid the bills first and got the leftovers, if there were any. I was amazed at how fast I could amass money in the bank when following the Profit First way. And because of that eye-opening epiphany, I now gift this book to all new business clients. Knowing my numbers means reviewing all accounts, both personal and business, regularly. From this alone, I discovered the wasteful expenses being incurred, i.e., subscriptions that were no longer being utilized, avoidable bank fees, and the biggest fraud. I am no longer reactive in my spending. I am aware of what's coming in and going out. I am keenly aware of my net worth because I review it minimally on an annual basis. I make it a habit to review my credit score, a critical number to know at least annually. A recent review of my credit report included the prior addresses and phone number of a former colleague. This type of mistake can affect my overall score and result in not getting the most favorable rate for financing needs. Knowing your numbers requires active management.

My relationship with money has been one of indifference. I am not sure if this stems from my upbringing in a single-mom household, but I always felt money was necessary for the essentials only. I have witnessed those who have lacked growing up not appreciate that their life is better as an adult and live beyond what they make. I must confess that I am a pretty low-maintenance individual. My husband will tell you that I am not a big jewelry person, and when it comes to cars, all I need is something reliable to get around in. I love vacationing but will always look for deals. My requirement for lodging is that the room is clean and offers free Wi-Fi and complimentary breakfast. When traveling, I will research the cheapest flight and airline that offers no fee for luggage. In preparing for an upcoming trip to New York, I reached out to one of my friends who grew up there to get advice on where to stay. Now her relationship with money is totally converse to mine; her vacations put mine to shame. So, of course, she is steering me toward an extremely high-end hotel and, in the same breath, telling me, "we could afford it." But you know I found THE one that met my requirements clean, free wifi and breakfast. Now don't sleep on a sista! I am all for enjoying life, as we have had the opportunity to travel to some pretty awesome destinations but being intentional about how it is being spent is my mindset. If I can get the same quality for less, it's a win-win!

I took the leap and joined the club because it was an opportunity to surround myself with like-minded individuals and share the 20-plus years of knowledge that I had acquired as an insurance and financial services professional. I realize very early in my career that we are not always aware of what's available that can have a major impact on our financial well-being. As I conversed with Angela, a powerhouse in her own right, all the cliches came to mind. *"Be comfortable being uncomfortable." "If you want to be a millionaire, you need to hang around with millionaires." "Connect yourself with the you that you want to become."* I love a challenge and am not afraid to try something new. This takes me back to when I worked a full-time job while attending college. At the time, I was the secretary for Dr. Malinda Taylor, Director of Elementary School Accreditation for the State of Tennessee. I was so fortunate to work for someone who not only looked like me but was always an encourager to do and be better. Growing up, having a JOB was stressed more than pursuing higher education. In that position, I was given the flexibility to take classes on my lunch break. Upon completing the associate degree requirements, I told Malinda, "okay, I'm done." Her response was, "oh no, you have to keep going and get your 4-year degree". Thankfully, I was smart enough to realize that she did not achieve one of the highest positions in the state with an associate degree. So as much as I wanted to believe I had done enough, I knew I had to continue if I desired more. I could say without hesitation that I would not be where I am today if it

were not for that relationship. She pushed the 20-something-year-old me out of being comfortable. I am so thankful for the connection that Malinda and I forged that resulted in the person I am today that decided to be a part of this awesome community.

My family: husband, Ben, and twin daughters, Ashley and Megan.

The most significant aha moment for me was seeing the impact that the knowledge I have acquired over the past 20-plus years would have on the phenomenal women in the group. If it were not for this great industry that I have come to love, I would not be where I am financially. Before, I was like everyone else, with the only insurance being what the job offered, not taking advantage of the various financial product offerings that would change the trajectory of my family's financial worth and having the proper protection in place so that our assets and income are not exposed in the event of a lawsuit. Insurance is more than just insuring your home and car. As we have seen from the COVID-19 wave, the future is unpredictable. An unforeseen event or tragedy can result in massive financial and emotional stress. I saw my mother experience this. In the summer of 1998, my 12-year-old brother drowned taking swimming lessons at the local YMCA. My mother had five children to take care of, and life insurance had taken a back seat to keeping food on the table. Who expects to outlive their child? And imagine not only experiencing the devastation of losing a child but not having the resources to bury them. My mother BORROWED the money from her father to take care of the burial expenses. This is an example of where no one ever wants to be. If I never appreciated what I do as a profession, I certainly do now. And I am so thankful for this opportunity to share it with many others.

Based on what I have learned, I would tell my 20-year-old self to retain the services of a financial planning professional. If I had done so, I would have been advised to start saving immediately for retirement and to purchase permanent life insurance. As an individual, I know this would have put me in a much better place financially. I did not get a life insurance policy that I owned until I was married and in my late 30s. And unfortunately, it was a tragic event that triggered that purchase. On October 17, 1995, I received the worst phone call you can ever imagine that my 12-year-old niece, Adrianne, had been killed. The two young men involved were only 16 years old. Right place, wrong time is the only way I can describe it. My husband was away on deployment, and at some point, in the grieving process, I realized that there was no life insurance for myself or our children. Like most people, all I ever had was what was offered on the job. I had recently resigned from the employment where life insurance benefits were provided, which left a serious gap in our family protection plan. I did schedule a meeting with a life insurance agent who, to my detriment, did not advise but let

My siblings and I. Robert is in the front row, center.

me take total control. I insisted on term insurance, and he obliged. Imagine the education I would have received if I had been privy to the advice of a financial services professional in my early 20s. It would have been life-changing.

The one word that describes my attitude about wealth is gratitude. I am so very grateful for the lessons learned as early as my first career job with the FDIC, where I witnessed a colleague pay cash for a car. Now this 27-year-old who grew up in the housing projects with a single mom and four other siblings never knew anyone who purchased a car with cash, and I was bold enough to ask how that was possible. While most, including me, would count this as extra money to spend, he shared that he continued the car payments as if the debt remained and redirected the funds into a savings account. Per a May 23, 2022, study by Money Watch, "the average age of an American vehicle has hit a new record, as supply-chain shortages make it harder for consumers to get their hands on new wheels. The average vehicle on the road this year is 12 years and two months old, according to data released by S&P Global Mobility — the highest number in the 20-plus

years this data has been tracked".[1] So, let's think about this. You have a car payment of, let's say, $500. In year four, the final payment is processed, but you continue as if you still have a note for the next eight years with the $500 going into a savings account. Over that time, you have saved a whopping $48,000. Now, how powerful is that? Starting each day by writing down the nine things I am grateful for both financially and personally is my superpower. And whenever I have a moment about where I am financially, I simply go to my journal and realize that I have come a mighty long way. Gratitude is my attitude.

My niece Adrianne Nicole Dickerson

ACTION ITEMS:

1. Secure the services of a financial advisor early."A 2020 Northwestern Mutual study found that 71% of U.S. adults admit their financial planning needs improvement. However, only 29% of Americans work with a financial advisor."[2]

2. Meet with your personal lines insurance agent annually. In the event that you are the target of a substantial lawsuit and don't have enough insurance to cover the damages that may arise, the expense would have to come out of your pocket. Furthermore, if you are sued, you are exposing your assets and your income. Depending on the state you live in, 25% of your wages can be garnished for up to 10 years until a lawsuit is paid off.

3. Purchase a personal umbrella policy. It steps in when the personal lines policy limits are exhausted in a lawsuit and can prevent the prospect of financial ruin due to an unintentional act or an unforeseeable accident.

4. If the only life insurance you have is what your employer offers, purchase a policy that you own and control. The policy on the job is a benefit while employed. Additionally, anything over $50,000 is considered a benefit and taxable to your beneficiary, vs. the one you own personally, no matter the amount, is 100% tax-free.

5. Include in your financial program permanent life insurance. It provides coverage for your ENTIRE life compared to term, which is for a fixed period of 10, 20, or 30 years. For example, if you're a new parent, you might buy a 20-year policy for coverage until your child no longer relies on you financially or a 30-year policy to pay off a mortgage. Less than 1% of term policies ever pay out on a claim, so it should be a supplement to, not your only policy.

6. Take advantage of any term policy convertibility option as early as possible. Don't ride it out to maturity, which is when the premium increases considerably, and the cost to convert can many times be unaffordable.

1. "With cars in short supply, U.S. drivers are holding onto their vehicles longer than ever"
 May 23, 2022, BY IRINA IVANOVA, MAY 23, 2022 / 6:34 PM / MONEYWATCH
 https://www.cbsnews.com/news/average-car-age-american-drivers-are-holding-on-to-theirs-longer-than-ever/

2. Northwestern Mutual Planning and Progress Study 2021 https://news.northwesternmutual.com/planning-and-progress-2021

Janet Williams Bruce

I consider myself a branch of the Jernigan Tree, deeply rooted in love, family, and celebration. My husband constantly teases me that we are always celebrating something. I own and embrace it, so I'm always ready to start the party! The Jernigan family is very large, and it started with my maternal grandparents birthing 15 children; my mother was the youngest and a twin. My mother was a strong single mother destined to show her children determination, sacrifice, and what it meant to care for your family. Our core nucleus - two girls and two boys raised in the '70s when life was much simpler. You had no clue if you were a "have" or a "have-not." I am the youngest girl who was fearless! There were no money discussions in the household that included credit, salaries, how much do you want to earn, retirement, etc. We were operating on good ole fashion tenderness, happiness, and everything was copacetic! Each of the 15 siblings had a large number of kids, there was a village filled with cousins all around us, most close in age, and all were hard-working career women striving for success. I often think back on what made us the happiest as a family and as children. It was being together, enjoying the small things like bike riding, playing hide and go seek, and the older siblings/cousins always looking out for the younger ones. You wouldn't believe it, but we occupied almost a complete block of houses, all initially owned by my late grandfather. My late grandfather gifted homes to a few of the children, and the one I grew up in was the one my grandparents resided in.

We were multiple families deep and full of family passion. Although I was not lucky enough to remember my grandfather, I absolutely remember my grandmother, her presence, and the role she played in our lives. She was affectionately known as "granny," and we all gravitated toward her. To this day, all of the Jernigan girls still reference the way she cooked, how hard she worked, but most of all, the way she took care of her family.

I was only 14 years old when I started working at the Boys & Girls Club, and from there, I continued to have a thirst for the next challenge. Throughout my journey, I always listened, learned, and continued to fuel my ambition by inserting myself into situations where I thought I could excel using my confidence. As an example, I would apply for positions where I did not quite meet the qualifications, but my self-assurance made me think I just might secure the position. I was brave and fearless! I would also ask management within the company where I worked what was their path to success. Fast forward to the present, I knew my innate ambition needed to intersect with education. Therefore, I knew I needed higher education to be considered for management or any real position of authority. I finished my undergraduate degree and completed my master's in management, all while working full-time. I didn't make any excuses; I made sacrifices working by day and studying by night. I knew there was a light at the end of the tunnel, and I was driving down the road towards it with my seat belt on fastened so tight.

Today, my immediate family currently consists of two adult daughters, one grandson, and a husband. The girls in the family have had the luxury of many transparent conversations about money and its impact. Both girls are college educated and have displayed a very responsible relationship with money thus far when it comes to saving, planning, and spending. One has already experienced home ownership, and the other one is currently working on her undergraduate degree with a minor in finance. As for the men, my grandson is already taking an interest in saving money by putting aside his earnings from chores and my husband is very diligent, extremely conscientious, and has never been known to splurge with money. Don't get twisted; he has a taste for the finer things in life but has always been astute. And based

on our early conversations when dating, he shared with me the lessons he learned after his credit card college days. But what's my desire? I want my family to see me as the person who guides, helps, and is an avenue for trouble-resolution discussions as it relates to money. Why trouble resolution? I find that one of the missing pieces in most families is having someone who is a sounding board to have those money conversations, whatever the issue might be. Having that go-to person to head off potential problems from happening in the future or providing a resource or a different perspective. Also, being able to help mold the skillset to become independent thinkers as it relates to money management. This proactive approach could save my family money, provide different ways to skin the cat and allow us all to grow smart financially. In most cases, money conversations are not in the equation with trouble resolution, but they correlate, so laying the groundwork to make those conversations easy has been my objective.

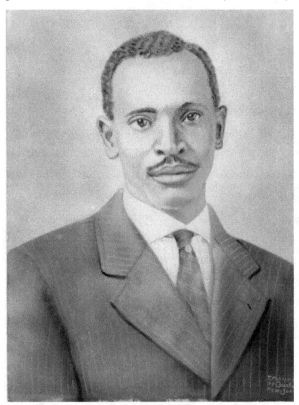

Oscar Jernigan - My Grandfather

The indication of wealth was not something that was discussed or what I saw when I was a little girl. I learned an inkling of what it meant to be wealthy when I started making money at a young age. I had no structure or understanding of money, but I knew I wanted to continue making more and more! More money to me equaled a stronger sense of security. My drive of "on to the next" to find the next job where I could earn more than I did at the last position. And because my mother was a single parent, she allowed me to keep my whole paycheck which assisted me with buying my own clothes, shoes, and anything else I wanted. This behavior had a two-fold impact on my financial knowledge. I did not learn any boundaries with money, and the faucet to spending turned on and was flowing. During recent conversations with my mother about it, she wishes she could have asked for a part of my paycheck, so I could have started to learn how to pay bills early on. From her perspective, She wanted me to experience what independence would look like by allowing me to manage my own money. Even though I opened my own checking account and started minimal savings, I was still immature when it came to understanding the full scope of money. I had no indication of what wealth was or how to achieve it. What I saw was an accumulation of some trendy feel-good items I bought, but what I needed to be schooled on was how to make my money appreciate versus the collections of assets that were destined to depreciate. My actions at the time were more about instant gratification and less about creating future growth. My understanding of wealth would come later when I understood what credit was first and staying abreast of my credit score.

As an adult, I define wealth by understanding how to save, having debt you can manage, ensuring you have a diverse portfolio, and setting up your next generation for success. Your family should have a vast knowledge of the importance of real estate ownership, stocks and bonds, investing through mutual funds/401K, and the importance of a six-month emergency savings. Being able to understand how all of these things function and work together can be a very daunting task, but the more you know, the higher the reward. The golden nugget, I'd say, is the earlier you start saving, in your early twenties or when you get your first real job, consider that "go" time in the beginning to build your nest egg!

Creating your overall personal financial portfolio is a must! Through my research, I found that a traditional financial portfolio is a collection of financial investments like stocks, bonds, commodities, cash, and cash equivalents, including closed-end funds and exchange-traded funds (ETFs). Building your personal portfolio can be done in segments, but you must stay ten does down focused on a goal of where and what it is you are trying to achieve. A few foundational items in establishing your portfolio are: knowing your current credit score, understanding income-to-debt ratio, and personal creditworthiness, and having a budget that you can commit to. Also, while learning more about money, I uncovered an article while doing research for my Thesis years ago that covered five money mistakes to avoid. The information in the article was very enlightening and relevant. In a nutshell, they are: paying minimum payments on

credit-card balances, not developing a budget, not participating in your company 401K, not understanding investments and diversifying, and lastly, paying full price for goods and services. These steps are simple and easy to weave into your everyday life. Once I understood their significance and importance, I immediately adopted each one. The residual has been tangible, and the knowledge allowed me to share with my family to equip them early on.

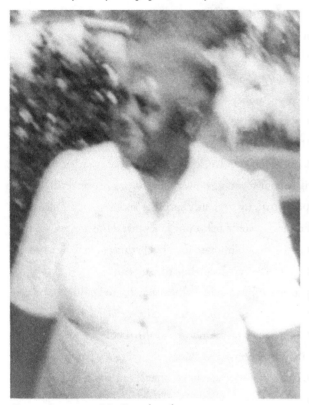

Connie Jernigan - My Grandmother

My present-day relationship with money is paying down debt and allowing my money to do the work for me. Of course, when I think about the evolution of my money relationship, it truly has expanded well beyond my Boys & Girls paycheck. I look for opportunities to grow my money, whether it be increasing a mutual fund, more stock diversification, or ensuring that I hold off on creating any new debt unless I have a plan with a target date for a pay-off. Also, I ask myself if it is a need or a want. Being fiscally responsible is the key now for me. I think back to when I didn't understand how the impact of what you do when you're young has such a strong outcome on what happens down the line. As an example, signing up for a credit card offer that is extended to you as a college student. It is way too easy to say "yes," and the lack of self-control to say "no" at 19/20 years old is not in the equation. The problem surfaces down the line because you are going to potentially damage your credit so early on, and it could take years to fix. The line of sight to repair your credit can be mostly foggy or filled with mist, depending upon how badly you have overextended yourself!

In my career space, I have executed several successful projects for corporate customers and groups, overseeing all facets of operations, strategy, and leadership. My experience and dependability solidly personified me as a successful Manager in Revenue Operations. Throughout my thirty-year telecommunications career tenure, I have demonstrated commitment, dedication, and the ability to foster strong partnerships, which have netted me a solid business reputation. Moreover, I have always been personally committed to excellence, being a change agent and a lifelong learning student. This has specifically paid large dividends when in-company opportunities arise. I have completed the following ITIL Certifications: ITIL v3, Operational Support & Analysis, Release & Control, and Principles of Project Management. I am a Certified Lean Six Sigma Black Belt. As a Black Belt, I worked on improving results using lean concepts to create efficiencies within the organization. This was a very rigorous program that required intense training, identifying resources internally, and lots of studying to obtain the certification. I've received several noteworthy accolades, including quarterly, monthly, and yearly awards for stellar work performance. Lastly, these are awesome accolades professionally, but what have you done for Janet personally lately? Well, a lot, but the story is still being written.

Additionally, it seems like just yesterday that I just racked up all of the professional recognition, and now I am close to retirement. This has required me to review my financial accounts so that I can lead an enjoyable retirement that includes travel, some shopping, and being able to pay any monthly living expenses we still have comfortably. I'd like to ensure my husband, and I have the healthiest relationship with money together and independently, which will allow us to be on the same accord. These are my happy home goals! Also, as parents, one major goal is to have our children be more successful and smart financially through understanding and exposure. A critical focus is to continue teaching our children how to make their money work for them, with the first order of business understanding credit, protecting it early on, and increasing their buying power.

When opportunities arise for women in any capacity, we should always explore and seize the moment. I was immediately excited when the RR Fund Club opportunity was presented. I secured my spot in the Club because this aligned with my quest to ensure my portfolio was buttoned up for retirement. It also continues the goal of my generational wealth path. When a conglomerate of different career women come together, the dialogue is multifaceted, creative, and other unlimited opportunities for personal growth potential arise. Normally, in

business, men typically are the beneficiary of a plethora of opportunities to grow wealth. I jumped at the chance to expand my retirement potential in a think tank of smart women from diverse backgrounds. My "ah-ha" moment of discovery was the very first RR Fund Club meeting. I was enamored by the number of professional women with the same goal of elevation. This created a deeper interest, and it enlightened my thirst for knowledge of more hands-on investing and money management. This was the first time I would have a birds-eye view platform to learn, be led, and participate, where the output would be potential financial growth. This group has proved to be a good source of mentorship and education. In the past, I learned a little bit about finance here and there, but this is a smorgasbord of life-changing information.

Brittany Clark (daughter), Janet Williams Bruce (me), Darryl Bruce (husband), Amaya Bruce (daughter), Zachary (Grandson).

I would tell my 20-year-old self to slow roll the spending and save more significant amounts of money. Seek out conversations with individuals you meet who might know more about money ask them to be your mentor. Learn how to make the money you earn grow for you exponentially. Buy real estate as soon as you can! Understand credit sooner rather than later because this will be your spending power in the future, so protect it. Review your credit report quarterly to reduce surprises and become familiar with your creditworthiness. I would tell young Janet that those dreams you have about your creativity, or a solution to fixing something or making a process better, could turn into entrepreneurship, so explore it!

I've got an attitude of gratitude! I am so grateful to be on this journey with a group that is forward-thinking toward financial independence. The word that best defines my attitude towards wealth now is "knowledge." The more I know about wealth opportunities, the more my family and I can benefit from the short and long-term residual. This leap into the group has changed the trajectory of where money will lead me, and I cannot wait to see where it goes!

Janet Bruce Williams

Jocelyn Gilchrist

I am Jocelyn Marie Gilchrist. I am a daughter of the most high God because He has shown His presence in my life for as long as I can remember. I am a wife because God knew what was best for me, so He sent my husband to me 17 years ago. I'm a mother of 3 because I fell in love with my husband's big family and wanted one of my own. I am a proud graduate of Hampton University because I wanted to attend the best HBCU. I'm an educator because it's in my blood, and I am passionate about being a voice for children. I am a realtor because I believe real estate is one of the most efficient ways to build wealth. I love homes, and my grandfather owned properties when I was young. I remember driving around with him to collect rent and feeling like he was the King of Denver. As a realtor, I still find myself wearing my educator hat, which is why I love working with first-time home buyers.

I was raised by and surround myself with driven, determined, and divine black women who regularly adjust my crown. If my friends and family were to describe me, you would hear words like funny, witty, and sarcastic. If you were planning an event, needed a good laugh, or needed someone to get you out of your comfort zone, you would call me. I love creating spaces to live, laugh, and learn from one another. It is important to know that all these spaces revolve around food. Last but not least, I recently went skydiving on my 40th birthday. When I jumped out of that plane, I jumped into a new exciting, productive, and unapologetic chapter of my life.

Starting this year, I wanted my actions to be bold, intentional, and fearless. Jumping out of that plane took courage, preparation, and faith. I had no idea that joining this club would be just as exhilarating. Less talk and new actions because I want more moments like this.

When I was a little girl, what was my indication of wealth? Good question, and it depends on where I was living in that moment. If I was staying with my mom, my definition of wealth was my grandparent's neighborhood. They lived in Park Hill in Denver, CO. When I stayed with my grandparents, my idea of wealth was my friend that lived in a big two-story home in Park Hill. I remember one year, Homearama was in Park Hill, and I got to go into some of the homes. A little boy that I went to elementary school with lived in one of the homes. In my mind, they were rich, wealthy, loaded, and any other word I could come up with at that time. I decided what wealth was in that moment. In my mind, if you had a nice two-story house, you were wealthy. It was just that simple. My grandparents lived in the same neighborhood, but their home was drastically different from my perspective, so I never considered them to be wealthy.

I recently learned that my grandparents were one of the first black families to move onto their block. I don't know my grandfather's financial number, but when he passed, his home was paid off, and he was able to provide for my grandmother. I choose to believe that he was wealthy now that I have a new perspective.

As an adult, how do you define wealth? I'm not going to lie; prior to this group, I defined other people's wealth by my five senses. I can see your house, cars, clothes, vacations, accessories, etc. I can smell your expensive fragrances, and I'm impressed because you know

how to pronounce them. I can hear your stories of luxurious vacations, successful business deals, and big money problems that I'd love to have. I can touch your fine linens. Finally, I can taste the five-course meal prepared by your personal chef. I assumed that if you have these things going for you, you automatically own real estate, invest, and participate in the stock market. These were my assumptions. Well, you know what they say.

I may have been off in my definition of wealth, but now I know that my perspective was all wrong. I'm actually going to give myself some credit because I'm not alone. Far too many people define wealth by material possessions in this country. To determine wealth now, I would need to know much more about a person's financial portfolio to determine if they were wealthy. I would need to know the behind-the-scenes information. I'm no longer distracted by what I can see. I know and understand the dictionary definition of wealth. My personal definition includes a sense of security that comes with knowing that I am making educated decisions about my money. Confidence in knowing that I am making the best use of my assets. A sense of peace in knowing that my money is working for me even when I'm not working.

This picture symbolizes home for me. Sitting on the couch with my papa at my grandparent's house was my safe space. He was an example of hard work, discipline, and my first introduction to money management. I put this photo on my desk as I made my final decision to join this club.

Two words, Reality Check. Income don't mean a thang if you don't have that swing. Swing, in this case, is your net worth. Knowing my number means knowing I cannot go X amount of time without working. Now that's scary, especially when I think about my future. The other scary part is thinking about what my future would look like if I never had this reality check. Knowing your number removes all the guesswork and speculation. There is no way to add your opinion or the perspectives of others because the number does not lie. I am a realist, so knowing my number makes it plain. It is black and white with little room for error. There is no one magic number that determines if you are wealthy. This is because everyone's number will be different. The amount of money I need to be considered wealthy will differ from yours. No need to compare. No need to keep up with The Joneses because I'm just trying to keep up with myself. Knowing your number is also a great starting point. This reality will let you know exactly where you stand and what you should focus on next.

I am proud to say that my relationship with money is evolving. I'm learning to appreciate it for what it is without making it my God. In the past, I've been a hoarder, giver, and worrier. I would not have described any of these phases as being completely healthy. In my early years, I would hoard it. In high school, I worked two jobs for a summer and saved $1,200 for a new car. I would count my little stack every week. I saved all my work-study checks for an entire school year in college. When it came time to rent my first apartment, my roommate at the time was fortunate enough to pay the entire rent in advance. I was so proud of myself for having enough money to do the same. I went to a check cashing place with a smile on my face. I don't even want to talk about the fees I had to pay to cash all those checks. I'm still mad. I think I was a hoarder because most adults in my life just talked about how there was never enough. All I knew was that it appeared to be the cause of a lot of pain and bad times for people. So I figured I could avoid the despair if I just held on to it.

Then I got married and started attending church regularly. I dug deep into reaping and sowing, and I am grateful for this lesson. A large part of my journey to become wealthy resides in my desire to be a lender and not a borrower. This giving stage took a back seat when life got real, and then I just turned into a worrier. I went through all of these phases without the proper knowledge of what money is. My relationship with money is and will continue to be multifaceted. I will sacrifice and save, I will reap and sow, I will make a plan so I don't have to worry, and I will continue to educate and challenge myself. I respect money. My relationship with money is a work in progress, but it's better than before.

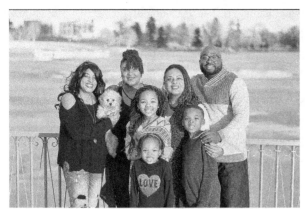

The WHY behind most of my decisions will always be my family. They are my source of love, strength, and joy. By God's grace and mercy, I accepted this challenge because they deserve this opportunity and I believe that you do as well.

I took the leap to join this club because I am at a point in my life where God has truly given me the desires of my heart. Now, I keep hearing Him say, no more excuses. He has shown me that He has provided all the tools, and now it's my turn to do this faith walk confidently. As always, I was inspired by my mother. Watching her strive to break the financial chains in her life is like watching Rocky. I couldn't help but get in the ring with her. What made this leap of faith so hard was the fact that there were time constraints. When it comes to my money, I have commitment issues (unless it has something to do with food). I'm the person who researches products, vacations, and programs for months and even years before committing. So, I had to fully rely on God and my trust in our vision. My goal and prayer had been to be a good steward of my money for so long, and I truly felt like this was the step, no leap in the right direction. I took this leap not only for myself but also for my children and my legacy. I do not have a wealth of knowledge to pass on to them right now, but they can at least watch and learn with me. Hopefully, they won't hesitate to take the leaps ahead of them when it is their time.

My most significant "ah-ha" moment has been during my journaling. My "why" behind joining this group is simple; it is a legacy. I always planned to teach my children about investing, but I was sure it would be an introductory course. My mindset is shifting; we can learn, grow, and build together. My children will already be on the road to wealth because of this journey. This statement is powerful for me; I can feel the chains being broken just by saying it aloud.

Ok, I will cheat and share my second "ah-ha" moment. I must confess that I have avoided the insurance talk like the plague. Insurance might as well have been a four-letter word to me. It was just too much. Yes, I understand the basics but what was frustrating was knowing that there were all these tips and tricks. I did not trust the agents and just wanted to know the real deal. One of our first meeting topics was insurance. I had never heard it explained like this before. I could finally wrap my head around all the pros and cons of each option. As a club, we were encouraged to review the terms of our policies and make the necessary adjustments. Sometimes we need that push to get out of our comfort zone.

I know today, I would tell my 20-year-old self that she was off to a good start. I would explain to her that her discipline in saving is admirable. Her ability to sacrifice to save will pay off if she learns what to do with the money. Education, education, education make learning about finances a priority. Because I know myself, I would have to talk seriously about not being afraid to take risks. I would also tell her that she should go ahead and have the money conversation before getting married.

Her first goal should be to purchase a home that has rental potential. I would encourage her to get a mentor in real estate. Do not wait to get your real estate license and start learning the market. It is never too early. All those college friends could be your first clients! If I could give her one sneak peek, I'd tell her that one day she'd have the opportunity to purchase her grandparent's home and start saving now. It will be the biggest real estate opportunity of her life. If she misses this opportunity, it will be a momentous regret. Lastly, I would advise her to surround herself with people that she can learn from, people that she can relate to, and people that she can help or mentor.

The one word that defines my attitude towards wealth now is obtainable. Wealth is obtainable now because I understand what wealth truly is. Knowledge is power, and my lack of knowledge was holding me back from reality. Wealth is within my grasp, and the more I continue to educate myself, the closer it becomes. Prior to this year, I did not believe wealth was a reality for me. Honestly, I was more focused on what I believed to be the basics of financial freedom. This meant having a savings account, an emergency account, minimal debt, and living comfortably within my means. I didn't want to share this, but here it is; I had just come out of bankruptcy. In many ways, I did feel like a failure, so all my big dreams felt out of reach at that time. I told myself to stay in my lane and thank God I made it out. Well, let me tell you something, I was lying to myself. The bankruptcy taught me a lot about money management, and it scared me so bad that there's no way I'm going back down that road. So, when I tell you that my word is obtainable, it is my proclamation, so stay tuned.

The first step is action, any action. I'm going to be honest; I don't even care what action it is. The first and most crucial step is taking any action toward financial freedom. Any step, big or small. The point is to move beyond your awareness, your fear, and even your knowledge. We can't just sit around forever talking about it. We can't waste any more time planning to take action. Nike said it best, friend; it's time to just do it. That action could be sitting down with a financial planner, sitting down with yourself or a partner to create a budget, or reading a book such as this one. There is no way for me to determine what your action should be. I'm not an expert. In fact, you may be steps ahead of me, but I know you won't reach the finish line if you stay where you are.

My specific action was applying for a new job. I knew that I needed to increase my income to meet the goals that I had been talking about for years. My goals included starting an IRA, saving for my first investment property, and saving for my children's college fund. I applied for jobs during the first few months of joining the club. It was important to know that I was moving toward my financial goals. Start with one action, and then take the time to plan out your next steps. I encourage you to break your goals down into small achievable steps so you do not get overwhelmed. Remember, friend, regardless of the step, you will be one step closer.

Dr. Karen Foreman Jackson

We desire to bequeath two things to our children; the first one is roots, the other one is wings. - African Proverb

When I was 12 days old, my birth mother took me to her friend's family and asked if they could keep me for two weeks. Those two weeks turned into the rest of my life. Although she returned, my birth mother did not have any plans to take me home. I guess in her eyes, I was already home. I am forever grateful for her intuition because I gained two loving parents and nine doting siblings.

My mother was a domestic worker, and my father was a porter at a local hospital. They also had a side hustle. They were the original Uber. As far back as I can remember, they had a steady list of customers who scheduled rides with my mom, and my dad would take them to places like the grocery store or pharmacy. My siblings and I eventually became part of the fleet as well. Although he made more money with this side hustle, my father kept his job at the hospital to ensure the family had health insurance. No matter the need, and oftentimes the want, my parents always found a way.

Neither of my parents graduated high school, but they were resolute in their belief that education was the key to success. They always encouraged us to set high expectations for ourselves. I remember when I told my mother I wanted to get a doctorate, her response was, "Just do it." Not once did she question my ability to get it done. What they lacked in financial abundance, my parents more than made up for it with love, encouragement, and dedication to our well-being.

"Moving on up to the east side" - Ja'Net DuBois

I cannot remember ever hearing the term "wealth" used in my home. I was more familiar with the term "rich," and my definition of rich was formed by watching "The Jeffersons." To me, the Jeffersons in that east side apartment with a door attendant and a maid epitomized "rich." They had a lot of nice things and always looked good. To me, that signaled rich. I never heard my parents talk about money much, so my understanding of wealth was limited to the tangible things I could see – homes, clothes, cars, etc.

While George Jefferson often flaunted the things he could buy, he frequently alluded to the access his money afforded him. His financial status allowed him to move in circles that were not previously available to him. Being in those circles provided him access to even more financial opportunities. George Jefferson was teaching an important lesson on relationship building as it relates to wealth. Access to people who can provide information you might not otherwise be able to access is key to wealth building. Although I might not have understood the nuances of those relationships, I understood that there were certain people he wanted to associate with to make money. Even as a little girl, I learned that the company you keep can influence your financial status.

"Financial independence gives us the power to decide our futures and liberate our conception of what's possible." Stacey Abrams

Thankfully, my definition of wealth has evolved, but the influence of George Jefferson is still present. While his delivery was often crass and materialistic, I came to realize there were many important lessons to be learned from his antics. Wealth is usually associated with a large accumulation of assets. I believe wealth is also about freedom, longevity, and legacy.

My parents at my sister's wedding.

Freedom

Mr. Jefferson often talked about how his money allowed his family to do things he was never able to do, and now that they were "rich," they did not have to do things they did not want to do. Money gave them more agency in the decisions they made about their lives. Freedom allows you to make a choice that is true to who you are. We often say that wealth gives you options — the option to live where you want, travel where you want, work when you want, etc. But the reality is that the options are always there. We can choose just about any option, but it has how we access those options that is truly grounded in wealth. We see people gaining access to circles of influence or taking advantage of certain options through manipulation, fraud, or going into debt. Wealth allows you to make choices based on your own terms without worrying about negative repercussions.

Longevity

Longevity refers to the time something or someone is viable or of service. How long your money lasts is also an indicator of wealth. The Rockefellers, Hearsts, and Waltons are examples of families with generational wealth. The original family members built a foundation that supported growing their family's net worth for generations. True wealth, if appropriately managed, is sustainable even after you are gone. Being rich means having a lot of money (whatever that is to you) at a given time. Being wealthy means, you can continue to grow your net worth throughout your lifetime and for future generations.

Legacy

For me, legacy is also an important component of wealth. It speaks to more than how long your money will last. It asks the question, "How is your wealth impacting others?" Wealth supports one's philanthropic efforts and ability to provide opportunities for others. Amassing a large net worth but not using it in ways that help to move others forward would not be fulfilling to me. This is not just about donations or handouts but about creating empowerment opportunities that provide education, networking, and access to environments that could change lives. Whether it's your family, employees, or the greater community, using your wealth to empower others helps to build your legacy.

"More important than how we achieve financial freedom is the why. Find your reasons why you want to be free and wealthy."- Robert Kiyosaki

"Knowing your number" is the point at which you will declare your financial freedom. For some people, it is a particular new worth. For others, it is a specific amount of money in the bank or being debt-free. For me, it is the point where I can own my time when a job no longer dictates how I spend my days. This number indicates the point at which I can make choices based on things other than money. This target or goal requires me to evaluate the things that are important and to develop a realistic action plan.

It is also important to understand the implications of that goal. What does the transition look like after you reach the goal? For some, this will be the point where they leave their current workplace. As an educator, I'm not sure that I would walk away from my career. I get fulfillment out of supporting my students. But reaching that target will allow me to explore different ways to support them on my own terms. Another consideration is how reaching that number will affect your lifestyle and those around you. Perhaps a simpler life is on the horizon, and the goal is not to maintain an extravagant lifestyle. Is your family in alignment with your goal? You will need their support to achieve and maintain it.

"Money is only a tool. It will take you wherever you wish, but it will not replace you as the driver." - Ayn Rand

My relationship with money is evolving. There was a time when I tried not to discuss money because I did not have much of it. There was no saving, no planning, and definitely no investing. When I got a "real job," I signed up for a 401K through my employers but did not initially max out my contribution, and when I did, that was it. My relationship with money was very passive. I thought if I checked off all the boxes, 401K, insurance policies, etc., I would be fine. As I got older, working on building wealth was difficult because I was embarrassed by what I didn't know. Even though George Jefferson emphasized the importance of relationships in building wealth, I experienced imposter syndrome and shied away from discussions centered around money.

My relationship with money was influenced by observing my parents' relationship with money. They always seemed to have enough money to pay the bills, keep us fed and clothed, and contribute to my catholic school and college tuition. My father always had bags of money around the house because he did not trust banks. My father was seven years old at the start of the great depression, and that experience, coupled with being a black man during the Jim Crow era in the South, helped to shape his beliefs about money. He developed a scarcity mindset. He held on to every penny. He was always planning for a rainy day. In addition to his job and ride service, he recycled newspapers and aluminum cans. My mother was different. If she saw something she wanted, she got it. She had credit cards for all the department stores and used them often. Her philosophy was, "You can't take it with you when you're dead, so you better enjoy it now."

My parents were diametrically opposed in handling money, and I fell somewhere in the middle. At one point, I was like my mother, enjoying a life supported by credit cards. Once I got the credit card spending under control, I thought I could save my way to financial freedom. I was happy at this point with my financial progress because I could see my bank account growing and my debt decreasing. When I had children, I realized that I could not save my way to wealth. I could not continue to have a passive relationship with money if I was going to be able to provide my girls with opportunities and experiences that would help them reach their potential and support their own financial freedom. My relationship with money is now one of partnership. I understand that money is a tool, and like other tools, it is important to understand the operating instructions so I can use them to help me reach my goals.

"Do the best you can until you know better. Then when you know better, do better." - Maya Angelou

As a mother and lifelong educator, I have always been a nurturer. It became second nature for me to always put others first, sometimes at the expense of my own well-being and peace. I decided to stop sacrificing my own well-being and focus on the things important to me, understanding that if I am better for myself, I will be better for others. This included my health, my relationships, and my financial security. When the opportunity to join the RR Fund investment club presented itself, the timing was perfect as my future financial security and that of my family, especially my teenage daughters, became a priority. The most appealing thing to me about the club is the focus on education. My parents could not teach me what they did not know. But now, I have the opportunity to learn more so I can pass it along

to my daughters. I feel obligated to make sure they learn all the things about wealth building that my parents did not have the opportunity to teach me.

Me passing along knowledge to me daughters. I pray they're listening.

The fact that the club only included women was important as well. This group includes people who have similar obligations and experiences navigating the world as women. As women, we are sometimes taught to rely on others for our financial security. This group completely dispels that falsehood. Being able to hold space with women along the financial continuum has helped me see the possibilities for my own future and the future of others. Additionally, the opportunity to be an angel investor to help others grow their businesses is in line with my belief that wealth includes empowering others to succeed.

"Don't ever make decisions based on fear. Make decisions based on hope and possibility. Make decisions based on what should happen, not what shouldn't." - Michelle Obama

I was ashamed of my lack of financial acuity for a long time, and I dealt with it by avoiding dealing with the state of my finances. I watched the financial gurus on talk shows and websites, and I bought a few books. I never asked questions or had consultations because I felt shame about not being adept in the financial realm. I had always done the right things in other areas of my life but had not approached this area of my life with the same drive, inquisitiveness, and purpose. I had a fear of being judged for not doing or even knowing the right things to do to support wealth building.

This group has shown me that no one knows everything and that there is no shame in asking questions. Ironically, I try to teach this to my students every day, but when it comes to my own finances, I do not take my own advice. This group encourages vulnerability to ensure everyone has the tools to make productive decisions. Education is key to building wealth, and you have to approach it just as you would anything else that is important to you. There is no shame in not knowing, and asking for help or clarification shows a woman who is comfortable enough to do the necessary work to move to the next level.

"For me, becoming isn't about arriving somewhere or achieving a certain aim. I see it instead as forward motion, a means of evolving, a way to reach continuously toward a better self. The journey doesn't end." - Michelle Obama

When I was 20 years old, I was a junior in college and rarely thought about finances. Not because I was financially secure but because I was the broke college student who always found a way to get by. I thought this was just how college students operated. I did not have anything to budget, so what was the point? Financial planning was something you did when you were older with a job. Invest? I thought you had to have a lot of money to invest. If I could share a few words of wisdom with my 20-year-old self, they would include:

- You do not have to have a lot of money to begin to plan for financial security. Take risks, as there is more to building financial wealth than saving money in the bank.

- Take some of your partying money and buy some stock in Microsoft. But first, learn about what stocks are.

- Educate yourself — you don't know what you don't know. There is an African proverb that says, "Wisdom is wealth."

- Wealth-building is a process; the earlier you begin, the better the outcome.

- Be confident in who you are and what you know, and always strive to be better and know more.

"Don't sit down and wait for the opportunities to come. Get up and make them."- Madam CJ Walker

The word that defines my current attitude toward wealth is action. I've come to realize that building wealth is an exercise that requires attention, planning, and work. At one point, I thought it was too late for me to begin creating wealth. However, I understand that while I cannot get back the time that has passed, I can make the most of the time I have left. The seeds I plant today have the opportunity to bear fruit for my later years and also for my children and their children. Joining the club has been a key step in supporting my own wealth building. Improving my financial literacy through engaging with others I can learn from has been a crucial component in this process. Reading books and articles on wealth building has now become a priority, along with setting goals and creating action steps based on what I am learning. Most importantly, I am no longer waiting for things to magically happen. I have become my own catalyst and am no longer afraid to take action.

"You have got to tell your money what to do, or it will leave." - Dave Ramsey

Everyone has their own financial journey, but there are some key actions everyone can take to move forward.

- Assess your attitude and actions around money. What has or hasn't worked? We have to identify what might be triggering particular attitudes and behaviors and find ways to manage the triggers and change behaviors that are not conducive to growth.

- Complete an assessment of your financial affairs. Sometimes we shy away from our reality because we are not satisfied with what we see, but we cannot change what we do not confront. You have to know where you are in order to move forward.

- Prioritize building wealth. Prioritizing includes committing regularly scheduled time to educate yourself and surrounding yourself with people you can learn from and work with. Furthermore, prioritizing includes setting goals and an actionable plan.

- Finally, Remember there are no shortcuts. You have to do the work.

Dr. Kathleen Cabler & Dr. Kendra Cabler

Few things are as wonderful as the love of a mother. Fewer things are as wonderful as the love of a daughter. I am Dr. Kathleen Cabler, and I am Dr. Kendra Cabler.

In this chapter, we share pieces of our financial journey woven through stories of personal growth and reflections. In sharing, we hope to incite laughter, learning, and reflections on your own money story.

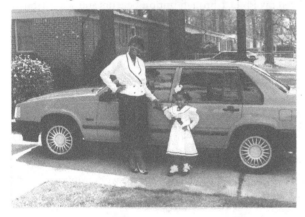

Dr. Kathleen and Dr. Kendra -the Early Years - at Mudear's house

Kathleen's Daughter – Kendra

Money, Money, Money, Money... Money! I may be a late 80s baby, but this O'Jay's classic seems fitting to start my money story. Growing up I never thought twice about money, I didn't know what my family had, but I knew I could have most of what I asked for. There wasn't a Christmas or birthday when gifts didn't abound, at least not that I noticed. Now, let me be clear, neither of my parents, in the past or present day, have lived the O'Jay's narrative, but to say our relationships and money stories are different is probably a gross understatement.

Raised as the only child in a middle-class family, working and working hard was absolute. My mom and dad worked outside the home, and I often had a front-row seat as an only child. More days than their employers might have preferred turned into "bring your child to work" days. I like to think those days played into my work ethic and sense of pride in earning what's mine.

I was the teenager waiting to be old enough for a work permit. I wanted money that had my name on it. Grateful for all that was given and hungry for what could be earned. I didn't have a plan for this money, but I knew my after-school Chick Fil-A order, gas for my inherited 96 Honda Accord, and new jeans could be acquired on my own dime, and I was proud of that.

The Wonder Years

Just as quickly as I'd landed my first job at a daycare nearby, it was time for me to leave home for college. Not far away, just a couple of hours drive outside of my hometown, I moved on campus and thus began my transition into adulthood. Finances were still far from my mind, I knew my parents were paying for my education, but I couldn't yet fully appreciate what that meant. The family's financial circumstances shifted a few years into my undergraduate journey. "Student loans? Everyone has those, right? It's no big deal." Still oblivious about what it costs to exist in the comfortable world I'd been afforded, I finished my bachelor's degree and went straight into graduate school. I know what you're thinking, and the answer is yes, there were more student loans.

If ever I thought of finances, it was this single directive, "Don't get a credit card," and since I hadn't gotten a credit card, I figured I was crushing it! "Killing the game" is likely what I would have said then. I graduated with my Master's degree, and it was time for my first professional job. I was so excited. So many years of school in preparation for this moment, the independence that teenage Kendra had been waiting to feel in all its fullness and glory. I got the job, searching purely for a role that spoke to my passions and not my purse. I hadn't considered that I needed a strategy or a minimum salary to guide my job search to land a gig that would support my needs and wants. I had two degrees and had already managed to get a couple of years of experience under my belt, and without a clue or care in the world, I signed an offer letter. It was 2012, we were coming out of a nationwide economic crisis, and I could barely afford my studio apartment in the neighboring town.

I know we're talking about finances, but I need to say this. Since I entered this world my parents have been showing up for me in more ways than I can count and there is no amount of gratitude I could express that would be sufficient for what I feel in my heart. While I pursued a job that I loved , they supplemented what my paycheck couldn't without hesitation. I know that's not everyone's story, but I am grateful it's mine. Even so, you should know by now that I value independence fiercely, and though I was grateful, I wasn't comfortable. I wanted to do it all on my own; I needed to prove that I could, not to them, but to me.

A year later, I took a new role and moved to a new city, where I would start to become the independent woman and professional I longed to be. With the job came a significant jump in pay, and I started to find my way. A year later, I felt a strong urge to return to the classroom. I'd told myself years prior that I'd be Dr. Kendra one day. Much more clear on what it meant to have taken out those student loans, I was very sure, "I won't be taking any more loans for school." I started and completed my Ph.D. (through tuition benefits and scholarships) and planted roots in higher education. I had a plan.

God's Plan

I was thriving. New money and new opportunities were finding me, and I was loving it. I was ready, clear, loved my new work team, and was proud of the work we were doing, but it was time for more. At the time, I was advocating for a promotion, an opportunity to really kick things up a notch. Anything was possible. But what followed wasn't on my list of possibilities.

It was March 2020. If you don't know what was happening, I'm not sure where you were, but I and the rest of the world found ourselves thrust into a global pandemic that would last for years. With more time at home due to lockdowns and more time alone in my apartment, I needed to busy myself. I read a book that would ultimately change the course of my life. Sitting on my couch with my thoughts, I began to wrestle with myself. "Who do you want to be? What do you want to do? Would that be your answer if you weren't worried about what other people would say? Can you do it? Will your financial journey have to start all over?"

There I was, face to face with my thoughts and desires to do and be something and someone totally different. I worried I'd gone too far down one path to turn back or turn at all. Still, I couldn't shake it. I had to move. It wasn't a physical move; it was a mental shift. Amid my promotion conversations was a salary negotiation. I found myself in the same position as countless women before me. Advocating for money that I'd earned, knowing that the men around me were bringing in more than double what I was, and being told that I just needed to wait. I'd hit that target in ten years but needed to pay the time. Don't let anyone tell you that you need to pay the time. Our ancestors already did that, but that's another conversation for another day.

A New Day, A New Dawn

I prayed fervently in this season. My heart was clear and loud. I just needed a plan, God's plan. I was going to change tracks. In fact, I was going to change vehicles. I was leaving education altogether. We're not here for my career journey, so I'll spare you the details; just know that in four months, I made the move with a $48,000 increase in salary. With that increase came an instant shift in my money mentality. With more financial security of my own than I'd ever experienced, I knew I also had more responsibility to steward it well and wisely.

I started aggressively paying off student loans. They were in deferment, but it didn't matter. I wanted the debt gone. I started saving like I'd never saved before. I wish I could take all the credit here, but when the time came, I recalled a "budget boot camp" class my church had offered years prior. I took those tools, and I made a plan for myself. I made a spending plan and a savings plan. I set goals and worked backward to figure out what I'd have to do to achieve them.

Another door opened. With it came another increase, $20,000. I'm about 17 months into this journey. I just closed on my first home. I'm learning about investments and what I can do next to secure the future I want for myself and my family. This journey is just beginning, so I don't have much to share, but I'll say this. Buy the house, Sis! And make sure you get that warranty; on everything!

Kendra's Mama – *Kathleen*

Rise Up!

Turn those lights off when you leave the room; turn the television off if you're not watching it; close that refrigerator door! Those were three frequent phrases used in our household - we attempted to eliminate any action that had the potential to waste money - or energy!

Growing up, we were very rich. Before you become too excited, it was not in the way one may instinctively think. While there was not plenty of money — love was abundant. If I was missing anything, I didn't know it - That is until I went into the workplace.

$2.38 — slightly over minimum wage was my hourly salary in 1974. I thought I was doing something great – I earned more than minimum wage. When I was 12, my mother, *affectionately known as Mudear,* became a widow. My father transitioned, leaving her to raise my seven siblings and me from the ages of 9-17; truly, eight was enough! I was number 5 of the seven girls and number 6 of the eight children. I have one brave brother! This unexpected loss impacted every aspect of our family circle and finances. Be prepared — financially - for the unexpected.

I married Joe at 28. Kendra blessed our union when I was 32. New wife, new mom, and a job outside the home was a way of life for me early on — and I loved it. Navigating my way from secretary to retail associate, and eventually, Store Manager is where I found my footing in management and leadership while increasing my financial acumen.

Ever heard the saying, "You don't know what you don't know?" As my career grew, I started to learn what I didn't know I needed to know. 401k — what? Stocks, bonds, diversified portfolio — huh? Although this was foreign to me, if I kept still and my mouth shut, no one would know what I didn't know, and I'd have time to figure it out.

Over time, I improved my financial acumen, leadership techniques, and strategies. I grew amongst the ranks in those walls, ultimately becoming one of the first African American female Store Managers and Owners for this major retailer. The owner simply meant I owned stock in the company. This gave me a voice — on paper. I was rising up. I remained in retail operations for 25+ years. So different from Kendra's generation – where it is 1-3 or 3-5 years, and they're on to the next opportunity!

Enlarge My Territory

"Jabez called upon the God of Israel, saying, 'Oh, that you would bless me and enlarge my border, and that your hand might be with me, and that you would keep me from harm so that it might not bring me pain!' And God granted what he asked"
(1 Chronicles 4:10).

And so, it was for me. The 25+ years in retail operations would prove to be good, bad, and ugly from early mornings and late nights to holidays and weekends — retail defined our life. It so happened; Joe was in retail as well. I exposed Kendra to retail at an early age. From hanging out in my office, building relationships with my leadership team, and hanging out in Joe's store, she grew up immersed in the inner workings of the retail industry. There are benefits to this exposure — she is wise with her money and can seek out a good deal as well as a bad one a mile away! – She got it from her mama — and daddy!

Dr. Kathleen Cabler - Store Manager Montgomery Ward

Although I loved things and was surrounded by them daily in my career, I learned early on not to have a love affair with money. I was taught to earn it, respect it, tithe it, sow it, and bless others with it — this was the law, at least in our home. At times there were minimal discretionary funds. At times there was an abundance of discretionary funds. *Give, and it shall be given unto you ...* was always more than a scripture; it is and always will be a way of life. The season didn't and still does not determine the level of faithfulness, thankfulness, or gratefulness. I love to bless others — and over the years, I've learned to be more intentional about being a good steward of my finances and now bless others according to the nudge of the Holy Spirit. When it comes to Kendra, she pretty much gets what she wants/needs — why? Because we can.

I landed my first Store Manager position in the early eighties. It helped me add to my savings to buy my first car. I'll always remember the ride to the dealership on Military Highway. Mudear was with me and a friend who worked in retail alongside me. After perusing and test driving a few, I settled on a cranberry 75 Chevrolet. It was the first large purchase I called my own. I was filled with excitement and very proud of my purchase — in the moment. As I drove over the bridge back to Mudear's house — the tug in my spirit about the car and the investment was unsettling. I listened. That same day we took the Chevrolet back to the dealership! That was the day I learned the magnitude of my negotiation skills-without losing any equity, I was able to transfer my $500 deposit towards a 1976 blue and white Maverick – already four years young — she was a beauty, and she was all mine. I adored her! Now my heart was happy. Happiness came with a car payment — a brand new financial obligation that would shape my financial worth in the eyes of creditors for years to come. Although I made every payment — on time, it wasn't because I fully understood the impact of a late payment on my credit scores. We all need to understand our credit scores.

This was one of the *first lessons* I learned in finance — be sure before you invest in that purchase and before you sign on the dotted line. Do not decide with your emotions, do your homework. I appreciated that Blue and White Maverick so much so that I teared up some years later when I traded it in for a brand new 1985 Pontiac Sunbird straight off of the showroom floor! That was a much smarter purchase, and I had an even more seasoned person with me. *Lesson two* — you don't have to be the smartest person in the room. Surround yourself with people that are happy to see you succeed and will help you to do so!

Don't be afraid to let someone else shine! As a matter of fact, encourage them to do so. The dividends will pay off. Encouraging Kendra to go after her dreams - and to dream big - today she is Dr. Kendra - Ph. D - she thought she could, and she did! And her dad and I supported and encouraged her every step of the way. She had a plan to include how to fund the dream! *Lesson three* — support the dreams of others. Supporting the dreams of others does not take anything away from you! On the contrary - I have gained so much by doing so.

Pay Your Dues

Growing up, Mudear would ask — did you pay your dues? She was referring to the monthly dues owed to the church every first Sunday. Like clockwork, we would each fill out our own dues envelope and drop it on the plate. Today I know 'my dues' as tithes and offerings I consistently pay on any financial blessing I receive. Never underestimate the power of sowing and reaping. I've been tithing — for real — for years! And I have been abundantly blessed! *Lesson 4 - Give, and it shall be given unto you ...* Luke 6:38 (KJV). Despite what it looked like, our needs were always met. As Kendra mentioned, she never went without. Did we always make wise decisions? Absolutely not. Have we learned from the bad decisions? Indeed.

Fast forward, my retail career propelled me into several other spaces. I am fortunate to be a professor at a local university, the same university where I earned my Doctorate in Strategic Leadership (DSL). As an aside, I walked across the stage debt free! How? I believe it is because of God's grace, mercy, and sowing and reaping! This part-time employment provides an opportunity to sow into the lives of young and seasoned students on all things leadership, organizational culture, values, ethics, and change management — and I love it. It also provides discretionary income that gives me the means to have what I need and want. I call it my 'sowing and blessing' money, as I use it to bless others without any thought of taking away from our household. Thank you, God! *Lesson 5* - do it because you love it and not because you have to! Things were not always this way; this came with time, and I'll say it again: with sowing and reaping. It is a testament to seed, time, and harvest!

What I now know – I do

As such, for Kendra and I to be a part of an elite group of women investors owning our financial future is liberating! When I approached Kendra with the possibility — without hesitation, she inquired about the next steps to sign up for the journey. Admittedly, there was a *gap* — a slight apprehension in *doing* – although I *knew* it would be good to *do*! Thank God I got out of my way and acted on what I knew. We've spent a respectable amount of time attending strategy sessions to make wise decisions with our investments. I am confident that we will execute the strategy and vision and make our mission of financial freedom a reality.

It was beneficial for me to include Kendra in the conversation to position her to experience financial freedom at a much earlier age than her father and I. Train up a child — or young adult in this case. This decision will have a much greater impact than any childhood lesson.

Keep It Moving

I was a toddler in 1960 when Dr. Martin Luther King, Jr. said this famous quote at Spelman College, "If you can't fly then run, if you can't run then walk, if you can't walk then crawl, but whatever you do; you have to keep moving forward." Although a toddler at the time, fortunately, it was one for the books, and I had access to it at a pivotal time in my life.

What Dr. King was saying is that no matter what you can do, you must keep pushing forward in the fight for justice. A message for me and ultimately Kendra was — whatever your fight – keep pushing for what you want and need – justice, fairness, financial freedom, professional satisfaction, and the list goes on.

Success

When friends all around me are retiring, I'm a little over a year into my 6th career at this seasoned age. I continue to work because I can, God is not through with me yet, and I love it! I got it from Mudear. *Lesson 6* - choose a career you love, and the compensation will follow. At some point, I will expand my coaching business and spend my golden years coaching others into making more intentional life choices to propel their dreams into reality — career number 7!

Yes, I'm successful. *Lesson 7* - I get to define success. Success for me may not be a success for you. This is my success: I know where my help comes from. I have my health and strength. I have the love of a man named Joe in marriage and friendship for 35+ years. I have a wonderful daughter - Dr. Kendra Cabler. I have the love of family and awesome sister friends. I've had six wonderful careers, each propelling me to another level of growth and financial stability. I've achieved the highest level of education in the land – I am abundantly blessed! Sometimes you just have to count your blessings out loud.

Kathleen and Kendra

Lessons I Caught While I was being Taught

When you know better, you do better — or at least that's the goal. Shorten the gap between knowing and doing. Don't let the opinion of others stop you from doing what you know you've been destined and graced to do. Free yourself from the opinions of others. Invest in you. Know that success is perspective — yours matters.

Know that failure is growth. Understand and protect your credit scores. Seek the advice. Be a mentor. Be a protégé. Do it afraid. Take advantage of opportunities. Don't let temporary unhappiness steal your joy. Buy life insurance. Put it in the Will. Never stop learning. Stay curious. Honor your commitments. And ... realize the consciousness that created unhealthy money habits cannot be the cure for a fresh financial start.

Lakisha Treasure

One cannot pick and choose the family they are born into but one thing is for sure, you can change the trajectory of your outcome. I basically grew up in two different households. When I was with my mother, I lived in a two-bedroom apartment with three sisters.

My grandmother also lived with us. She was there to get us on and off the bus, cook and she taught us to clean very well. She was a no-nonsense type of woman. Pretty much every day, she would ask me to walk to the Be-Lo grocery store to pick up items for dinner. I would gather up my friends and we would walk down Canal Drive which was a very busy street. The majority of the time, I would buy bread, ramen noodles, franks, and beans. She would hand over a book of food stamps. The stamps varied in color depending on if it was a one, five, or twenty. She usually gave me a book filled with ones which were the colors white and brown. Checking out at the register, I would dig into my pockets to pay for the food, and at times I felt embarrassed. Looking back, there was no need because the entire neighborhood used them. Of course, back then I didn't realize that my household was struggling financially. However, a part of me felt that it was not normal to pay for groceries this way.

The Journey Begins

We were also the neighborhood 'Candy Lady' as they called it. You could always buy a sugary frozen cup from us. We had every chocolate bar and various flavored sour power strips. Kids knocked at our door as soon as the school bus dropped them off. Traffic jams at all times. This is when I saw the hustle in my family. Any way to make a dollar. In addition, every weekend, we had to sell donuts and chocolates called Katydids. The cost was a whopping $8 per can. It became additive learning different ways to bring income into the household. I was learning how to grind, I was learning how to keep a few pennies in my pocket. I would not trade the experience in for anything but the little wisdom I did have revealed to me that there had to be a better avenue to bring in additional revenue.

Every weekend I would visit my father and bonus mother. They would pick me up and I would cry. I would cry because I was leaving my lower-class neighborhood to enter into a middle-class neighborhood. Sounds strange right? It was a feeling of guilt, leaving my sisters behind knowing that there was more to life than what we saw. I blamed myself because I had the opportunity to witness the beauty on the other side. The neighborhood I lived in was not unpleasant as it could've been worst, but my father's home was plush, outlined with

convenient amenities, tennis courts, a neighborhood pool, and a nice floor plan. I even had my own bedroom, the second biggest room in the home. The environment was completely different.

Growing up in two different households created and built a unique young woman. On top of that, I had two extraordinary women raising me. I knew how to fit in with the lower class but I had the confidence to fit in with the middle class. Some days, I used food stamps and other days, I had fifty dollars cash in my pocket. I pretty much mastered these two worlds. My mother showed me how to grind and my father taught me how to save. My mother displayed the gift of giving even when you didn't have and my dad taught me how to tithe. My mother trained me to strive for more and my father demonstrated how to take care of your possessions. One day my father rolled up in his new turquoise, four-door Honda Accord Sedan. The car seemed as though it pulled up in slow motion. I was soaking it all in. I was young and didn't see many new cars, and the color! I jumped in; the smell of a fresh car. I thought he was the smoothest man alive. From that day forth, I knew that I had to save my money, go to school and work hard. He was an amazing influencer.

Years later my mother moved us from a mediocre neighborhood to a quaint, very small, and cozy condo in Greenbrier. It was still a two-bedroom, but the area was fresh, surrounded by huge trees that created much shade, a mall was located directly across the street and we were surrounded by brand-new shopping centers. Whatever we needed was at our fingertips. I was so proud of my mother. She wanted her girls to grow up around a specific type of people. One day she said, "I rather have my girls crammed in a two-bedroom condo vice live in a four-bedroom duplex in the hood." CHECKMATE: There is no other move. She knew that she didn't have another option." We were getting older and she realized that she had to change up our environment. This is when my mindset began to shift drastically. I was being introduced to new friends. They would invite me to their homes and I was intrigued by the size of their 2500-square-foot havens. Others were living like my dad, "I would say to myself." When my new crew and I would walk to the convenience store no one used food stamps. This was new to me. Everyone had cash and it created a different vibe.

My school bus would drop off and pick up a few of my friends from the most elegant neighborhood in Greenbrier. OMG! The homes were gigantic, baby mansions. Windows down, I would peep my head out the window, thinking to myself "one of these days, I am going to resign here." There was one black girl who was the school's valedictorian. She stayed in one of the biggest homes in the neighborhood. She used to tell me that her parents made her read as soon as she got off the bus. School didn't end in her household until 5 pm. I knew that I had to stay up on my game, be smart, study, make plenty of money, and save, in order to have a chance to live in this lavish neighborhood. I believed that these people had to be filthy rich. At that moment, I knew I wanted to be rich. I doubt that I was thinking about wealth. I just knew that I gravitated to a certain type of lifestyle. I knew what I wanted. My heart leaped for the things that I was attracted to. If you think of blessings, you will attract blessings. I was never comfortable with just getting by. My eyes were focused on what I wanted my life to represent and thirty years later, I live in that same neighborhood that I manifested when I was a little girl. God had big plans for this young dreamer and I didn't even know it at the time!

My Hero

Today, I tend to say, "I am everyone's type and biggest cheerleader." I am that girl everyone can relate to, and I tend to make everyone feel safe. I get a rush from being able to impact someone's life. You can sit me in the middle of any crowd, and I will fit in perfectly. Nothing is more gratifying than hearing a person's story and being able to respond by sharing a similar one. This made me extremely relatable. I believe that my purpose is to help others and remind them that there is hope. I thrive on being a blessing to all with whom I come in contact. Like a tandem bicycle, you don't have to match my speed just as long as you pedal. Though I love to influence others, I firmly believe that

it is equally important to surround myself with successful women who can impact my life as well. Someone once said, "Surround yourself with people smarter and wiser than you." The people in our lives will give you weight or wings, and I accept both.

I am also a dreamer and a visionary, which fuel my willingness to grow and improve. Like a chess game, I wait patiently to make my next precise move. At all times, I act as if I am either experiencing, preparing for, or recovering from a tidal wave. I understand that life doesn't always go as planned, which is why I care so much and can appear slightly critical (mainly with myself). I am highly ambitious and constantly work to promote myself physically, mentally, and spiritually. I am tough on myself and have very high expectations for my life because this is it! I am highly motivated to achieve new goals and constantly challenge myself. I never felt the need to compete with others but to compete with myself. One of my favorite affirmations is "I am who God says I am" because I sometimes struggle to believe what I am. At the end of each day, I celebrate as I am reminded of God's correspondence after each day of His creation; "It was good."

Two Moms are Better than One

During undergrad, I worked for a company where I assisted mentally ill adults. I was starting a Master's Program at NSU and was unable to juggle work and school. Being responsible I decided to put school first. But it was hard to give up this job because my schedule was extremely flexible. I would work around the clock because I could take my patients to appointments, the mall, the library, you name it. I was spoiled because I realized I could bring in income without being tied down to one central location and I loved it. This opened my eyes tremendously.

Every morning I sync up with a few of my wonderful accountability partners. This is a time when we meet God early in the morning and speak our 'declarations' and 'I AM' statements with boldness and share our testimonies. One morning, I shared that, I ran across an old notebook, and from my penmanship, I would guess I was around 12-13 years of age. In this book, I had a list of goals:

1. I will drive a range rover.

2. My income will be $63K a year

3. I will live in a big beautiful home

4. I will be a doctor

In 1995, I believe, this is what I considered wealth. My heart was filled when I found this book, and I quickly realized that most of it had come to fruition. The outcome was slightly different but it was almost spot on. I was extremely frugal and held onto a dollar as a little girl. I refused to waste money. So I should not have been too surprised. Habakkuk 2 says, "And the Lord answered me, and said, write the vision, and make it plain upon tables, that he may run that readeth it. For the vision is yet for an appointed time, but at the end, it shall speak, and not lie: though it tarry, wait for it; because it will surely come, it will not tarry." BOY, did God keep His promise?

As a little girl with big dreams, wealth meant making money while not being locked down. It was based on materialistic possessions with having the finances to pay bills without hesitation. That's it! As an adult, the word "wealth" took a slight turn. Money can undeniably help you achieve your goals, provide for your future, and make life more enjoyable, but it must guarantee fulfillment. We must know how wealth can disturb our well-being. Wealth is about having a life balance. It is being confident about your decisions. Wealth is freedom. It is being able to set your priorities and deciding what's important to you. People are unable to dictate your future. Wealth is having peace of mind, and it can quiet the nerves. As they say, "Wealth is good health."

Wealth spills over to family and friends. If I got the key, all of my love ones can walk through the door, right along with me. Wealth is being passionate and motivated about what you do. It's when all of your needs are being met, you are a lender and not a borrower.

You have the privilege to help others financially. Wealth is when your money flows from generation to generation to generation. Wealth is having assets and no liabilities. Wealth is having money stacked for rainy days. It is making money in your sleep. It's financial freedom, working because you want to, not because you need to.

Jay-Zs lyrics, "Men lie, women lie, numbers don't" always stuck with me. The beauty that attracts my eye is made possible and can be explained by numbers. Numbers tell you how you're doing, for instance, how much you have in the bank, your FICA score, the number of months remaining on your mortgage, your blood pressure, and body mass index. With that stated, there's an importance of "Knowing your number." It's critical to understand your financial and health results. I cringe every time my spending and budgeting statement reads, "On average, you spend $2,958.00 more than you deposit each month. Setting a budget can help you stay on track." Nevertheless, this keeps me in check by helping to eliminate unnecessary expenses. Now I work to create discretionary expenses to identify where monies can be saved. My financial statement is my living document, my financial bible that helps with business decisions by showing if I am on target with planned income, expenses, and profit. Knowing my number helps sum up how well I am doing money-wise. Through continual analysis, investing, and prioritizing, I will have the confidence in knowing that I will have the life envisioned from now until retirement.

I treat my money very kindly and spend it very wisely. I believe that to reap financial blessings, you must sow financially. There is a deep connection between money and me. Even when I was a child, I kept change in my pocket. You would never catch Kisha without a few coins in her pocket. Even in college, my friends always borrowed from me, and it was my pleasure to do so. Money and I have a pretty healthy relationship. I handle it will care, never disrespect it and I love it. Money reveals the real you. Therefore, I separate emotions from money because it can stir up feelings of anxiety, contentment, greed, and rage. I don't get frustrated when it doesn't come to me quickly. Instead, I brainstorm ways to receive more. I've witnessed that when I treat my money well, it's reciprocated. I roll out the red carpet for my money, and my cash rolls out the red carpet for me.

I am fortunate to be able to save, and it's a great habit. When it comes to money, you either master money on some level or money will eventually master you. I am grateful to have money flowing in but I have never been very knowledgeable in investing. Without investing and tracking, it lies dormant. For some reason, I always felt safer watching my money grow in a saving account, which is a bad habit I am trying to break.

Given that I always lived within my means, I thought saving would generate wealth however not in the approach I was taking. I quickly realized that it was not a suitable long-term approach. I must admit that I have mastered money to some degree; however, we (money and me) need serious counseling regarding investing properly.

There's no such thing as wanting what you already have. One of my biggest requests to God was to connect me to self-motivated, driven, empowered women. I wanted to be among other business-savvy women. I've always had brilliant women by my side but I was looking for more. I was always told that you should never be the most knowledgeable person in your group. And by no means am I the wisest nor most intelligent, but I needed to get a grip on something more. I needed to locate an online 'financial dating app' of some sort as I needed to be amongst millionaires and business-minded women.

I often share my story about leaving my 6-figure job; the type of stares received is unexplainable. If you want to kill a big dream, tell it to a small-minded person. If you are trying to become a surgeon, why would you get advice from a plumber? If my God is limitless, then I am too. This makes my income look like chump change compared to what's out in the vast universe. My job holds me down but it took years to realize that I was not fulfilled. I was only going through the motion. One day, I woke up and said, "There is no way I can remain in this position. When I look into the future, I could never see a beautiful painting of my current job. " It was a daunting and depressing feeling, and I knew I had to do something about it. I could not picture myself at the age of 60 years of age, staring at a computer screen for eight hours a day. As much faith as I have, I didn't feel that God was quite ready for me to quietly submit my resignation letter. After praying day in and day out, God answered my prayer. When I received the call to join the RR Fund Club, it was stated that each woman was handpicked. This was a start to a new beginning. I knew I had to get comfortable feeling uncomfortable if I wanted to succeed.

My most significant AH-HA moment was back in 2010 and I was 100% debt free. I was 29 years old and my husband and I were just married. We were on a plane heading to Turks and Caicos to celebrate our honeymoon. We looked at one another and stated "WE ARE DEBT FREE." We felt like Super Stars. We were able to pay off our fabulous wedding and paid off our F 150 truck and sports car. We

didn't owe a soul. It was the best feeling in the world. Debt-free! We knew that the real planning would begin after the honeymoon as we were ready to purchase our dream home. We didn't want any other major bills besides our mortgage. I was proud of myself. I was proud of my husband. We didn't allow money to handle us but we handled it. We handled our business. And truth be told, we could have done better especially with investing but that's a whole topic within itself. We lived within our means. We looked at our immediate family and stated that we wanted to do better. We wanted our children to have a head start. We listened to God and He ordered our footsteps. Though I didn't always make the best decisions in life, God was strategic and gave me the wisdom that I needed in specific areas of my life. I realized that if I could do it anyone could. I was not rich however I spent wisely and responsibly.

I was having lunch with my now 11-year-old son and he wanted a pair of Yeezy's. He could have afforded them. He has his own bank account and he is privy to the dollar amount in his account. He had received $200 for his birthday. Window shopping, he sees the perfect pair. The cost was over $300 dollars. He said, "Never mind, it's not worth it." It touched me because even though he had the money to buy it, he was wise enough to say, "I can do something more beneficial with $300." It was the beginning of wisdom. He was emulating his parents. Generational curses were being broken at that exact moment and time. It was a gentle reminder that God will always give you the desires of your heart when positioned on His axis.

The Treasure Family: Building Wealth together

If given the opportunity, I would tell my young, 20-year-old self, Galatians 3:29, "If you belong to Christ, then you are Abraham's seed, and heirs according to the promise." "Young Lady, the Heavens are opened and there's a river of miracles waiting just for you: now go and get it." Put God first because His timing is perfect. Set BIG goals; remain steadfast, unmovable, unshakable, and disciplined. Whatever you do, pay your tithes all the days of your life because there is power in giving back to God. Invest early because time moves swiftly and it's moving with or without you. Never get too comfortable because there's always room to go higher whether it's physically, mentally, or spiritually. I would remind myself that this day in time, there's no excuse not to generate millions. This is an easy thing in the eyes of the LORD (2 Kings 3:18).

Get comfortable with being uncomfortable because change will permanently remove one from their comfort zone. Live within your means, and don't try to keep up with the Joneses. Chase the bag as long as you receive a return on your investment. Chase the materialistic bags (exquisite weaves, designer bags, big boy cars) once you are a homeowner, life insurance policies, assets, and investments are in place. And continue to educate yourself about the power of wealth.

Wealth is making God the one and only CEO of your life. You will lack nothing when He is in charge of your life. Let me say that again, LACK NOTHING! That is true wealth. The word to describe my attitude regarding wealth would be "**Evolving.**" My idea of what wealth meant in my 20s is different from how I view it now. As time continues, my perspective and thoughts on the meaning continue to mature and expand. In my 20s, I thought the keyword to wealth was a substantial amount of money, and I assumed this was displayed in the form of expensive cars, big homes, and lavish trips. Ironically, I bought a 645i convertible top BMW at the age of 28. I had a big house and had the liberty to take trips but was far from wealthy.

Wealth is owning who you are. There was a time when I would show up to work to collect a paycheck, and I was content being a young woman in my 20s climbing up the corporate ladder just to be able to have a good quality of life. I would conform to what a professional woman should be and look like in corporate America. For instance, I would not wear ethnic hairstyles (natural hair). I was consumed with

wanting to please others, and I would second-guess myself. I had to unlearn and detach my mind from how the world believed I should look or act.

Mental Wealth is just as important. Mental wealth is when you no longer need decisions validated. I no longer believe wealth is working to collect a "Fat Check." My 7th-grade teacher, Ms. Reese, warned me to combine my passion with my career. Unfortunately, I didn't listen but her words stuck with me and now I understand. Being wealthy is connected to your purpose and God's will. I am finally ready to take a leap of faith and transition from my corporate position into my purpose. It's scary and uncomfortable, but I know this is the only way to create wealth for myself, my family, and future generations. Wealth is creating a legacy like never before.

What do you want God to accomplish in and through you? Write them down. Take baby steps and set realistic goals. This is a game of "hopscotch," not a "long jump."

- Are you confusing busy work with productive work?

- Are you dreaming and not acting? Faith without works is dead. There is a reason we must be doers of the word and not hearers only. Actions will bring you the clarity you crave.

- Are you being too frugal? Are you being impatient? It takes money to make money.

- Are you wrestling with yourself? IF so, STOP and cast all your fears to God.

- Are you putting limits on yourself? Do you understand that God is working sovereignly on your behalf? He wants to see you win, and He is waiting for you to make the first move. He doesn't need you to think for Him. Take a position and He has it from there.

- Are you facing your fears and the unknowns? If not, do it boldly because fear is only the enemy holding you hostage with an empty clip. You can do it!

Lolita Hanley

What doesn't break you makes you stronger. Death can make or break you. I decided to let it make me stronger. With June birthdays seven days apart, my mom and I shared a close bond. With her unexpected passing from pancreatic cancer, she left behind a lifetime of lessons. In the nine months that I became her caregiver, she used every opportunity to share her life story with me, birth new lessons, and leave a legacy to remember.

Coming from humble beginnings, she worked hard to become a best-selling author, successful businesswoman, and loving wife, mother, and grandmother. Affectionately known as Dot, she left her mark wherever she went. Her confidence, intelligence, and giving spirit transcend and inspire me to be a woman that she would be proud to call daughter. Her dedication to her family demonstrated love in action and set the example that allows me to love my kids, high school sweetheart (husband), extended family, friends, others, and God without conditions.

Always one to advocate for higher education, she would be proud to see her two grandchildren doing so well in college. Parenting these young men is one of the biggest joys in my life.

Mom – her love knew no bounds

"It's ok!"

Those were the last words she spoke to me, and they ring in my ear every day. She taught me to feel fear and do it anyway. These words of wisdom gave me the courage to open my own real estate brokerage firm in the middle of the 2020 pandemic. In honor of her birthday, we opened the doors in June 2020.

I live life with no regrets and understand that I am a small part of God's bigger plan. As I learn new guiding principles that force me to step out of my comfort zone, I rely on an amazing support team and am committed to learning how I fit into the latest part of God's plan – My finances.

Raising these boys has been my greatest joy

The scripture that guides me is Isaiah 43:19. It reads, "See, I am doing a new thing! Now it springs up; do you not perceive it? I am making a way in the wilderness and streams in the wasteland." My life mission is to keep my spiritual eyes open to what God is doing, even if it seems inexplicable or defies logic. It is in these moments that God changes my perspective and guides me on a specific path for His sake.

Shop Till You Drop

Growing up, I thought we were rich. We had a black Lincoln Continental, a burgundy customized conversion van, and my brother drove a mint green Nova. We lived in the suburbs in a detached single-family ranch with three bedrooms, a basement, and a full bath and the Christmas tree was always bursting with gifts.

When it came to shopping, my mom was one of the best. As a little girl, some of my fondest memories include traveling to California, Florida, New York, and Virginia to indulge in a variety of shopping experiences. We looked for bargains in some of the best department stores and malls in the United States. Some local department stores knew my mom on a first-name basis. They would even hold items for her in anticipation of our arrival on the weekend. At times, it felt like we had our own personal shoppers, and I loved every minute of it. Being able to provide all the things she could not afford growing up was her motivation, and I was a willing participant. I learned that a credit card and determination went a long way on the clearance racks at some of the finest Department stores. Even present day, it feels like hitting the jackpot when I find a quality article of clothing on sale in my size. For the duration of my school-aged years through college, my reward for maintaining A's and B's was shopping trips or money. So, for me, as a little girl, my indication of wealth was a house, cars, clothes, credit cards, and later, college.

As I still equated wealth with having credit cards, it was no surprise that I was approved for my first credit card at the age of 18. It was August 1989, the beginning of my freshman year — the Chase Visa representative set up a table in The Commons at VCU, and I think I was one of the first ones to sign on the dotted line. This was the first of many credit cards that were soon to come. I was not concerned with credit card interest, annual fees, debt, or how credit cards worked because my mindset was that rich people had credit cards, and I wanted to be rich.

Finding My Way

I later paid off all my credit cards and currently use a couple for their perks and rewards while paying off any balances immediately. For anyone who went through a Dave Ramsey class, you know the process.

As I got older, my parents' career advancements afforded them opportunities to plan, travel more, and buy bigger houses and bigger cars. I continued to watch how they spent their money, what they spent their money on and how they paid their bills. I am thankful for the healthy financial patterns I was taught and observed based on their actions and behaviors.

As a young adult, my ideas about wealth began to expand, although not to the degree of wealth accumulation. However, it now included making enough money to pay bills, live comfortably, shop and travel. As my mom and dad modeled the importance of job security and having a strong work ethic, my definition of wealth extended to stability. I did not realize that this also trained me, in some ways, to resist change and led me to play it safe for years because I was reluctant to take risks. I am just beginning to overcome the play-it-safe mindset.

Although I did not have a comprehensive definition of what wealth meant growing up, conversations about credit scores, paying bills on time, and maintaining a savings and checking account were the norm in my household. As an adult, I have applied these lessons and they serve as a strong foundation as I learn how to cultivate an even broader pathway to a wealth mindset.

According to the book, Millionaire Next Door, you are wealthy if your net worth is twice as large as your expected net worth. This definition goes far beyond my little girl definition of wealth — house, cars, clothes, cards, and college, but we will get into how to determine your wealth status a little later.

As my wealth mindset shifts, clarity and opportunities present themselves as if they were waiting for me the entire time. As this happens, my view of what the world and wealth offer, shifts. Knowing what wealth looks like drives me to increase my earning potential, create a positive cash flow, develop wealth habits, and define and meet greater financial goals. To me, wealth is a mindset that provides healthy boundaries and guidelines that lead to success. These guidelines position me to make wise decisions and sound investments.

Although I should have taken heed earlier, I am discovering the secret beauty of compound interest and leveraging. It is possible to position yourself in projects that yield a high return and create a positive cash flow that works for you while you are sleeping.

Imagine This? Freedom.

Freedom to be, freedom to explore, and freedom of thought.

A life where you can make wise purchases without worry and have more than enough to help others because you followed the appropriate paths to get there.

Strength in Numbers

The idea that only people with millions of dollars in their bank accounts are wealthy is conceivably the biggest misconception about wealth. Before embarking on this journey, I recall hearing that you need to know your net worth and what you need to retire comfortably. However, my knowledge stopped there, and I had no idea how to apply it. Present-day, knowing that number is imperative as I reach retirement age and desire early retirement. So, what does it mean to know your number? Where do you stand when it comes to wealth? According to the Millionaire Next Door, your number is your expected net worth compared to your actual net worth. The formula can be found by googling – Millionaire Next Door formula or wealth according to the Millionaire Next Door. If you are like me, you are in for a surprise. Knowing this number will allow you to acknowledge if you are falling short or meeting your financial potential. Once you know your number, you will be equipped to take action by learning key principles that help you build and manage your wealth so you can experience financial freedom. Knowing my number, I realize that I have work to do. I had to accept that I needed to change my view of money, start understanding its principles and adopt a wealth mindset. My goal is to become a Prodigious Accumulator of Wealth or PAW status, according to the Millionaire Next door. Equipped with this new wealth mindset, my beliefs are focused on a new target; therefore, my actions are headed in that direction. I know my number and have left my old post. It is time to move from being an Under Accumulator of Wealth to becoming a PAW.

It Takes Two

Until recently, I was comfortable with low-hanging fruit in my relationship with money. What I mean by that is going for things that come easily and settling. However, my mind is open to new ideas and opportunities to increase my earning potential in order to reach my desired net worth. In the past, my relationship with money was to play it safe, and that held me back. If I could pay bills, go on vacation, shop, and eat well, I considered myself wealthy. However, creating a wealth mindset allows me to see the world of money through a bigger lens. Money can be used for a purpose greater than us. When financial abundance is achieved, the idea of using it for good stirs an even greater passion in me to have a healthy relationship with money. As a late adopter, saver, and person with a low-risk tolerance, the idea of having a healthy relationship with money is comforting. Being around the right people and having a strong faith has allowed me to step aside and allow God into my worldview of money. It is time to pivot. My beliefs are now focused on the new target, and money is a welcoming and healthy part of it. My relationship with money is equivalent to a thriving relationship. Together, we will work through difficulties, have fun, learn life lessons, grow from mistakes, breathe in some fresh air, and enjoy new experiences that require me to step outside the box, or even better, recognize that there is no box. I will continue to nurture this relationship and give myself permission to have a healthy relationship with money.

United We Stand

Although I have always had a play-it-safe relationship with money, in my mind, I have been drawn to something more. My mind was always searching, yearning, and knowing there was more to learn and room to grow. Therefore, when the invitation came to join the club, it was a no-brainer. The opportunity to share ideas with other like-minded women was intriguing, as well as the opportunity to learn the fundamentals of wealth in a supportive environment with a team of professional women. Since joining, we continue to move collectively to build wealth as we learn new concepts about money and are introduced to professionals in the industry. This has all been attributed to a shift in my mindset. If you want the new thing, you must let go of the old thing — those old mindsets that influence how you think, feel and behave — "Now it springs up; do you not perceive it? (Isaiah 43:19) Before joining, I knew that I had gone as far as possible with the limited knowledge I possessed, and in order to grow, I needed to be around like-minded women with similar aspirations. Together, we have pooled our knowledge and resources to make sound financial decisions. I am all in. This invitation came at the perfect time.

Let There Be Light

My "ah-ha" moment came when I realized the impact it was going to have on my life, my family, and the life of others.

Family: The Major Why

I caught the vision. Initially, I accepted the invitation based on the merit of the founder. I heard the vision, but I was more in my subconscious mind. It was after having a dream about being able to help myself and others, as well as realizing that God had led the charge to present this opportunity, that I had no choice but to say yes. I realized that I was in the right place at the right time. Until recently, my relationship with money has held me back from taking more chances. However, with the energy created by our co-op of women and divine intervention, I have overcome this hurdle and am inspired to create wealth for myself and others. Our vision is a win-win for all, and that is one of the beliefs that I hold in high regard about wealth. As stated earlier, my idea of money was to have enough to pay bills, vacation, shop, and eat well. However, with this newfound passion for learning about wealth and creating a life that relishes in abundance, this former idea quickly fades. There is more to life, and I enjoy this new adventure and freedom that I can see just above the horizon. I live in the present moment with the idea of a better future.

Titus 2 Woman

"Older women likewise are to be... teaching what is good, so that they may encourage the young women."

I want my 20-year-old self to know this: You are epic! Life will be a series of unexpected lessons. Despite all the constant frustrations, you will have many hindsight moments that will propel you to greatness. Everything that has happened has led you to this moment and worked out exactly as it was supposed to. Don't change a thing — all the paths brought you here, all the people were meant to be, and all your successes, failures, and heartbreaking and heartwarming moments will be worth it. You are on your way to making all your dreams come true.

Don't ever settle for the easy way—as a matter of fact, just don't settle. Life is too short. And remember that this current version and all versions of you are accepted and loved by God, and that will never change. Permit yourself to chase your dreams and goals while you are young with fewer responsibilities. Invest for the future today and learn as much as you can about money now. Read as much as you can about developing a wealth mindset and continue to partake in the habits of wealthy people until you get to the next level. Put more in savings even when it's uncomfortable. Live beneath your means as you invest and find the path that calls out to you. As you do this, you will acquire money to invest wisely, accumulate compound interest, and continue to find your divine potential and calling. The people you meet will have an impact on you. Find mentors and like-minded people, and your confidence will rise as you develop and form healthy habits for success. These habits will include saving, investing, and reading, and will become a part of your life. Walk in wisdom. Knowledge is knowing, but wisdom is applying that knowledge. Follow your dreams. Be at peace with what has happened, is happening, and will happen. Navigate through the murky waters and follow the breadcrumbs to your true passion. Take the risk now to follow that passion and discover the seeds of greatness that are in you. Remember that there is a perfect plan for your life, even when it does not seem that way. So, make the most of what is in front of you, put these principles in place, and you will enjoy that sweet bank account sooner than you think!

You got this!

Cruising: Enjoying the fruits of my labor

One Word Can Make the Difference.

Fortune is the one word that defines my attitude regarding wealth. The Latin proverb "Fortune favors the brave" resonates within me. Those who are willing to take calculated risks and be courageous reap rewards that outweigh the risk. When I speak about risk, it is not just risk in business but also a risk in thinking differently, a risk in letting yourself evolve, and a risk to accept new ideas and beliefs to navigate a pathway to a healthier wealth mindset. When our beliefs change, our thoughts change, and when our thoughts change, our actions follow. While being brave means taking a risk, there are principles that are important to follow. A wealth mindset means spending less, making wise investments, and looking for ways to improve your financial standing with calculated risk. The good news is that anyone can develop this mindset with a bit of dedication. So, dare to take a chance and see what amazing rewards will follow.

Expand Your Vision

For the reader, I say, take the first step by making the decision to commit to changing your mindset. Faith requires you to take the first step. If you never get your feet wet, you will never know what could have happened, and you will never see the outcome. However, there is one thing we can know with certainty: 100% of nothing = 100% of nothing. In other words, 0%. Fight that voice inside of you that resists change, give something, and see what emerges. If it doesn't work, it is not permanent. There are many forks in the road. Try one road and if it is a dead end, turn around and go the other way. Create a vision board. See where you want to be. Where do you see yourself? What type of work are you doing? Who are you with? Are you traveling? To get what you want out of life, it will require you to be intentional

and take calculated risks. Choose to believe and watch for the rewards as you move in faith. I want to share a story with you. A story about an introverted, middle-aged African American woman who decided to step out on faith and do something different. She met 50 new women who were like-minded, goal-oriented, and ready to walk by faith. She joined an investment club and believed that there was more to life than where she was at the time. She is now a part of something bigger than her, and she wants to share this journey with you. Can you guess who that woman is? With a slight description change, this woman can be you.

Wake up each morning with a sense of purpose that allows you to be the best version of yourself. Be determined to do something new. We all took a risk when we joined this club. It does not always look the way we think it is going to look. But I have learned that:

"A journey of a thousand miles begins with a single step." —Maya Angelou

Are you ready to take that step with me?

"See, I am doing a new thing! Now it springs up; do you not perceive it? I am making a way in the wilderness and streams in the wasteland." — ISAIAH 43:19

Marion Uzzle

In 1970, I was in the sixth grade and excited to be preparing for the annual field trip to Jamestown & Williamsburg. We had recently moved from our brand-new home in a great community to a much smaller house in the projects with mouse traps and crawling bugs. My parents were newly separated, and our way of life significantly shifted. We were a family of nine with my parents and now it was eight of us without our dad, the breadwinner. The family plan was for mom as the Domestic Engineer (stay-at-home parent) to nurture the family daily and for dad to go to work. He had a great job as a foreman at a local warehouse which allowed him to support the family. I recall being so thrilled to go on this field trip. When my mom gave me the money for the trip, she softly said, "I want you to go but there isn't any spending money in the budget."

I heard her but I pretended I didn't because it was becoming common to hear that we don't have money for this or that after my dad left. I knew in my mind that on the day of the field trip she would have it. The trip day finally came, and we arrived at the school early in the morning as we were always punctual for school and church. When I stepped out of the back seat of the car and closed the door, I went to her window and said, "Ok ma, how much do I get?"

She looked me in the eyes with a tear and said she didn't have spending money. She turned away so I wouldn't see her tears. I stood frozen because I couldn't believe I was about to get on the bus with my friends and schoolmates without any money. I walked on the bus fighting back more warm tears running down my face. I declared in my mind that day that if I ever had children, they would not experience the hurt and disappointment I just felt due to a lack of finances because dad left. Fast forward years later, as a single mom, I held as many as three jobs at one time to make ends meet. The fear of that feeling repeating itself in my son's life is what I believe developed my strong work ethic. I was determined that his young life would not experience that pain.

Born the second of seven siblings, I was named after my paternal grandfather, Marion, and given my paternal grandmother's middle name Ann. It is an honor for me to have their names. My work as a CRA - Community Reinvestment Act, Mortgage Loan Officer, allows me to originate residential mortgage loans utilizing my knowledge in the areas of opportunities for affordable lending. For the last 20 years, I have been able to assist homebuyers and homeowners with knowledge and understanding about building wealth in the area of homeownership. My weeks and some weekends include teaching homebuyer education throughout Hampton Roads and sharing knowledge about grant opportunities to assist with down payment and closing costs. These classes also include money management and of course credit management. As a single mom at that time with one son whom I love with every fiber of my being, I wanted to put an end to renting and purchase a home to position us so that he would have a better opportunity for a safer environment to live and grow. Purchasing my first home nearly 30 years ago, I wasn't aware of these programs which I qualified for. Since I didn't have enough money saved for a down payment, my only option was my 401k plan. Due to my personal experience of not learning about the financial opportunities available, it is my mission to ensure that I share all that I know wherever I go to give a hand up to others looking to purchase or refinance a home. I believe that it is essential to give back, and I enjoy the opportunity to do so in the form of education. The topics are easy to digest and interactive.

A few years ago during a conversation with my Senior Pastor, Dr Geoffrey Guns at Second Calvary Baptist Church, he agreed that it would be ideal for the surrounding communities to attend the homeownership classes at our church. He believes that it is critical to bring awareness through education to understand the process. Homeownership is a way to increase your net worth and gain wealth. As of August, 2022, household wealth among homeowners is a whopping 1,469% higher on average compared to renters, excluding home equity, making the allure of homeownership even more enticing.

When I was a young girl, my perspective of wealth wasn't part of my vocabulary. I thought people were rich when they gave to families like mine. I was happy to have lots of siblings because you always had a play mate. We didn't have the disposable household income to splurge on buying new clothes and shoes. Our nice clothes and shoes were to be worn on Sundays for church. My mom was a great seamstress, so she made a lot of our clothes. We received gently used items often. Because my family experienced food and clothes from the hands and hearts of other caring individuals, I believed others were wealthy if they could give to the less fortunate and not miss their belongings. My prayer was to be able to do the same one day. It's never too late for a random act of kindness or an intentional one for that matter.

My definition of wealth has changed with experience. In 1983 the median family income was $24,580. That was the year I began working as a server in the Phillips Seafood Restaurant in Norfolk, VA. I felt a sensation of wealth when I started to receive weeks of big tips. I remember feeling excited to count it night after night to deposit it into my newly established bank account. Having $100 a shift in tips was exhilarating. I was determined to make sure I was the best server ever!

I worked every shift assigned to me. I worked for others who chose to pass up their shift. My thoughts told me that those who passed up their shifts must be well off if they can consistently choose not to work. As a server, you meet people who travel from all over the world. That is when my motivation to travel grew. I had a strong drive to work to earn more and save more. My first bank account was opened while working at Phillips, and to date, I have the same account with the same bank. I knew then that one day I would achieve the things I dreamed of. Being disciplined with my earnings and savings became a weekly priority. I often prayed for understanding of where I was financially and where I could possibly be. I asked myself whether I should be striving for higher earnings. Am I making good use of my time, energy, and money? Is it time to speak with someone that can tell me what to do with my humble earnings? Becoming financially fit is a process, as is becoming physically fit.

I now know that your health IS your wealth! Having consistent habits of maintaining good health is important to my financial success. A vital component of my wealth journey is learning to feed my body, mind, and spirit properly. I strive to have a healthier diet. I focus on daily affirmations. I set aside time to pray and meditate.

I thought being wealthy was a privilege that women and those of my ethnicity dared to believe was achievable since that was not the model I saw in my community or on television. Women work extremely hard to succeed, but acknowledgment is not often received. I frequently think of opportunities to grow financially. How can I become a woman of wealth? Invest more? Buy fewer finer things? Utilize professional, financial support? Invest in my physical and mental health. I will implement these and more into my planning goals as best practices.

How do I know my number/my net worth…Since joining this group of phenomenal women we have been introduced to ways to look at our finances more strategically. In determining my net worth I took my age and multiplied it by my total income and divided it by 10 and looked at that number. I did it again to be sure. I have some work to do! Knowing my number is not enough; learning how to plan to increase it strategically is the key. Dr. Geoffrey V Guns often suggests living often increase it strategically is the key. Dr. Geoffrey V. Guns often suggests living off 30% of your income by tithing 10%, saving 10%, and investing 10%. The Bible says *"the blessing of the Lord establishes wealth and difficulty does not accompany it."*

In 2013, I wanted to start a business as a real estate investor. I was already a landlord and figured it was time. I shared my dream with my dearly beloved husband and explained my plans during one of our crisp morning walks. As the wind blew in my face and my mouth felt dry, I was determined to get my vision out to him. To my expectation, he said no. With more knowledge and information, I still heard no for the next two years. During the second year of 'no', I met with a friend for a usual dinner. We laughed and talked about events and business. She unexpectedly shared the same interest about real estate investing and that she had just received her new business license to

do the same so naturally I was convinced it was time. Neither of us knew that we were each focusing on building a real estate portfolio so in my mind this has to be confirmation! The search for the first investment property is found to purchase, renovate and sell. It was so exciting and scary at the same time! The numbers were attractive, so I used my personal savings, brought the property, hired the contractor and the journey began. Things were going great! One evening my Realtor called as she often did. She started with "Are you sitting down and are you somewhere that you can talk?" I said yes and she said, "turn on the television." Her voice dropped and softly she said, "I'm sorry to tell you that the house is on fire and it's on the news." I looked at the TV screen and I immediately lose all consciousness seeing the house up in flames, my mind left me, my heart skipped a beat, the blood rushed to my face, my mouth felt dry, and my foot trembled. None of these things were happening to me because of the house being on fire but because I had not told my husband that I proceeded despite him saying no not yet. I hung up the phone and went to pray. How would I tell him? How do I explain things from the beginning to that moment?

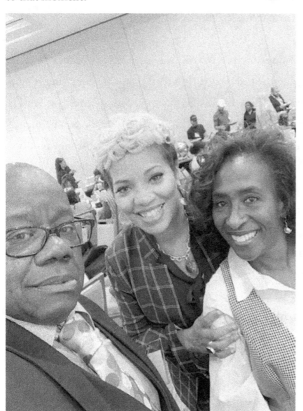

Dr Geoffrey V. Guns, Dr Angela Reddix & Marion Uzzle attending Urban League of Hampton Roads event 08/30/2022.

So many thoughts of sheer disappointment in myself ran rampant in my mind. I had no words. I felt guilty. I went to bed but couldn't sleep. I had a pity party. I had to fight off the heaviness I was feeling because that would not bring forth an answer. I awoke in prayer and partial solution mode. During my pity party, I was thinking of who I needed to contact for the next step. My mind automatically goes into solution mode when I have a problem so the pity party was intermittent. I love a good party but this one I couldn't let consume me. It was a long and arduous process. During this time of digging myself out of the pit, I was forced to gain more knowledge about how insurance works, what the fire department expects with appointments and reports, what each attorney requires financially and in detail and so much more. In all thy getting, get understanding is what I kept repeating to myself. I began to feel lifted. While all of this was happening, I discovered another property I wanted to buy. I thought to myself what are you doing? This was the solution...keep busy. After careful consideration, reviewing the numbers, preparing the scope of work, and prayer, I did it. I closed on it and the carefully selected contractor began the rehab work. By this time my husband was on board working side by side as well as other family members. Oftentimes I look back and think how was I able to stay on this journey in the middle of all the chaos happening? How did I continue to make these financial moves in the middle of this humongous crisis? How was I able to keep my mind together going to work as a loan officer and managing the construction of another property while dealing with the legalities of the first one? What was it pushing me to stay laser-focused on the goal? I went back to my intimate prayers with God and my quiet time seeking direction. I thought about my vision board I created in 2008. It included purchasing multiple properties. It also included one of my favorite scriptures, Jeremiah 29:11 "For I know the plans I have for you," declares the LORD, "plans to prosper you and not to harm you, plans to give you hope and a future". This means that it is not a promise to immediately be rescued from hardship or suffering, but rather a promise that God has a plan for our lives regardless of the current situation. I have found myself being freed from heaviness that should have lasted longer in situations that were unimaginable. I know it was the hand of God showing mercy during those times.

The second house was beautifully completed and sold. My husband had a lot of input on this one. It was during the rehab of the second house that I confessed to him and spilled the beans on everything about the first property. We drove by the location of the first house that was no longer there as I gave detailed descriptions of that journey. It was now just dirt and a partial fence remaining. It was sold to an investor who built a beautiful, brand-new home there. I painted the entire picture from beginning to end about what happened. He was

more involved with the vision and the process coming together by that time and agreed that he would not have been ready to process it all in the beginning. I felt that and needed to hear him say that as well. Many more properties have been bought, renovated, and sold that he took charge of and I am so thankful that it has worked out that way. I have had many financial missteps in my life and realize that it is ok to not be ashamed of the missteps on the journey of life.

Joining this fantastic group of women is one of the best decisions I have ever made. We are in the room and are collectively making financial moves that will be game-changers for years to come. I flipped through my mental Rolodex seeking a mentor before joining the group to fulfill various areas in my life. What I have gained has far exceeded my thoughts. I was seeking one but received many. The topics we discuss are rich and respectful. Our leader, Dr. Angela Reddix, is fierce yet humble, powerful yet transparent, and no-nonsense. She also fully respects your time! It is a grateful feeling to be here. When I learned that one of the group's goals was to work toward closing the gender wealth gap and placing a high concentration on developing women financially, I knew I was in the right place for financial growth. A McKinsey & Company article says,…Women are the next wave in US wealth management. The good book says "*whoever gathers money little by little makes it grow.*"

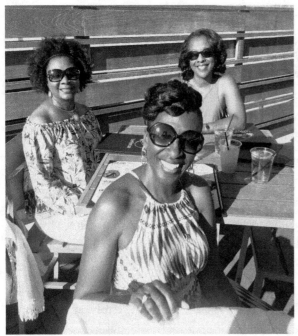

Supportive Women with me - Stacey Carter (homeschool mom of two college graduated sons/one daughter) Angelia Williams Graves (Realtor/Broker/Member, VA House of Delegates)

The power of investing is a fruitful way to put your money to work for long-term growth. Smart investing is a great way to allow your money to outpace inflation while increasing in value. I experienced an Ah-Ha moment during one of our impactful meetings when a female-owned company pitched its business to us for capital. They presented the product, gave statistics, and had samples for tasting. They shared their passion and provided a great presentation. Afterward, we deliberated and followed parliamentary procedures to conclude a final vote. Each person that had input gave it, and it was professionally received and noted. It was a fascinating experience. I thought, ah ha, this is how it happens when you are IN the room.

What I would tell my 20-year-old self… Prepare your mind for strength to achieve new goals. Stay open to learning new things and remember that in all thy getting, get understanding. Be watchful of financial obstacles as sometimes they are driven by emotional thoughts. The thoughts you have about money can propel you or hinder you. Money is essential, but only in the context of how it will serve the goals that you create for the future. Spend time getting educated about finances and how they work. Don't be ashamed of past mistakes; we all have them.

Treat yourself the way you treat others. Love yourself more and more each day. Take time to pamper yourself. A healthy body is a healthy mind. Refrain from comparing yourself to others since everyone has their own race to run, your mental and physical health are both vital to the success of your plans.

Take action, speak with a wealth management advisor to start or review your financial goals, reach out to an insurance agent for avenues of strategic investing, increase your deferred compensation contributions, seek guidance to improve your credit scores, reduce spending and increase savings, get pre-approved for a mortgage loan to buy that new home. Buy investment property to become a landlord.

Keep supportive women close. Trust your instincts and stay focused. In the school of wealth creation, there is no such thing as a dumb question. Make every day a learning process as it gets better along the way. Be prepared, as anything can and will come up. On your journey to financial freedom, you may stumble and fall but get back up as the race is not given to the swift nor to the strong but to the one who endures to the end.

The one word I would use to describe my attitude towards wealth now is Becoming. Even with talks of inflation being on the rise, interest rates increasing, and limited affordable housing, these obstacles will soon turn the corner as they often do. When it comes to

wealth, I trust that when it is obtained, the future is secure, and life is experienced through a different lens. I am becoming more connected with talks of inflation being on the rise.

Good things are happening on this road of life, and most experiences will work out for the best. I am becoming a better version of myself which enhances my thought life daily. I love positive affirmations as they constantly bring forth a smile! I am excited about greater opportunities that are coming my way! I will continue to make short-term sacrifices to achieve long-term goals and then maybe just maybe retirement will come sooner and be more fruitful! I want to sow good seeds to reap a full harvest. In essence that's my focus for wealth creation.

I currently reside in Chesapeake, Virginia with my husband of 22 years. We have a beautiful, blended, and extended family whom we love dearly!

In conclusion, speak those things that are not as though they were.

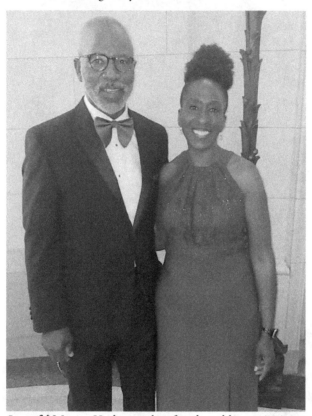

Larry & Marion Uzzle attending family wedding 09/27/2019

Michelle Brown

My life began in Ironton, Ohio, a small town in southern Ohio, nestled along the Ohio river, bordering Kentucky and West Virginia. An industrious community where everyone knows your name, and the median income is around $35,000 per family. I am the daughter of Paul Jackson and Helen Brown, two parents who could not be more different when it comes to financial resources. My dad always held corporate, white-collar positions. He worked for the same company all his career and retired after 40+ years there. My mom also worked all her life in various hourly positions. She was a counselor at a group home, a store clerk at a jewelry store, and retired as a corrections officer at a juvenile prison. I lived with my mom growing up, and all my life, we lived with or within three blocks of my grandmother, Alma Sanders Brown. My grandmother was, and still is, everything to me. Do not get me wrong; I have great parents who were both very present in my life. Both my parents and my grandmother played a role in shaping my beliefs about money. So much of who I am and how I think about money is because of their example and all that they taught me.

My life was very full growing up. My mom was resourceful. If there was a free or subsidized program, she signed me up. I took full advantage of everything available to me. From Girl Scouts, the Boys and Girls Club, Operation Be Proud, church groups, and sports groups, you name it, I did it. I still do not understand how my mom and grandmother made ends meet and ensured I had the life I had.

Michelle's parents, Paul and Helen

As a young girl, I observed many indications of wealth and lack thereof. The first experience I remember happened when I was in kindergarten. My mom was a single parent, and she was working at the local jewelry store. Based on her income, we qualified for social services, one of which was free lunch. At school, during lunchtime, the teacher would line up the class according to how we paid for our lunch. If you paid for a lunch, you got a solid blue chip; if you got reduced-fee lunch, you got a chip with one hole; if you got free lunch, you got a chip with two holes. Mind you, this experience was nearly 40 years ago, and I still vividly remember it. I was not upset about qualifying for free lunch; instead, I was most upset about not having the same chip as my best friend. The teacher separated us in the lunch line, and I hated it. I remember going home and being sad. My mom told me not to worry and that she would fix it. From that day on, my mom paid for my lunch. How did she afford it on her salary? God only knows. But she did it so that I could be in the same line as my friend. I always knew that my friend lived in a bigger house than me and that she had a dedicated playroom for all her toys. Her father was a local attorney in town. As a child, I never associated any of that with wealth or better than; it was simply different from my house. My friend came to my grandmother's house and the apartment where my mom and I lived at least once a week. I never felt shame about my home setup. But the experience at school was the first time I was acutely aware of our differences, yet I did not fully understand why — not at that time. Nor could I understand the financial stress that decision must have caused for my mom. To her credit, my mom never complained or stressed to me about money. Now that I am old enough to understand

how little she made and how much things cost, I have a deeper appreciation for what she did. I will always admire my mom's selflessness and sacrifice for me.

My mom and I lived in the housing project until I was around 7 or 8 years old. To me, I thought of projects as apartments. It was not until I was much older, possibly when I was in college, that I became aware that housing projects were subsidized housing for poor people. Many of my friends and family members lived in the housing project. I never associated living in the projects as meaning that we had less. My Uncle Bill and Aunt Loretta had the most beautifully decorated apartment in the projects. I always dreamed of having a home that looked like theirs when I grew up. My mom also took pride in making sure our apartment was well-kept both inside and outside. She planted flower boxes and hung wreaths on our door. She also had a reputation for chasing away the kids who liked to loiter outside of our doorsteps. My mom is a quiet, mild-mannered woman. She stood about 5'7" tall, and she was very slender. She was not a big physical presence at all, yet she was not intimidated by the teenagers and young men who physically towered over her. She would always remind them that she had me, a child who lived in the house and that they should respect her and our property. She instilled in me the importance of taking pride in your home and your neighborhood and wanting the best for yourself regardless of your circumstances.

I learned the value of saving from my grandmother. When I was born, she opened a savings account for me. Anytime I came into any money — winning at bingo (I will share more on this later), birthday gifts, money for making the honor roll, or from odd jobs - I always gave some to the church in my offering and deposited some into my savings account. If there was anything I wanted to do, we saved. Saved enough to go on the trip, saved enough to look nice while I was away, and saved enough to have spending money. My grandmother taught me never to leave home without money in my pocket.

My first big financial win came in junior high school. It was a tradition in my family to go to the bingo hall at the local Catholic church. Although I was underage — maybe the laws were different in the early 90s – I was allowed in to play a bingo card. My mom and grandma both played multiple cards. I only had one sheet, and each of them watched over me to make sure I dabbed all my numbers. On this particular evening, I won the last game of the night — the cover-all. The prize was $1000. $1000! You would have thought I died and went to heaven. As with tradition in my family, the winner always shares their winnings with the people you came with, so I gave a part of my prize to my mom and grandma, and our two bingo companions. My grandmother also made me give to my older cousin who lived with us and my two uncles who lived nearby. I then had to tithe and put half of my remaining balance into my savings account. I was able to keep the rest for

Michelle, and her grandmother, Alma, traveling to visit Michelle's father in California

myself. Before I went to the bank to make the deposit, I took the time to iron each one of the dollar bills. I was determined to make sure each bill was wrinkle-free and crisp. Very crisp.

As an adult, my perspective of wealth is vastly different from what it was growing up. My first taste of extravagant wealth happened when I left for college at Duke University. This was my first time being in a community of wealthy people. In my town, some select families had money. They lived in nicer neighborhoods and bigger houses; however, I never wanted these neighborhoods because my mom would tell me the stories of her childhood when Black people were literally not allowed in those neighborhoods. At Duke, I was surrounded by real money. Tuition, room, and board at the time were over $50K a year — nearly double my mom's annual salary - and to my surprise, 60% of the students could afford to pay the full tuition without financial aid. I lived in a triple dorm room, an intentional choice to save money, and held a work-study job all four years. Neither was the norm for my classmates.

In my first-year dorm, they posted our names and hometowns outside our dorm room door. One of my dorm mates was from Georgia, and I asked where. He was from the country of Georgia and was the son of a prominent political leader. From that interaction, I knew at once he was special, and I also learned Georgia was a country. A place of which I had never even heard. I later learned that other kids

in my class had prominent parents. Their parents were CEOs, business executives, prime ministers, senior government officials, and even royalty in their home countries.

Before college, I was not self-conscious about what I had or did not have, but the differences became clearer on campus. I could not afford to fly home during our breaks. At first-year student orientation, they gave us a picture book of all the students in the first-year class, around 1,200 or so, and it listed our names and hometowns. I scoured the book to find anyone who lived within an hour of my hometown (there were three of us from the area), and I reached out to ask if we could carpool home. I remember two girls in my dorm making fun of me for doing that.

In my hometown, the nicest department store growing up was JC Penney and Harmon's, a local family-owned store. Never had I heard of Saks Fifth Avenue, Lord & Taylor, or Neiman Marcus. When formals came around and the girls were shopping for dresses, those stores were not an option for me.

I made friends with a woman from New York City, who often referred to her "apartment" back home. I was surprised that someone as sophisticated as her lived in an apartment, not a house. For a small-town girl like myself, I associated apartments with the housing project where I once lived. Nothing wrong with an apartment, but it is not anything fancy. A house was the housing standard that I aspired to have. I later learned that apartments in New York City are very fancy and quite expensive. To the tune of multi-millions of dollars fancy. My friend lived in Manhattan. Her father was a senior partner at a consulting firm, a career I had no understanding of or familiarity with at the time. She was wealthy. Her apartment was nothing like the housing project.

When I graduated college, I accepted a job with an annual salary of $39,000. Hard to believe this was good money at the time. When I got the offer, I had simultaneous feelings of happiness and extreme guilt. I knew my mom would be so proud, yet I felt guilty because I knew my starting salary was more than what she earned despite working her entire adult life. Four years prior, when applying to college, I filled out the requisite forms to qualify for financial aid. That was the first time I saw the amount of money my mom and dad made from their respective jobs. To this day, it still seems wrong to me that I, as a young adult with a college degree and minimal work experience, was paid more than my mom, who worked her tail off picking up hours, working overtime, doing much harder work than I ever did in my first professional job.

From my time at Duke on, I have continued to be around people with more financial resources than me. I often say that life was better when I was poor because I did not know any different. I was not aware of what all I did not have. That may sound crazy, but growing up, most people were working poor. Certainly, some people had less than me, and those who had more. But none of us had an extravagant amount.

After Duke, I moved to Dallas and was introduced to "old money," both the expression and people with generations of wealth in their families. Then I was off to the University of Michigan for business school, exposed to high-paying careers, and reset my financial aspirations. Before business school, I knew doctors and lawyers as high-earning, prestigious careers. Jobs such as management consultants, investment bankers, private equity, and entrepreneurship were less familiar to me, not professions I seriously considered or desired. Upon arriving at business school, I soon learned that many of these roles were the most coveted among my classmates.

Upon graduation from business school, I landed at Bain and Company, a top-tier management consulting firm. There were countless days at Bain that made an impression on me, and one such day was when the Forbes billionaires list came out. There was a buzz around the office, and I learned that one of my good friends at the firm was the son of a man on the list. Soon after, I came to realize that many of the people who started with me at the firm were the offspring of very wealthy parents, including a woman who is now one of my best friends.

My job at Bain came with a six-figure salary, a significant signing, and annual performance bonuses. I remember the days when I dreamed of making $50,000 a year and thought that $50,000 was "making it." The year before I left the workforce to attend business school, I achieved my earning goal and made $52,000 a year. Mama, I made it! Fast forward just two years later, I was earning four times my dream amount. Yet, I was beginning to be conditioned to believe I was not earning enough.

I have shared many stories, yet I still have not answered the question: How do I define wealth? In short, it is complicated. Wealth is money; it is assets; it is access and experiences; it is also unattainable. My experience has been that no matter how much money and wealth one has, they want more. Even for me, a self-made "millionaire," I do not feel wealthy or as if I have enough.

The exercise of reading *The Millionaire Next Door* and calculating my wealth number was meaningful to me. So much so that I recalculated a couple of times because I did not believe the result. I even calculated an extreme scenario to confirm my answer. I really enjoyed reading the book. I know I started by saying most of the people I grew up with were poor, and it is true that almost everyone in my neighborhood had about the same number of financial resources as my family and me. However, there were a few families in my hometown who had significantly more. They lived in more manicured neighborhoods, they had multiple cars, and their kids had Liz Claiborne purses and Guess jeans — the ultimate status symbols of my childhood. Reflecting, I imagine these families quite possibly were the millionaires next door. They were the local doctors, lawyers, and the family that owned the McDonald's franchise, the Pepsi distributor, and the owner of the local grocery store chain. The truck driver who owned his own truck. None of these folks flaunted their wealth. They had access to different things than me. For instance, there were only a handful of foreign luxury cars in my town growing up. My dentist had a Mercedes. A judge drove an Alfa Romeo. I saw a BMW on occasion. I knew these things were unique, but I never wanted them. The nearest foreign car dealership was more than two hours away, and at the time, I thought going that far to buy a car or for car service was impractical and not desirable. The well-to-do people were members of the country club and members of Sta-tan, the local pool, but again, I heard stories from my mom about not being welcome there – Black people could not go when she was growing up – so the things they had were never the desires of my heart. Why would I want something that my mom and her friends were prohibited from enjoying?

Back to my number, I was a PAW, a prodigious accumulator of wealth. This ties to my childhood and my grandmother's early lessons about saving. My mother is also a saver, so my grandmother taught us both. If you do not have enough for what you want, save up, and that is what I have always done. For every job I have ever had, I always paid myself first and put a percentage of my earnings into my savings. Once I got corporate jobs, I maxed out my 401k's and then learned from the likes of Suze Orman and my dad about the importance of having emergency funds for at least six months' worth of expenses. Because I never wanted to be poor again, I always had access to more than six months on hand. As I had access to more financial resources, I learned that cash on hand, even in an interest-earning savings account, is not the most productive use of my money. Because I am who I am, I feel more comfortable always having access to cash that is liquid and immediately available to me. I keep more cash on hand than my financial planner advises, but I am now more diversified in stocks and other investments. However, for the first time in my adult life, I am actively spending down my savings.

I left my high-paying corporate job to take a breather. Covid hit in the two years preceding my exit from corporate. We all have stories to tell about how the pandemic affected us. As a Black woman executive in the airline industry, it was a tough time for me. Both my community and the industry I dedicated twenty years of my professional life to, were dying at an alarming rate. At the same time, I lost two personal friends, which caused a moment of reflection for me. My best friend from childhood, a woman I have known since elementary school, lost her brother tragically. He was a local celebrity with a larger-than-life personality and was only three years older than us. He was not supposed to die. Less than a year later, one of my dear friends, who was the same age as me, also passed away suddenly. She was the CEO of a booming hair care business and my sounding board for all things personal and professional. Both losses were a wake-up call for me to live the life I wanted, not the life people expected of me. I decided that at this moment, the grind of being the senior-most Black woman at a Fortune 100 corporation was not the life I wanted to continue to live. As I author this story, I am now five months post my corporate departure and pregnant with my first child. Never did I imagine my story taking shape in this way. I am a person of faith and trust God's timing. This is exactly where I am supposed to be.

I describe my current relationship with money, as the kids say, as a situationship, an entanglement, and it is complicated. I know what it is like to not have much money and to have a lot more money than many, yet significantly less than some. I constantly ask myself when is it ever enough? I fear running out of money and being poor, even though my life as a child when I was poor, was quite good. I am not sure why I fear this outcome so much. As a former executive, having lived in big cities, working for prestigious firms, and associating with people who have a lot of money, I often question if I should aspire for that too. I am a capitalist; I believe in making money. Where I differ from others is that I am anti-maximizing profitability. I do think there should be a limit on what is enough.

Do I believe one should be able to make a profit by supplying a product or service? Yes. Do you need to squeeze every cent of profit in the process? No. But where is the line, and who decides what is enough profit and what is too much? I do not yet have the answers to these questions. Personally, I believe all employers should pay a living wage. I aspire to eventually run or own a company that employs other people. When I do, I will share the profits of my business not only with shareholders but also with the staff.

Michelle with her son, Jackson

I took the leap to join the RR Fund because I believe in the mission. Women who share knowledge on finances, invest in other women-owned businesses and create more women millionaires. What is not to love? I remember when my cousin called me to pitch the club to me, and we bonded more deeply at that moment. I have always admired my cousin and the moves she is made in her life. She is an executive connected to our family, friends, and faith. Our family, the Jackson Family, is remarkably close. Her mom and my dad are siblings. Siblings number 9 and 10 in a family of twelve. The Jackson family is big, loud, and complex. We talk about many things, but money and investing are not common topics. Why? God only knows, but my cousin and I are determined to break the cycle.

My most significant ah-ha moment since joining the RR Fund has been a lesson in leadership. To be an effective leader, it is important to have clarity of vision and a focus on executing your plan. Dr. Angela Reddix, our club founder, had a vision for this club, and she went after it. As I get to know her better, I am learning that she has a history of being clear in her ideas and committed to the delivery. The learnings I have gained by watching her work have been as valuable as the financial knowledge gained from the group. Our group is incredible; multiple business owners and other professionals. People always make strong contributions that educate me on a topic that I am unfamiliar with or cause me to think about a topic from a distinct perspective. I joined with the intention of building wealth and paying it forward, but there have been many more lessons and learnings from this experience.

Based on what I have learned, I would tell my 20-year-old self to simply start by taking some action. She should surround herself with other investment-minded people and ask them questions or commit to learning together. I would remind her that no amount is too small to invest, and money compounds over time. I would tell her to buy life insurance and try starting a business to understand if entrepreneurship is for her.

For all of you reading this, my hope is that you are inspired to act.

• First, educate yourself. Read *The Millionaire Next Door* to get started. Know your number.

• Second, protect yourself. Max out your 401k. Contribute to an interest-earning account every month. Take steps to allow your money to work harder for you.

• Third, build your network. Hire an accountant and financial advisor, and eventually, an estate attorney — taking this step to build your team may require patience and perseverance.

I knew for years that I needed a team yet did not know how to find the right professionals nor did I know what questions to ask of them. The RR Fund did educate me on what to expect from a financial advisor and how to vet them. Oh, how I wish I were a member of the fund years ago when I initiated my search! Talk about money strategies with people who have money. Who are the millionaires next door in your network? Ask them how they did it and get referrals for professional services. You do not have to talk about the balance in your account. Instead, talk about your money strategies. How are you planning for retirement? How do you prepare for taxes? How are you investing? How are you protecting your estate, with a will or a trust? It is not about how much you have but instead the actions you are taking.

You go, girl. You've got this.

Pamela Katrancha

My name is Pamela Jo Salem Katrancha. My mother wanted to call me Penelope and my father disagreed. They settled on Pamela. He called me by my full name, never Pam, like most other people except my Uncle Max, who insisted on calling me Pammy. My mother chose my middle name for no other reason than she thought it went well with my first and last name. My Aunt Josephine, my father's older wealthy sister, thought I was named after her. As a result, she showered me with lavish gifts, much to my mother's delight. By the way, since college graduation, I have preferred to be called Pamela and it is the name I use as my signature.

I grew up in Johnstown, a small town in Western Pennsylvania. I liked the area because it was a melting pot of many ethnicities and the first question you asked a new person you met was, "What are you?" Their answer indicated their nationality. I delighted in responding when asked what I was, "I'm 100% Lebanese, both sides, all the way back." And for me, all the way back meant to the Phoenicians, according to my mother who was also proud of her heritage.

I've been spelling my married name, Katrancha, since my wedding day. My husband is 100% Croatian, on both sides, I suppose all the way back to Constantine. I got married before women maintained their maiden names. Instead, I spell and pronounce mine constantly and sometimes just shake my head and chuckle at the mispronunciations.

If I sum up who I am as a woman, I am the daughter of a brilliant and beautiful mother who, in her own mind never attained all that she wanted to become because of restrictions imposed by her parents that led to her getting married at age 21. She gave birth to four children (I am the oldest) and divorced my father before their 20th anniversary, which was not typical in her generation. She did go on to have a successful career as an auditor for the United Mine Workers, a position that required a master's degree, although she was hired without the degree. She enjoyed many friendships but never remarried. She lived to be 86, while my father died at age 64.

I had a loving relationship with both of my parents until the day they died. I continue to have a loving relationship with my three siblings. I have discussed some of the painful aspects of our childhood with each of my siblings separately but when we are together, we choose to reminisce and laugh a lot about the happier times. If the truth be told, I worried internally as a child but "whistled through the graveyard" and "put on a happy face" for the public and my younger siblings. Don't get me wrong, I enjoyed life, but I was afraid to feel too comfortable for fear it would all end soon.

As a child, I learned the "happy face" behavior when I was in first grade. The summer before first grade, we moved to be closer to my mother's parents. On Halloween, my mother would not allow me to go trick-or-treating with my new best friend. The next morning, I heard whispers between my mother and my aunt, but I did not know what they were saying. When I went to school, my teacher was crying because my friend died. My friend was found murdered in the cemetery which was located within walking distance of my home. No one ever talked to me about the incident. I used my imagination, at least as much of an imagination as a first grader could have, and decided my friend was strangled.

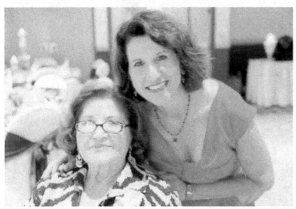

Me with my mother

I always remember my friend on Halloween, a holiday that I've never prevented my own children from celebrating, or trick or treating. While thinking of her three years ago, I decided to Google her name. I never expected to find any information. Much to my shock, the first thing that appeared was an image of her school picture. I was afraid to look further but I did and finally found out what happened to her. The newspaper article and the court case were right there for me to read. I was home alone the day I made the discovery. I was both shocked and upset to find out she was kidnapped by a previous sex offender, who was also a local repairman and retired merchant seaman. He apparently passed out on top of her, and she suffocated. I know I've carried my version of this story with me all my life and now knowing the whole truth, I realize it influenced the way I've dealt with fear, which is still a bit like "whistling through the graveyard" and putting on a "happy face," but in a more mature way. I am sure my mother thought she was protecting me. I knew something bad happened, but now I know what truly happened.

My mother's best friend was my Aunt Peggy. She wasn't really my aunt. She was my mother's childhood friend. They met in second grade and remained friends until their deaths which came to them in their mid-eighties within a year of each other. Peggy married Uncle Walt (not a real uncle either). She was a banker, and he held an upper management position with US Steel. They lived comfortably and I remember when they built a new home, it was the biggest house I had ever seen. They had no children. When my sister and I were invited to spend occasional weekends, we felt like we were staying in a mansion. I also remember looking forward to our visits and feeling safe at Aunt Peggy and Uncle Walt's house.

All our neighbors and friends lived more as we did, with one exception. We rented houses, and they all lived in modest houses of their own. Like the other moms, my mother did not work outside the home. While the other fathers were primarily blue-collar workers, either employed in the steel mills or the coal mines, my dad dressed in a coat and tie and wore a fedora and spectator shoes. He was gone for two weeks at a time and took an airplane wherever he went as a traveling salesman. I liked the fact my dad was different from the other fathers. My parents went out dancing on the weekends when he was in town. My friends were in awe of my parent's lifestyle. Although I realize it was more comfortable to think of my father's life as glamorous rather than the cause of our struggles, I remember hearing a landlord threatening my mother because the rent was not paid. He continued to shout at her while she was crying. My father was out of town at the time.

There was not a great deal of communication regarding our family history. I loved eavesdropping on conversations that taught me things I would not have known otherwise. For instance, my father came from a wealthy family that owned a hotel, restaurant, and convenience store. His family had a car and took their children on international vacations. I was so impressed but not as impressed as my mother, who benefitted from the Lebanese custom whereby the groom's family paid for the entire wedding, including her costly wedding gown. The most significant aspect of my father's family history is when his father died at age 45, he left his wife, my grandmother, to finish raising eleven children and manage the family business. She did so with an iron fist and lived to 83. I don't remember ever receiving a hug or kiss from her.

You might say my mother almost came from a wealthy family, or so the eavesdropping goes. My mother's father went to Lebanon in his early 20s to find a bride. My grandmother was a fifteen-year-old daughter of a Sheik (the equivalent of a mayor). I am not sure of the source of my grandfather's money, but somehow, he was able to take his new bride to Europe. They vacationed there for several months before returning to the states where they started having children right away. My grandmother had eleven pregnancies, but only seven of the children lived. Five of her seven children were born in a six-year period. My grandmother died at age 54 of uterine cancer.

My mother's father was a gambler, and it is assumed he gambled away the family wealth very early in his marriage. It is also alleged; his fingerprints were in the FBI files due to being caught producing moonshine. Nevertheless, he ended up working in the steel mills to

support the family, stopping at the pool hall most days on his way home from work. He lived to 63 and moved in with my parents after my grandmother died.

As an adult, I do not consider wealth to be what others have or do not have. I consider it having enough to feel financially secure and the ability to get what you need or want without feeling greedy or gluttonous. Wealth is about the ability to donate to causes you support. Wealth is seeing your name as a contributor in the back of a program of an event you enjoyed attending and knowing you gave more than the price of a ticket. Wealth is making wise purchases and investments and feeling proud of yourself for spending responsibly. Wealth is being able to provide gifts to loved ones. Wealth is being generous with your time, talents, and finances.

Knowing your number means "getting it" when it comes to being on top of your own situation, whether as a business owner or your personal finances. Knowing your number is living within your means while setting your sights on an achievable goal by knowing how to attain it, not hoping you'll achieve it. Knowing your number means believing you can do or be anything or anyone you choose. Knowing your number means realizing a challenge is part of a plan and something to embrace, not avoid.

I saw a plaque years ago that spoke to me. I purchased it and still have it hanging in my kitchen. It reads, "The best things in life aren't things." That said, my relationship with money is complex, to say the least. I pay my bills on time. I am a bargain hunter in terms of purchases, and I do comparative pricing before making a major purchase. I don't shop for myself a lot, but when I see an item I want, I think twice and then I buy it. Sometimes, I laugh at myself and with the person I'm paying for my purchase as I say out loud, "I probably shouldn't buy this, but I deserve it." I also spend a lot of my money on others. Sometimes I think I could be a professional shopper because I do enjoy looking for unique gifts that match the recipient.

I remember watching my maternal grandmother and my own mother stress about the holidays. They were forced to live from paycheck to paycheck and there was barely enough money to pay the bills and buy groceries let alone find any extra money to purchase gifts. They were both married to men who had no sense of money management. My grandfather gambled part of his paycheck away on his way home from work. My dad traveled and personally lived on an expense account or, more than likely, part of the money he earned in a commission-based job. I will always remember one night before Thanksgiving when my father finally came up with the money to buy a turkey and the fixings. I am going to guess he may have bounced a check at the grocery store. I knew I would never live that way. I oversee the finances in my household and my husband is happy to have me do it because he is aware of my upbringing and knows I am interested in having us live comfortably yet within our means.

Me with my Women in Business plaque

I'm not sure I would call joining the RR Fund a leap. I don't often deliberate for long before deciding. Still, I do carefully consider how I want to spend my time and money. I've admitted more than once, I'm addicted to activities. Although others looking at me from the outside might think I'm over-scheduled, I am selective in how I spend my time. I have significantly benefited from projects I've participated in since I met Dr. Angela Reddix,

I became a mentor in the beginning stages of Envision League Grow. Assisting and influencing young girls with their entrepreneurial dreams has been life-changing. I was a mentor in Reddix Rules which allowed me to share my thirty-plus years of running a successful business with women who were just starting out. I knew I had skills and stories to share with the up-and-coming business owners, and I loved being their cheerleader as well as an adviser. Now I am a member of the RR Fund, meeting and regularly learning from a group

of women who believe we can make a difference in this inequitable world. My experience in these three ventures has provided me more than I've given, although I always feel valued.

Me with the Girl Bosses from ELG

What I like about "ah-ha" moments is that I have them often. In the case of the RR fund, my "ah-ha" moments happen each month we meet. I think the overall "ah-ha" is the more people you get to know or interact with the more "ah-ha" moments you will have in life. Just when you think you've figured something out or know it all, someone comes up with a brilliant idea or suggestion that expands your knowledge and experience. The exchange of ideas for a common solution has been enlightening, to say the least, and exceptionally informative. The "takeaways" are addressing issues on behalf of others, as well as for us as individuals.

My advice to a twenty-year-old woman is you're about to enter the adult world, and you should do so as a sponge. Soak up everything you can regarding knowledge, experiences, and people. You will learn something every single day that will change your life. Be open and interactive. Embrace difficult tasks and never give up. Don't be sure you know what you want on any given day. Change your mind often. Understand that resources are there for your convenience and use them wisely. Push yourself. "Tell the truth; it's the easiest thing to remember." Be honest with yourself and others. Your expectations may bring about your greatest disappointments but accept disappointments as an opportunity for a better outcome. Know that you are the future and will make a difference by showing up.

When I was twenty, I had just completed my junior year in college. Although I lived away from home, I lived on a shoestring at school and went home most weekends because I could not afford to stay at school. Following junior year, I saved up enough money to go to Florida with my roommate for spring break. I can honestly say, it was my first real experience with independence, and I loved it. I looked forward to the future and could not wait to be on my own.

I don't want to overthink my attitude toward wealth at this stage in life. It would be impossible not to reflect on struggles that I observed in various family members' lives because of a lack of wealth or lack of having enough. I would instead think of wealth in terms of the legacy I can leave, including how I lived my life and taught my children to live theirs. I believe wealth results from hard work, good decision-making, generosity, and leaving something for the next generation. I also believe the next generation needs to do the same and hopefully, through these efforts, everyone can have a fair and equitable lifestyle. I don't need more than anyone else, in fact, I would give some of what I have if others could live better. I will start with my own family and hopefully, teach them how to do the same. The word that describes my attitude toward wealth is LEGACY.

I am often surprised to realize others find my words helpful. It is not that I lack confidence; it's that sometimes, I am just thinking out loud when an idea occurs to me.

I love when I come across a great quote that I can relate to. Although I usually forget it before I write it down, a few have stuck with me that could be relevant in terms of imparting wealth advice. For instance, "The best things in life aren't free" is not profound, but so true. Regardless of what some people may have led you to believe, "Money does not grow on trees," either.

When you enter a relationship, get to know the whole person and their background. You might be surprised because, "The apple does not fall far from the tree." "You can't judge a book by it's cover." And ,"You don't always get what you want." If you are looking for life to be easy, think twice. "Everything is hard before it's easy."

And one thing is for certain, "You can't grow when you are comfortable."

Keep looking for new and different ways to learn. Broaden your horizons because you don't know what you don't know. "The capacity to learn is a gift; the ability to learn is a skill; the willingness to learn is a choice."

Never underestimate yourself. You can do and become anything you want if you don't let anyone say you can't. "When women do better, economies do better." Whatever you do in life, "Stay true to yourself and never let anyone distract you from your goals."

Years ago, while jogging, I ran by a Unitarian Church that had a sign in front that read, "Love is making order out of chaos." I've never forgotten it, and I think of it often. In fact, I would like to think I have patterned my life after it. We have all encountered chaos in our personal and professional lives. I believe how we approach the chaos and, more importantly, move through it and reach a better place on the other side, dictates how we will live our lives in general.

My last quote is one I said to my two sons for the first time in elementary school and repeated many times throughout their lives. Now that they are grown men with children of their own, I don't say it to them anymore, but I'd like to think it was meaningful. I just blurted it out the first time I said it, and it almost caught me off guard. I try not to use it to judge others and although I was directing the comment to my children as cautious advice, I use it as a means of self-observation even to this day. "The way you do anything is the way you do everything." It allows me to recognize my style, approach, attitude, and accomplishments.

Me with children, grandchildren, and husband

Rozita Washington

Who am I? I would have answered this question quite differently if this were two years ago. I would give my name, position, company, and what I do. But after the sobering impact of a global pandemic that even the greatest countries, scientists, clergy, and governments can't contain, it has allowed me the freedom to be me, no-holds-barred. So, I offer the answers to these queries from this authentic lens.

I am the Beloved of the creator of this life, I call Him God, my Heavenly Father. He made me a nurturer of people's gifts and an overseer of resources and their optimal application. I am a great steward of capital (profit), people, and purpose. I am a believer and understand how to use the creative power of words. Words are seeds, spirit, and life. They actually perform, whether we believe it or not.

I am an entrepreneur. I get excited by the possibilities of creating, innovating, repurposing, and establishing through entrepreneurship. As an educator, I think that learning cultivates change and action. I accept the responsibility of growing myself and others. I love the reality that everyone can improve themselves if they so desire. I believe that you already have everything you need to make a difference internally. It just needs to be stirred up and cultivated along the way.

As long as we have breath, we can make a difference. Why is it important to make a difference? Because people don't typically want what they can't see. Would you follow a person that does not represent what they're selling? Probably not. Once we learn and grow, it's an opportunity to show (it). Nothing beats realizing the difference your living; your life makes without performing; but rather, simply being. And once we realize we can't control others, it's the epitome of freedom and peace. So, it's extremely important to renew our minds from old patterns to new patterns. I am what I believe!

My indication of wealth was my mother's words to me. She told me throughout my childhood that I was born a leader. I heard it often; hence, I believed I was a leader because my mother perceived it first or perhaps because I had repeated exposure to her uttering it. I begin with this answer because wealth was not exhibited in my upbringing; it seemed out of reach to me. I didn't connect wealth to leadership when I was younger.

As I reflect on signs of wealth in me, I recall my peer's expectations of leadership throughout elementary, middle, and high school. And my teachers were no exception, they were both encouraging and (believe it or not) discouraging throughout my formative years. In my early years, I would make my doll babies and my little sister my workers and assign them tasks. I had a knack for writing plays, songs, and poetry, and performing these for my family while casting my sister in the performance.

My work ethic and determination were modeled and instilled in me by my mother. She was a powerhouse in her career as a master administrator for executives in the architecture and legal industries. I was always structured, vision and goal-oriented, independent, organized, and responsible.

My "grannie grits," as I affectionately referred to her, also deserves a notable mention. Every Sunday, my grannie would give my sister and me a quarter or two to place in the "offering plate" at church. Every month, I observed her prepare a tithe and offering envelope. She deliberately separated the two; she believed in giving God a tenth of her gross income through the church, and the other was a free-will contribution.

This is how I began. My Heavenly Father creating me in my mother's womb. My mother is 6 months pregnant with me.
--Psalm 139:13-18

I closely emulated her as a teen and young adult in this regard. Ultimately, I continued to believe throughout my life that I am blessed to be a blessing to others. Whether it was my giving to a church, a family member, a college student, or another non-profit, I just trust God to take care of my finances and my life. Because I believe that He who gave it to me would continue to provide for my needs and the needs of others through me, I became a philanthropist and have remained a tither. In hindsight, I believe wealth was established in me through the life of words I heard, through the demonstration of scripture I witnessed, and through the vision, I dared to believe.

Generally, I define wealth as capital, but it is much more than that. In my perspective, wealth began with mindset and a generous spirit. This practice cultivates the covenant of wealth in my life. It's the flexibility to move with purpose, acquire assets, and, most importantly, maintain my health (physical and mental). The value and intention of capital are meaningless without health. We can't fulfill purpose without health, an absolute necessity for the fulfillment of life. Hence, I redefine wealth as the ability to realize my mission by expanding my knowledge and transforming my mindset while caring for my body and soul. Practicing my purpose, redeeming my mind enables me to create or recognize the opportunities that bring in the increase (capital).

The goal is to have a distinct understanding of your vision, establish resources (whether financial, technical, or human), and move forward methodically in the direction of achieving it. Find your network of people you can learn from and do it actively and deliberately. We each are an apprentice of someone whether it is intentional or not.

Shirley King (my mother) and me in her office in 2007. Before she retired from my firm in 2013, she was my CFO at LTC, Inc.

Psalm 127:3 and Proverbs 22:6

I consider the definition of "My Number" from two angles: first, my current financial health, and second, my long-term financial ambitions. I think about my financial health, like my physical health. I believe knowing your numbers represent personal responsibility and accountability to both yourself and your purpose, family, and/or business. You cannot correct or scale unless you are in possession of your numbers (credit scores, debt, income, interest rates, etc.) to take action.

The other perspective is identifying your financial goal realistically. Understanding inflow and output is important to reach the financial picture we envision. Stewardship of your money, in my opinion, is the measure of accountability for fulfilling your purpose. I observed a long time ago from a brilliant businesswoman; to be accountable for every dollar spent, who is spending it, and for what reason. She devised a lean financial system in her firm, propelling her to unimaginable heights.

In general, I believe money serves the mission I was created to fulfill as an entrepreneur. It serves me, not the other way around. The balancing act of saving, investing, and spending is a reflection of stewardship. Making "money" a priority or an objective has never worked for me. I must prioritize my goals, and the money will follow. When we do outstanding business, treat people well, and support those in need, we will find that increase (money) follows us. Being generous with your financial resources is a great way to develop a healthy relationship with money and strengthen one's faith. After I had the epiphany that the rule of planting and harvesting is an overarching

principle that applies to every facet of life, be it money, relationships, things, etc., I began to witness sustainability. Finding a balance is essential to changing most behaviors, Balance determines sustainability and creates authenticity.

My decision to take the leap and join the club was a no-brainer! First, I've known the head of the investment club for more than 26 years. And over the last 17 years, I've watched her develop into this amazing businesswoman. Second, I joined this group to participate in what I hope will someday become a movement. Dr. Reddix is well-known for her ability to create and transform people's lives. This club will provide women with the chance to broaden their financial knowledge, build their financial portfolios, and influence the mindset of their families and community.

I look forward to our exchanges and testimonials of the progress we and others in our reach achieve.

My ah-ha moment happened between my first and second meetings. As I scanned through the chat remarks, listened to the questions posed to the speaker, and heard the reasons we joined the club, I realized that we're all the same and predominantly desire the same things. This genuineness among the women allows me to share freely, be uninhibited, to tell the truth, and realize that we share something in common. We are women (regardless of age, race, background, or education) who desire an abundant life (not only money but legacy), great love, and longevity in our careers, families, and purpose.

With what I now know, I would advise my 20-year-old self to let go of the disappointment of the "no". I would tell her it's not over. It's just not now;

My sister, Ronzell Pettaway, and I. Officially, my first employee. We're 10 and 8 years old.

delay is not denial. I would say to her to redirect your emotions and intentions to the next opportunity or create the opportunity. I would also tell my 20-year-old self that all business isn't a good fit and that you don't have to embrace every opportunity. Follow your gut instinct; it's always right.

And lastly, I would say guard the input you receive from people or peers, especially those who haven't journeyed on the same path. Identify the right resources to help you navigate.

The words that define my attitude toward wealth now are:

Promise Believe Possible

It's a promise to those that believe it's possible. My mantra: I will accomplish everything I put my intention toward. Let purpose lead, and wealth follows. There is nothing impossible with God!

My viewpoint has altered over time, and today, rather than focusing on the financial aspect of expanding my mission, I am more concerned with achieving my mission. In my younger years in business, the focus was on whether I would be able to attain my revenue target by the end of the year. Most times, I reached it, but it was grueling, and I was burnt out.

My sister, Ronzell Pettaway, and I. My first best friend and confidant, forever. We are 36 and 34 years old. Proverbs 3:15

My experience focusing on revenue was fundamental in establishing my view of wealth. For example, you can make one million dollars in revenue and have $940,000 in expenditures. For me, that's not wealth; that's working backward. If your debt-to-income ratio is high, you may be falling short of your target. But when you strike a balance between understanding your numbers and executing your mission with the right resources, that's a good place. I'm not promoting that we should not have a financial objective, but don't obsess about it. Focus on the people, the customers, and/or the mission. Before the attacks of September 11, 2001, I had become obsessed with spreadsheets and monitoring of accounts. The takeaway didn't match my effort.

I wish to start from the inside and work from there. When our soul is in need of healing, the fullness of everything else doesn't blossom. So, I encourage every person to let go of all the disappointment, blame, unforgiveness, and the rehearsing of the story! Release it. Set yourself free! Every situation you go through provides an opportunity to learn and grow. This club is representative of your choice to grow. It depicts your readiness to make a better life. Congratulations on this first step!

The next and equally important action is guarding your words. Words create or they destroy. You will always have what you say, whether you believe it or not. I remember a saying growing up: "sticks and stones may break your bones, but words will never hurt you". This is absolutely false. Words are effective; they hurt, uplift, edify, and so much more. Words are life and spirit! They create "what you see". I took a break from social media, the news, and other sources of unhealthy information at the onset of the pandemic to better control what I was taking in and be more responsible with my words. It's remarkable how much of what we speak and ultimately believe is influenced by the music we listen to, the people we talk to, the songs we sing, and so on.

My "Grannie Grits," Beatrice Cannon APRIL 5, 1922 - MAY 29, 2016. I was competing in a pageant at Langley Junior High School. Psalm 145:4

Finally, I challenge the reader to write out your vision (what you desire for yourself, your family, your business, and your career). The objective is to make it a reality (bring it to life). And we do this by nurturing it every single day: find a mentor or network of like-minded thinkers, use YouTube and TedX Talks or other similar sources to point you in the right direction, take a class (virtual learning is prevalent now), write down the plan but make it realistic and measurable (start with 3 to 4 goals at a time), literally add the details to it from quantities, resources, costs; picture it in your mind (meditate on it), find a declaration (or scripture) to dissect while incorporating your vision into it, and repeat and never give up. You have what you say! You have what you believe!

You will find that your vision will begin to take shape as it transitions from paper to purpose; unplanned possibilities and paths will emerge. And rely on your instinct no matter what works for someone else; your gut (spirit) is guiding you.

Education is not a predictor of success; action is! The forerunner to action is mindset. RR Fund Club is the platform, and you are the instrument! Ladies, be free and be great!

Dr. Stacy Scott-McKinney

T his chapter is dedicated to the first man I loved, my dear father, David W Scott, as he soldiers on in his valiant fight against a gangsta disease called Alzheimer's.

Three Words

A number of years ago, in April 2007, while struggling through the pain and anguish of a failing marriage, I sought what's called "a Reading." I was admittedly soul-searching, looking for divine guidance and direction. The prophet or Reader "Bill" used the bible and meditation and foretold parts of my future and relayed uncanny features of my past. I had never been to a Reading and had absolutely no idea what to expect. Actually, I was quite skeptical. Thinking, 'a likely scam' but inwardly hoping for a message from God. The more he spoke, the more I realized that this elderly, thin, soft-spoken black man truly had a gift and he shared insight on the best path forward for rebuilding myself spiritually and emotionally. Bill never asked for any information about my life before, during, or after the reading, with one exception.

At one point, while he was talking, he suddenly lifted his head up, looked into my eyes as if scanning my soul, and asked, "Who are you?" He said The Spirit asks this of you. Amazing. How did Bill know that I had been struggling with that very question for some time? I was feeling too old to have to wonder and seek answers to such a fundamental question. I was approaching my 43rd birthday on that day and felt lost. I had given my life to Christ years before, but somewhere over the ensuing ten years, I became lost in all the details of my life. Mother of two sons, dutiful daughter to aging parents, wife, and physician were just some of the hats I wore and roles I had enjoyed but felt pulled in every direction. My anguish stemmed primarily from my marital and dire financial problems, and I was overwhelmed and terribly unhappy, as was my spouse. I always admired people who appeared to have a strong sense of self, such as my sister Sharon and best friends Rochelle and Claudette. But at that time, in the spring of 2007, I was sad and feeling defeated by the circumstances in my life and not understanding how I got here and who I was. What a simple question, "who are you?" but these three words provoked deeply profound thoughts and sincere introspection. The Reading challenged me to desire, more than anything else, to understand who I was to God, and to know and understand my soul, and this led me on a spiritual journey that spanned the next ten years.

To understand who I am, I had to go back to my childhood and reexamine my upbringing and certain pivotal events of my early life.

Growing up in the sixties in Hollis, Queens, New York, I was aware that my family was "middle class." We certainly were not poor nor were we wealthy. We lived comfortably, and my parents provided everything we needed but not everything we wanted, a theme and concept that everyone should assess from time to time throughout their lives. I believe my parents made good decisions, always with our best interests in mind. I attended public schools but was bused to a predominantly Caucasian neighborhood in Flushing Queens starting in fourth grade. My parents knew that the schools in our local community did not have adequate resources and crime and drugs were also on the rise. They made a pivotal decision to seek better public education alternatives. My father, David, was the proverbial tall, dark and handsome man with a big heart, quick wit, phenomenal memory, and engaging smile and was so well regarded by all. He was a police

officer for the city of New York, studied hard, and achieved many accolades and promotions during his esteemed career, even achieving the position of First Deputy Police Commissioner for NYC. My mother, Yvonne, was a lovely, elegant lady who nurtured us, sang lullabies to us, took us for treats when we had to go to the doctor, and was and still is my best friend with a heart of gold that only rivals my father's. We affectionately referred to her as Lucy because she was as humorous as Lucille Ball and kept us all laughing. She was a stay-at-home mom most of my young life and then became a bookkeeper for a daycare center in Hollis. Both parents were working in the 1970s, and having a two-income household, they were able to provide resources to greatly enrich our childhood. I grew up taking a family vacation every year (even traveling to Nassau Bahamas when I was just ten years old), going to summer camps, tennis camps, sleep-away camps, piano lessons, ballet, and dance classes. My parents were always hosting parties in our basement with their friends or for our birthdays. These parties featured great music (on LPs back then), lots of dancing, and often featured my mom's juicy fried chicken, mac N cheese, and collard greens.

My Parents, David and Yvonne Scott, circa 1958

We lived in a comfortable two-family house with my grandparents living downstairs and my family living upstairs. Our home was often the temporary home to other relatives when they were in need or when they were moving up north from the Carolinas, where my grandparents were from. So, I grew up witnessing lending a hand to help others get on their feet financially and off to a good start in New York.

We had to do our chores every Saturday morning before being able to go outside to play with our friends, and we were given an allowance if we completed those chores. No chores; no allowance. I enjoyed saving up my allowances in my piggy bank and then buying treats. It could be an ice cream sandwich, a burger from our local White Castles, or a black cherry sundae from Mister Softee. On the other hand, my brother, David, whose nickname is Poppy, spent his allowance immediately. He earned it; he spent it. I was a saver, and as I became older, my purchases were centered on clothing, black memorabilia, and black doll collecting.

I do not recall a time when we struggled to keep food on the table or when we went to bed hungry. We really were unknowingly quite fortunate. My parents often lectured us about wasting food: "don't you know there are families in Africa and India starving?" they would chastise. As a rule, we had to finish our food before being permitted to get up from the kitchen table. Of course, my brother and I found ways to get around that rule. We didn't care back then about the cost of food or really think about the plight of our brothers and sisters in other countries. Frankly, we took it all for granted. I used to stash the food I thought was disgusting in my soda can when my parents were not looking and just recently learned that Poppy would throw his uneaten food out the window! Hilarious.

My first Christmas with my parents and siblings, Sharon and David (Poppy), 1963

Another indication that my family was middle class was the mini-celebration that would ensue whenever we bought a new car. One of my earliest memories of the excitement a new car would generate was the occasion when my parents bought our new 1975 Chevrolet Monte Carlo. White on the outside and burgundy on the inside, this car even had swivel bucket seats. I vividly remember the day my dad turned the corner from 104th Ave onto our block with this snazzy car. We all marveled at its sleek style, and we jumped in, and he took us for a spin over to my cousin Pam and Ted's home on Long Island. I recall one of the many times when my dad was promoted; he had always wanted a Jaguar. Some people consider their car a status symbol, but for my dad, it symbolized a reward for his hard work, studying, and passing his promotions exams. Dad later sold the car. He learned that luxury cars cost a fortune to maintain and that particular model always broke down and was in the repair shop.

If I had grown up non-middle class, my relationship with and view of money and wealth would be fundamentally different. I doubt wholeheartedly that I would have spent so much money on clothes, designer bags, coats, and shoes in my 20s and 30s. I would have saved more and shopped less, but I didn't have any models of great stewards of money as a resource during my upbringing. No one taught my parents the best strategies for maintaining what they had achieved. There was no such entity as a Financial Planner in the black community back then; if there was, my family had never met one. People didn't want others to know what they had or didn't have. It was about keeping up with the Jones or at least the appearance of doing so.

When I was young, I assumed the wealthy were all those who had colossal homes, fancy designer clothes, opulent jewelry, and fine cars. I never thought about having a certain threshold of money in the bank to buy those things, nor the cost of maintaining them. Affordability assessments did not exist in my young adult mind. Growing up with TV and seeing the lives of "the rich and famous" depicted in the media, I subconsciously desired the trappings around these celebrities, and I noted they always looked so happy on TV or in print. I focused on attaining material things rather than on having an income stream and building my savings, and I mistakenly, like so many, assumed that with wealth comes happiness. I now define wealth as having the resources to be financially independent, which is an amount unique to everyone, and this independence would substantively contribute to one's overall happiness. A recent article in Psychology Today posted on March 28, 2022, entitled *How Happy are Millionaires* found: "Millionaires are happy, but not extremely happy." "The super-rich are slightly happier than the rich." And, "Those who earn their millions are the happiest."

In my life, there is an inverse relationship between my reliance on wealth-building and my reliance on God. The closer I have become to God, the less reliant I become on wealth building and, the more financial assets I attain. Conversely, the more disconnected I was from God, the more reliant I was on wealth building and the fewer financial assets I actually had. I have realized and lived the scripture from Matthew 6:33 "Seek first the kingdom of God, and all these things will be added to you." When you learn to accept His promises, God will pour out that which He has for you. My happiness now stems from growing a more intimate relationship with God and not from growing my relationship with wealth and money.

To properly tell the story of my relationship with money, though, I have to first tell the story of my relationship with God. While it is not my intention to gender God because I believe God is un-gendered, I will refer to God with the He/Him pronouns for the purposes of my writings. God has always had His hand on my life; however, it was not until many decades later that I actually discerned this and could tangibly see and feel His presence.

Patience and Faith

When I was 11 years old, my beloved grandpa James died. I had never experienced the loss of anyone close to me before. His death shook me to my core. You see, I was my grandfather's little girl. We lived upstairs from him. He doted on me, adored me, and I loved him fiercely. I saw him as a big teddy bear: rough, tattered, and torn on the outside but had a soft heart on the inside. Grandpa walked with a cane and was a little bent over from an old back injury from when he worked in construction building the GW bridge. He always had his pipe in his mouth that just teetered on his lip, looking as if it was going to fall out at any moment but masterfully never did. Grandpa liked to eat whole walnuts that he would crack open and would motion me to come to sit next to him or on his lap. Whenever he had houseguests, he would call me into the living room. I cringed because I was terribly shy, but I understood he was proud of his youngest granddaughter, and I wanted to please him despite my discomfort. When he died, I was lost and devastated. I prayed to Jesus to bring him back to me. I prayed every day and cried myself to sleep every night for many weeks and probably months. I believe I was probably clinically depressed, but back then, parents didn't take their children to the doctor for emotional issues; you just had to 'get over it' at some point. I distinctly remember talking to God every night before I fell asleep. I asked Him why He took grandpa from me and prayed and sobbed to God to bring him back. I was in deep grief and missing my grandfather. My grandfather did come back to me, which sounds unbelievable but I will explain. In the early morning of March 1, 2000, I dreamed that I was back in Hollis, Queens, and I was walking around the corner in my neighborhood, and as I turned from 205th onto Hollis Ave, I saw my grandfather.

My maternal grandparents, Andrew and Hattie May James, circa the 1940s

I recognized him immediately, even though he was a young man. I had never known him in his youth because when I was a little girl, he was in his 60s and 70s. I hadn't even seen a picture of him that young. Nevertheless, I recognized him. He was wearing all red, which was quite vivid and stunning, in fact. In my dream, he was standing up straight and tall, no longer bent over, his skin was a flawless dark brown, and he was warmly smiling. Our eyes met as I turned the corner; I exclaimed in shock, "Grandpa!" and we gave each other the biggest bear hug. I was oh-so-happy and elated, over-the-moon ecstatic to see him. Then I woke up.

Later that morning, during a conversation with my mom, I casually mentioned that I had just dreamed about grandpa. I had never dreamed about him since his death, not even once. She said, 'Stacy do you know what today is, and I said 'no.' She said, "Your grandfather died 25 years ago today... today is the 25th anniversary of his death". I was stunned. Praise God! I saw my grandfather again! 25 years to the day after I cried out to God, I felt grandpa's embrace in a dream that seemed so real, and I was unbelievably thankful for the long-awaited, merciful spiritual reunion. God answers our prayers, and we just have to be patient.

With Every Ending Comes a Beginning...

In the fall of 2017, I had a conversation with God in my version of a War Room. My walk-in bedroom closet had two functions; customarily, it housed my clothes and shoes, but when I needed to have a heart-to-heart with God or cry out to God, this room was my oasis and my most revered place of worship in my home.

It had been approximately three years since my husband, and I separated and one year since our divorce was final. I told God that I was starting to get lonely and that I was ready to have a partner and be in a committed relationship. During the three years since my separation,

I had intentionally worked on rebuilding my life. I had focused on strengthening and rekindling my relationship with friends, attending more of my church's Discipleship Group meetings, playing tennis, traveling, and working diligently on my finances. I had depleted all of my savings in the years preceding, which stemmed from legal fees for my divorce and a business venture that I had ended. I was starting over financially and relationship-wise and was re-awakened to my spirituality. The Reader Bill had prophesied that I must 'rebuild my life' ten years prior, and he was correct. I felt whole again, and I knew who I was. I could answer the question of who are you. So, one fall night in 2017, I prayed a very specific prayer in my War Room that evening. Most of my prayers were always for others, but on this occasion, I asked a prayer for myself. I gave God details of who I wanted. Always praying, though, 'if it is Your will', I asked Him to send me a partner who would treat me as special as God knew I was, a partner who would uplift me, love, and cherish me and bring me joy. It is by no coincidence that on the day that I was finally able to retrieve the furnishings that I had put in storage three years earlier, a day that I would throw away all the unwanted items that were vestiges from my former life, I met my special friend. Less than a week after I prayed in my War Room, I picked up my furniture from storage (so glad to get rid of that monthly bill), moved them into my recently purchased home, and then packed up my car with the items that needed to go to the city dump. My car was full of "stuff"; every crevice was filled from floor to ceiling. At the dump, I relished hurling those items into the heap of garbage below. Symbolic, I suppose, because I felt closure. A chapter of my life ended, and I was successfully moving on. After leaving the dump, I thought about going to church. I had started attending a second church that had services Saturday evenings, and if I hurried, I would make it on time, but there was a voice in my head saying I shouldn't go now because I was too sweaty, probably funky too and my clothes were certainly not clean nor pretty. I reasoned I was at least neatly attired and put those negative thoughts aside, and off I went. I really was craving a message from God on this celebratory day of new beginnings. I was blessed with a powerful message from Pastor Dale, and as I was waiting in line to get a CD of the message, my soon-to-be partner came and stood in line behind me. We struck up a conversation, and there was definite chemistry and excitement in the air. I believe God heard my prayers from just a few days prior when I said, 'I am ready,' and so He led our paths to fatefully collide. God has answered my prayers once again. This time though, He only waited days from when I asked, not twenty-five years.

I have so many amazing stories of God working in my life, but I will share one final story of His awesome presence and how my reliance on God guides and directs my steps in all areas of my life, including and especially decisions surrounding finances.

How Great is His joy in the Victories You Give! Psalm 21

In 2017, I was diagnosed with a health condition and occupational injury that the Reader Bill actually foretold ten years earlier. I had absolutely no idea what he was referring to back then, but now I did. The next few years would then become a journey to a very dark place that nearly broke me. I went through a legal battle with my employer to secure appropriate accommodations for my disability that spanned many years. This accommodation was necessary for me to be able to work and not be forced into an early retirement which would have been financially disastrous. In April 2019, I won a jury trial granting a scribe (medical note-taker) as an accommodation, but my joy and relief were fleeting when just two months later, my employer declined to replace my current scribe when she went off to graduate school which appeared to be in direct violation of the recent court order. I found myself in mounting pain, highly stressed, confused, angry, and overwhelmed with how to physically do my job without the needed accommodation while waiting on the slow legal system to address my cause. I filed a disability discrimination lawsuit in the fall of 2019, and the case was finally heard in March 2022 in the District Court of Washington DC. The seven-member jury, after my six-day trial, found that my employer violated my civil rights. Those three years (from 2019 until spring 2022) of working through the legal system while trying to stay focused on taking care of my patients while in considerable pain and while attending to the critical health concerns of my family all the while having to address seemingly unending streams of legal filings and briefs proved to be, by far, the hardest three years of my life. During this same time, I helped manage one serious health crisis after another for my parents and closest loved one (lung cancer, lung resection, Alzheimer's, heart surgery, appendicitis, bowel obstruction, amyloidosis, incapacitation, cardiac arrest, heart failure, acute renal failure, heart transplant, bowel perforation, progressive dementia). I had other close relatives with very serious mental health crises at that time as well.

And then there was COVID! Sadly, two cousins died from COVID in 2021, and I lost my father's youngest brother, my beloved uncle, and my dear aunt Helen from a non-COVID disorder that took her life within days of my son and I arriving in California to get him settled into his freshman year of college. I tried my best to help manage and juggle all these situations with my loved ones, and these were not minor medical concerns but life-threatening and critical crises, happening one after another, and at one point last fall, both my mother and father were in the hospital at the same time on different wards. I felt like I was a distant cousin of biblical Job with the constant stream of calamities, chaos, and emergencies. Going to my doctors, speaking with my relatives' doctors, coordinating their care, traveling up and down the highways, and helping to navigate the academic needs of my sons as they transitioned from school, all the while working in an extremely busy medical practice, was mentally and physically exhausting. I was perilously near a breaking point. Not unexpectedly to some, in the summer of 2020, I realized that I was suffering from anxiety and was diagnosed with an adjustment disorder. The weight of the world seemed to be on my shoulders, and I was struggling to find joy in my existence. Physical pain was daily and severe. Emotional pain was daily and severe, and I felt as if I was drowning and struggling to keep even my nose above water. I chose not to use pain medications except Tylenol occasionally and sought other treatment modalities, including physical therapy and steroid injections. I recall in those dark days that I would drive to work, sit out in front of my office, and dread going in. I knew I could not keep up with my position's charting responsibilities and the number of unfinished charts grew to a staggering number. I had never in my life experienced a sense of dread. I had spoken to many patients over the years who had described their anxiety or depression as such a feeling, and while I could empathize, I did not really have a tangible sense of what they were experiencing.

Now I knew, first hand, up close and personally. It is a horrible feeling to have sustained dread. Adding to my misery, I had insomnia. I just could not find a comfortable position at night but my inability to sleep was more from this insidious feeling of despair and doom that began to surface when I went to bed every night. If I were able to fall asleep, I would not stay asleep. If I woke at 2 or 3 am I would be up until my alarm clock went off at 7 am. As I got dressed and headed to work, the fatigue weighed me down, and then the feeling of doom would grow, and by the time I reached work, it was at a screaming pitch in my head. I wanted to run away from my life and all the pressures I was facing, but my patients and my family depended on me. Also, when you are the only doctor in your family, everyone relies on you for all their medical questions. Even though that is not your area of expertise, you try your best to help everyone in need. My medical practice is very busy with highly complex patients and a steady stream of time-sensitive tasks. It is a challenging work environment as I intentionally provide thorough, comprehensive care with compassion and professionalism at all times. I never discussed my legal plight with my patients and tried my best to solider on at work. I was often comforted by the many kind words of these wonderful families or by a sudden unsolicited hug offered by some of my patients. One gesture in particular that melted my heart was a one-year-old who toddled over to me, put his arms up for me to pick him up, and then snuggled up on my lap and went to sleep. Priceless. I did not want to move, but I had other patients waiting. My patients have no idea how much they blessed me and encouraged me to come to work every day when I wanted to give up and throw in the towel. You must be a multi-tasker extraordinaire as a physician, but now I had to do it in pain, with legal filings due and with family health crises overflowing. I had fleeting moments of joy. Mercifully God sent two essential ingredients for my emotional healing. First, He sent an angel for a therapist. Facts!

She was kind, thorough, sensitive, intuitive, practical, informative, warm, and genuine. She counseled me and helped me find my footing and, in a sense, to re-establish my soul's consciousness. My soul was stunned. It was as if time stood still while I was in a boxing match with the G.O.A.T and had a barrage of punches landing one after another and I was dazed, confused, and unable to fight back, but I was not knocked out. Counseling helped me to shake off the punches and get back in the ring with more awareness of how to fight defensively. After I was discharged from virtual counseling sessions, God presented his next gift, which was life-changing as well. I stumbled upon an unassuming book by an African prince: *When Kings Pray and Fast*, by King Adamtey. This gem was monumental in helping tactically and offensively prepare me for the legal battle with my employer by strengthening my spirit and firmly and forever re-establishing my awareness of my direct connection to God. I learned the power and importance of prayer and fasting. I knew my life, physical, and emotional well-being depended on strengthening my relationship with God. I knew that in all times of distress, God had been with me and had sent me signs that now, years later I realize in retrospect were signs from God. Just as the movie War Room was pivotal and helped me to prepare for my divorce through dedicated prayer time and spiritual vision boards, fasting helped me to pare away

those unhealthy foods in my life that I craved, and through giving something up for God, I grew my relationship with God. In my life, whenever I cried out to God, alone and in deep prayer with no one near and with tears and snot running down my face, God ALWAYS answered me. When I was tearful at my kitchen table in January of 2022, two months before my civil rights trial, because I was starting to feel anxious about the upcoming legal battle with my employer, He told me to get my bible and open it. I opened the bible to Psalm 17. I had never read this Psalm before.

In fact, I was more familiar with perhaps the most famous Psalms 23 and 91. As I began to read Psalm 17, I started to cry tears of joy when I read... "let my vindication come from you".... "As for me, I will be vindicated and will see your face." At that moment, I knew with certainty that I would win my trial with God's help. He gave me critical instructions: I must prepare and that my preparation would come through consistent prayer and fasting because just as there are spiritual beings and angels here to help us, there are also spiritual beings fighting against us...the other side has their weapons, and so I must put on the spiritual armor of God. Every morning before I start my day when the house is still, and everyone is asleep, I dedicate 30-60min to spending quiet time with God, praising God, giving thanks, and petitioning for others and myself at times. During this dedicated time, I do not answer my phone or check my texts, I do not turn on the TV, and I make a point not to make any decisions until I have given thanks to God and prayed to God on behalf of my loved ones and my patients. I invite God to help guide me with every decision I need to make, no matter how mundane. Then I read the bible and study His word. This is my morning ritual, my daily bread.

I Will Guide You Along the Best Path for Your Life, I Will Advise You and Watch Over You, Psalm 32:8

In December of 2021, my partner's friend sent us a text that his daughter would be in town to promote an investment club for women and that she was a very successful entrepreneur in Virginia. I knew I would not be able to attend due to a work conflict; however, my partner went on my behalf and returned so excited to share what he learned. He was very impressed with her presentation and knew I would likely want to hear more, so he thoughtfully passed my number to her and asked that she call. As promised, a week later, as I was about to begin work, Dr. Reddix called. We had a brief but informative initial conversation, and we realized that we knew each other professionally years ago. That was comforting, and I took it as an initial affirmation, but I prayed about this venture as I knew it would require a leap of faith. I talked to God quite a bit on this matter and was admittedly grappling with the concept of wealth building. I kept remembering the scripture from Matthew 19:24 "I'll say it again-it is easier for a camel to go through the eye of a needle than for a rich person to enter the kingdom of God." I have been familiar with this passage since the 90s and felt it cautions us about attaining wealth. So, I carefully sought God's will on this matter, and after having a more in-depth conversation with Dr. Reddix and feeling her positive energy, God led me to move forward. I did desire to learn how to invest in the stock market and real estate and was eager to also be in the unique position to collectively invest in women of color-owned businesses. This mission of the Club resonated especially with me because I started my first business back in the early 1990s, in my late twenties.

Scott's Medical Books was my initial foray into being an entrepreneur if you don't count my successful lemonade stands as a child. I sold discounted medical books as a side hustle while working as a medical doctor for GW Health Plan. Unfortunately, I did not know how to capitalize on the use of the emerging internet for marketing and generating sales, and the business could not grow. I enjoyed it nevertheless, but it was more of a hobby. In 2005 I started at Sandy Springs After Hours Pediatrics, the first urgent care dedicated exclusively to pediatric patients and owned solely by a woman of color. Not only did this business fail, but the conflicts surrounding funding this venture and the time commitment required proved disastrous in my home. This business was started as a way to help my parents with their finances because I saw how they had insufficient assets to adequately continue to fund their retirement and this stress and strain on my parents, who had sacrificed so much for me (putting me through college and medical school) was mounting. My father, in particular, was terribly worried about their finances, and I thought I could help by creating an additional income stream for them. While a great concept and my heart were in the right place, I did not know how to scale this business, manage the fixed expenses or market it to health practices to expand and grow. Ultimately, I closed the practice years later having lost almost all of our family's savings which irrevocably strained

our marriage. The first book we read in the club, The Millionaire Next Door, profiled the dismal business acumen of most physicians, myself included. Offering sage advice to start-ups is a priceless gift and one that I wished I could have received when I started either of my businesses. My riches-to-rags experience was altogether harrowing and humbling but, in that failure, I learned how essential it is to do your due diligence in thoroughly evaluating any business venture and seeking the best mentors for the endeavor. The financial strain this placed on my marital household also triggered a more thoughtful and intentional approach to rebuilding my finances but now with one income in a new single-parent household. I felt compelled to painstakingly map out my own financial plan, calculating how and when to pay off debt, budgeting every aspect of my life and my children's needs and expenses, and vowed to never let a business venture jeopardize the financial stability of my home.

My sons witnessed my eventual financial discipline but earlier in their lives, I should have been more direct with them regarding handling money. They grew up in a two-parent household and despite the eventual marital strife they knew they were loved and their needs provided for. We always tried to instill a work ethic that centered on the importance of focusing on educational studies, completing homework, and assigning household chores. We enriched their lives by committing to their pursuit of sports, musical arts, traveling, and spending time with loved ones and friends. We went to church regularly and in their later childhood years I began attending a church that did not require "dressing up". The lack of formality was appealing to them because they never willingly went to church as they hated having to wear suits and the services were too long for their squirmy selves. As important as all these details were in planning for their lives, I do not believe I intentionally spoke on or taught them about money except how to count it as this was an obligatory lesson in early elementary school math classes. How could I have overlooked such a significant aspect of their lives? When I was growing up my parents did not have discussions on money or wealth building. Their message to me was the same as my message to my sons: 'do well in school so that you have career options and you will have the economic resources to maintain a roof over your head and be able to buy the things you desire for yourself and your family when you grew up'. What is it about money, our use of and misuse of it that evades so many of our heart-to-heart discussions with our families? I believe, in the psyche of many, myself included, there was a stigma tied to Money. Growing up, we learned in church about the biblical verse in 1 Timothy 6:10 "For the love of money is the root of all evil" and who in black culture can ever forget The O'Jays 1973 classic, For the Love of Money? The cautionary lyrics are just as hauntingly memorable as the melodic bass opening riffs. The reciprocity between Music and Religion is undeniable. Head-bobbing, foot-tapping, finger-snapping, The O'Jays rhythmically reminded us:

For the love of money
People will lie, Lord, they will cheat
For the love of money
People don't care who they hurt or beat
For the love of money
A woman will sell her precious body
For a small piece of paper it carries a lot of weight
Call it lean, mean, mean green
Almighty dollar
—The O'Jays

But this is a song about the sins and brutality of money, not about its duality. Music is so influential though. Somehow wealth building became psychologically synonymous with the gluttonous love of money and its perils and not about the doors it opens, the economic uplifting of disenfranchised households and communities, and its empowering effect.

At this investment club, we are creating opportunities not just for ourselves but for our community of women-owned businesses. When you are not successful in a business there are obvious economic effects on the family and this will strain even the most grounded relationships as I had experienced. I feel so privileged every month to be in the company of such fascinating and strong women and

trailblazers. It has also been both a humbling experience and enlightening at the same time and I feel overwhelming gratitude for being presented with such as special gift at this time in my life.

If I was given the chance to go back in time to offer advice to myself on how to invest and build wealth, I would urge the young adult Stacy to Diversify *early*. I tried to do this but I did not have the proper education and oversight to permit those businesses to be successful. It is so important to have multiple streams of income, harkening back to one of the most popular English proverbs: "don't put all your eggs in one basket". I would say "Stacy, those eggs can be dropped, stolen, lost, or eaten and when you look up, they could be gone". I would tell her to first find a successful and passionate mentor to help guide her; that she will need to save more ritualistically, and participate in her employer's retirement fund making sure to always meet their threshold for earning matching funds, and it is imperative that she consult with tax and financial experts consistently during her life to be sure she is appropriately utilizing tax reduction strategies and managing her assets adequately. I would also tell her to start a family business, involve her kids, and in fact, hire her kids to create a legacy for them. Lastly, I would tell her to be sure to faithfully tithe from her heart and teach the kids the importance of this as well.

One Word

My chapter in this anthology began discussing a three-word question but will end with a one-word action for the reader.

Me, NYC June 2021

There is one word that connects Yahweh or Jesus Christ, Dr. Martin Luther King, Jr., Malcolm X, Harriet Tubman, Dorothy Height, Muhammad Ali, the Williams sisters, the Obamas, Mother Teresa, Gandhi, Bishop Desmond Tutu, Nelson Mandela, Ida B Wells, Pastor Tony Evans, Shirley Chisholm, and Mary McLeod Bethune to name a few greats. The single word that links these influential leaders, religious figures, civil rights activists, and magnificent athletes, and that describes the thread that binds them eternally is *perseverance*. This word is a noble word that is in itself compelling in its command to stay strong no matter what. Our souls can persevere in so many manners. We can persevere boldly, unapologetically, defensively, offensively, and even humbly. Whether you already know your calling or were just given a glimpse of your calling, you can be certain that you will have curveballs, missteps, falls, setbacks, injustices, disappointments, tragedies, and all manner of chaos that will frustrate and disappoint you at times. God mercifully will send little nuggets of hope in various forms and at the appointed time to encourage us or help us to go on such as when my beautiful friends in Atlanta gifted us three months of catered meals for every day of the week during my dark days. Their gift was sorely needed but I would have never asked anyone for this type of help. Women know what we go through wearing so many hats in a family and eliminating the task of meal prep for months was unbelievably generous and practical.

We cannot take our wealth and assets with us to our one true heavenly home but we can use our resources while here on earth to bless others and magnify the kingdom of God. That is what I choose to do. And that is how I have come to reconcile the biblical verse from Matthew 19: 24.

My "ah-ah" moment came not as a sudden epiphany but with the gradual evolution of my spiritual growth after going through the fire of my failures, trials, and tribulations. My long-standing view of wealth as being on, if you will, a spiritual slippery slope was finally

broken. I have come to realize it is OK to build wealth but never let wealth build you. I also came to understand the verse in Ecclesiastes 5:19-20 'that God gives people wealth and possession and the ability to enjoy them, to accept the bounty of their toll as it is a gift of God'. I am forever thankful for every aspect of my life and for all that He has given and excited and trusting of where He will lead.

I pray that the reader of this chapter is blessed with the gift of perseverance and may God strengthen us all to endure in all areas of our lives. Dorothy Height once said: "Greatness is not measured by what a man or woman accomplishes, but by the opposition, he or she has overcome to reach his goals". We overcome by persevering. And always remember the true source of your strength and power is the sovereign Lord.

Susan Pilato

G rowing up, we had an attic that housed all kinds of treasures which fascinated a young five-year-old girl like me. One day I found my way through several boxes of old forgotten items and came across an old leather satchel. It was full of important documents filled with big words that I could not understand. Oh, what fun I had spreading those documents all over my little desk, pretending to be an executive running my own company. The fun ended when my older brother found me with his antique briefcase and its contents spread out all over my room. That was my first experience with upper management shutting down a project of mine.

I suppose one could say that business was in my blood from a young age. Dreams of creating my own enterprises were brought to life through lemonade stands, a crab business that was short-lived as the crabs got away before I could sell them, and an invention of filtering carbon dioxide from car exhaust by using screens in a tailpipe. I even created a model showing three stages of screens in half of a soda can and sent it to Chrysler for review. They were kind enough to respond to my nine-year-old self and explained that the molecules of carbon dioxide were a bit smaller than my screens and they thanked me for trying to help clean the air. There went the go-kart I was going to buy with the proceeds of my brilliant invention.

My mind never stopped dreaming of owning my own business one day. I had no idea what it would be exactly, but I knew I wanted to create something of my own. To me, that was the way to wealth, independence, and happiness.

Both my parents were leaders and great examples for me to follow. Dad was General Manager/Vice President, and part owner of a car dealership, and Mom was the leader of our family. She also served as president of any organization she was involved in. When I was thirteen, Mom died of breast cancer, and Dad and I were left on our own.

My sister and brother were already married and had families of their own. I saw the worry in Dad when the bills came in from the hospital, but he always told me we were going to be okay, and in the end, we were. Knowing I had only one parent left terrified me until I turned eighteen when I would be legally independent if anything did happen to Dad. Thankfully, that beautiful man lived to be 94, so my fears were gratefully wasted. However, that fear instilled a desire deep within me to create my own independence of wealth. To me, that would come through owning a business of my creation.

Today I own a company with another woman business partner called PC&A Business Environments, which provides commercial office furniture and design services. I am also the CEO of a second company I created with my team, Mantra Inspired Furniture, a solid wood commercial office furniture line built by the American Amish community.

My dreams of becoming financially independent came true through many failures and successes over the years. If it were not for the lessons learned from failures, the successes would not have been achieved. Too often, one can become overwhelmed by a mistake or failure and miss the most valuable life lesson in embracing that mistake and turning it into an educational moment. I can say from experience that many of my so-called failures led to my successes because I chose to learn from them and take those lessons to move forward on better-chosen paths.

As I look back at my younger self, I realize that wealth meant independence to me. Independence to take care of myself and my loved ones and to have backup funds to rely upon when life jumps up and grabs you by the backside of your pants. Today, my view has not

changed a great deal, although true wealth to me now means that I can give back to efforts that help others and make our world better with empathy, education, and support. There is no doubt that I was blessed by parents who allowed me to dream and supported those dreams when I was young. They taught me with our blessings comes a responsibility to help those less fortunate by providing opportunities to find their own paths to stability — either financially or emotionally.

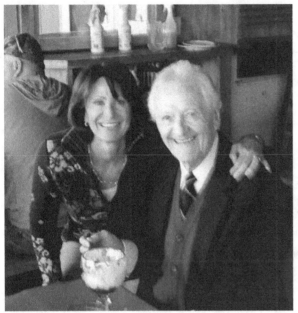

Susan and her dad

Early in our marriage, my husband and I understood the importance of seeking financial advisors to help us get a footing on how to save for our future. Having both partners on the same page with saving and spending money avoids much destructive debate and stress in a marriage. My strong advice to anyone considering a life partnership with someone is to have this serious conversation before signing that marriage certificate. Once that marriage is official, so are the ties to financial debt or well-being for now and forever.

After paying off our credit card debt from college, we both vowed never to have a balance again that could not be paid off within the thirty-day billing cycle. In other words, we would not spend more than what we could afford each month, and we have kept that vow throughout our marriage. We were fortunate to heed the advice of "paying ourselves first," which meant putting away something in savings or investments.

In the beginning, it was as little as $25 a month, but that amount grew as our careers progressed. This provided a path toward diversifying our investments in real estate, stocks, mutual funds, annuities, and our own businesses. Due to the necessity of having lines of credit for our businesses, we have had to provide an annual statement of our total personal net worth to assure the banks we were in good standing financially. This annual review also allows us to review our progress and status with our advisors to determine whether our goals are being achieved. Knowing the amount needed to provide the standard of living desired for retirement is critical for understanding what must be achieved in saving and investing funds. For us, this is directly affected by the progress of our careers and decisions made in the ownership of our companies. Reviewing these factors annually gives me a sense of control when deciding our next steps with investments, whether in our personal portfolio or decisions on expanding our businesses.

My father once told me to do what I love, and the money will come. I have found this to ring true in following my passions and finding the courage to plow on when all seems impossible. When owning a business, the responsibilities can be overwhelming at times. It never escapes me that the decisions I make will affect not only my family but all the families of the employees who work in my company. Our company focuses on relationships first with our coworkers, vendor partners, and most of all our clients. Establishing trust amongst each other, whether it is a coworker or client, breeds relationships that last and will continue to weather successes and failures. Things don't always go perfectly, but if you have the trust of your coworker and client, then anything can become a success. Once you have this foundation of relationship and the proper discretion in spending and saving, the money finds its way to a healthy profit margin that is fair to the company and the client.

Reflecting on the correlation between my relationship with money and how I perceive the creation of success within a company, I realize that focusing on achieving set goals for my business was the same approach I have with money. Much of the success in my business was found through the consistent discipline of appropriate budgeting, and I have had the same success with my personal financial goals. It has always been important to me to have financial stability for my family and balance so that I maintain a healthy relationship with money. I have seen others become consumed with money and the material things it can provide. While these things are fun, they provide little to feeding one's soul. Relationships with others and community provide balance in life, not money. However, understanding what will bring peace of mind for one's overall financial stability can provide a certain comfort that will alleviate worry and stress, opening the space

for richer relationships with others who are important in your life. It is essential to create a plan of action to meet your "number goal" and practice the discipline to maintain it.

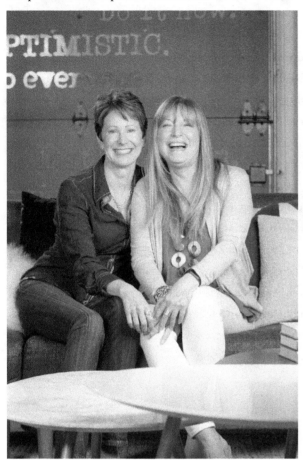
Susan and her business partner, Donna Counts

I remember clearly the day Dr. Angela Reddix and I had lunch at one of our favorite hotels in Virginia Beach, The Cavalier. There was something light and airy about the atmosphere on that restaurant's porch that day as she described the investment fund she had decided to create. This fund was for women only, and the investments would be made in women of color businesses. The irony did not escape me that we were discussing this financial vehicle of possibility for women in a hotel that opened in 1929 as a luxury resort for the white wealth of that time. The hotel had a board of trustees at its opening that was made up of all white males, and the 19th Amendment enabling white women to have the right to vote was still new. Women of color still did not have the right to vote then nor throughout much of this hotel's existence.

So, here Dr. Angela Reddix and I were discussing a possible dream that would have been impossible when this hotel opened. So obviously, for anyone that knows me, I was definitely in! There were two options to join this investment fund — one for individuals and another larger investment for businesses. Well, if you ever have the opportunity to work with Dr. Angela Reddix, you will quickly find she is impossible to say no to when she asks you to be a part of something as special as her creations. As I have done before, when making an important business decision, I took a deep breath and said, "Absolutely, I am in for the corporate level, and I'm excited to get started."

During our investment club meetings, I listened to and learned from many of our brilliant investors. They tell stories of how they decided to become financially independent. They talked about some of their "ah ha" moments, which led me to reflect on my own. Learning to manage debt was the biggest "ah ha" moment I had on my way to understanding how to gain financial independence. I had previously thought debt was another four-letter word. However, debt, when used wisely, can propel you into a better financial situation. One of our financial advisors illustrated the effect of how increasing your monthly mortgage payment pays down the principal balance owed quicker, and therefore, saves you a substantial amount of interest over time. My husband and I applied that method of adding to our mortgage payment each month, and as we were able, we added more. We refinanced to a 15-year mortgage, and before we knew it, we were in a position to completely pay off the house. Having that debt behind us allowed us to increase our investments toward our future and more quickly reach the financial stability number we had determined for ourselves.

I've been asked how I would advise my 20-year-old self on finances if I could go back in time. I have thought much about this question, and I realize the advice is summed up in one word — patience. My mother died at age 54 and had so many unrealized dreams for herself, my dad, my siblings, and me. Looking back, I see that I have been running against a clock that keeps its time to itself. None of us know exactly when our last moment on this earth will be. Out of respect, love, and missed opportunities of experiences with my mother, I have been racing to make every minute count to the extent that I began to feel anxiety over simply being still. This included my feelings about finances. In the years after college graduation, I honestly did not understand the balance of debt, expenses, and income, and therefore, made terrible decisions.

My impatience to jump into what I viewed as life's pleasures without the finances to back them were flat stupid and impetuous. Thankfully, the lesson was quickly learned as I did not want to live out the rest of my life in debt that was out of balance with my income.

What I would say to 20-year-old Susan is this: "Girl, be patient with yourself and use time as a tool for independence rather than it being a threat. Use the time to plan and enjoy the journey while you find your way to financial independence. You will get there, my friend, and it is much easier with patience than anxiety. Your choice."

Susan and her husband, Vince, and son, Sam

After speaking to my 20-year-old self, I thought about my current attitude toward wealth and what word would best describe my thoughts. That word is balance. We live in a society that focuses much attention on the material things in life. While nice clothes, homes, cars, and other material possessions can be enjoyable, they can also provide a divergence from creating financial independence. Learning how to balance purchasing things with paying my family first through investing and saving has provided me with a life free of additional anxiety to the stresses life already brings. Balance is created by using discipline, and with your financial well-being, keeping your wants in check with your needs and income.

One last bit of advice in the form of a question. Are you truly paying yourself first? There is discipline involved, and it is not always easy, but I can tell you that it will become easier with practice. Budget what you will spend on going out or buying material things and stick to that budget. If you plan with patience early on, I can promise you there will be a day when you can go out to eat without worrying about the check coming at the end of the meal.

Tali Starks

Who Am I? Is by far the hardest question I have ever had to answer. Aside from the titles I proudly wear — mother, wife, friend, cancer survivor, who am I really? I am more than the little girl born and raised in Washington, DC I am a true Washingtonian – an anomaly in this city of transients.

My parents, both now deceased, were in their 40's when I came along, and therefore I sometimes refer to myself as an "oops baby." As an only child born to older parents, I tended to have an "old soul." Now, at 53, I guess my age and soul have finally caught up to one another.

For the majority of my education, I attended private school, so it wasn't until I entered a DC public high school that I rode the bus. To say I was a sheltered child would be an understatement. After graduating from School Without Walls in 1986, I entered James Madison University (JMU) that fall. Now, after what some may call an unproductive year, I returned home to complete my college education at the University of the District Columbia – in 1996! Yes, it took me ten years to receive my degree, but I finished!

As for that year at JMU, I would call it anything but unproductive. While not returning and graduating from JMU is one of my biggest regrets, I met some great people who helped make that one of the best years of my life. Therefore I will never call my freshman year of college unproductive. Shortly after graduating college, I married. I am a wife to one (24 years and counting) and a mother of two. In 2019 I was diagnosed with stage 3 breast cancer, and shortly before the pandemic lockdown in 2020, I completed chemotherapy and underwent a double mastectomy. To say I don't look like what I've been through is an understatement. I am proud to say that because of God's grace and mercy, I survived, and I'm cancer free!

I would best describe myself as an introverted extrovert. Tell me I'm not the only one who enjoys people but can dislike them at the same time. In short, I'm a moody mess! While I love all things social, and some would say a contributing factor to my one year at JMU, I also enjoy doing things solo. I like the ability to move freely and without restriction. I've been known to have my inside voice on speaker and then end up hearing Steve Urkel's voice in my head saying, "Did I say that?" Please charge it to my head and not my heart.

Wealth nor money was ever discussed with or around me as a child, so I cannot honestly say that as a young girl, I had any real concept or understanding of the matter. My parents came up through the depression and Jim Crow. Therefore, having a good government job and home was the benchmark of success. Thinking back on my upbringing, I would say any ideas of wealth were based on possessions. Wealth was the size of one's house or car, the quality and style of clothes, and the jewelry a person wore. The images of well-adorn celebrities on TV or in magazines were what I associated with being wealthy. JET and Ebony magazine were my introductions to wealth. If it was the ability to purchase the finer things of life, then as a child, it was clear to me that my parents were not wealthy.

Even though I lived in a house with both parents, had two cars, and attended private school, I was very aware that money didn't come easily. My parents went to work every day! My father worked at the post office, and my mother was a federal civil servant. Now I realize some would say I was wealthy as a child, but I never felt that way. There's something about hearing your parents argue over money that doesn't scream rich. As I became a teenager, my father started to stress to me the importance of saving money, which is certainly one way

to build wealth but never was there any discussion regarding life insurance, the purchasing of stocks, or other such investments. I suspect, like many others, for a litany of factors, I'm not the only one to have entered the arena of financial planning late in life.

Standing outside of my family home (where I still live today); "Little Bug", was the pet name my Daddy gave me.

As an adult, my thoughts on what constitutes wealth have certainly changed from that of a young child. To start, wealth for me begins with health. Now I know this is a book regarding financial matters, but if a person isn't well physically and mentally, then how can one go about the work of obtaining wealth? So having good health is key to the foundation for building wealth.

No longer do I believe wealth is associated with material possessions. I'm sure we all know people, and we might even be one of those who have really nice shiny expensive things but don't have many or any resources to fall back on. Can you easily pay your living expenses and have the resources to take care of the unforeseen? I know it doesn't seem like much, but for the vast majority of people, it's a big accomplishment. Saving money in the bank is the simplest thing a person can do to build wealth, but it doesn't get the largest return and isn't always the easiest thing to do.

So now my idea of wealth is very simplistic — the ability to cover monthly expenses and having a rainy day fund. Not being able to cover living expenses and unexpected emergencies is a major contributor to a person's stress level, and we know how stress affects one's health. Removing the stress of daily financial concerns makes it easier to focus on acquiring some non-tangible assets — a retirement account, life insurance, savings bonds, and stock investments, things I consider the icing on the cake.

To me, "Your Number" is either the dollar amount a person deems sufficient enough for her or him to walk away from their 9 to 5 or even a specific amount of money saved in the bank. Short of what one would or could do if they win the lottery, most people never give any real thought to what their number is or even how to work toward it. Typically we don't think about how to get out of the rat race until we've been in it for way too long. By then, we are older with more responsibilities, and it can be difficult to plan for this mythical number. Knowing and planning for your number should begin at a young age.

Knowing "Your Number" is personal and obviously varies from person to person. However, the number you decide on isn't just personal because it's yours; it's personal because it will undoubtedly require you to sit with yourself and determine what is and isn't important in one's life. Unfortunately, being honest with yourself is often one of the hardest things a person can do.

Getting to "Your Number" is a fluid process that will change as life's events occur. Can you keep the same number if you marry or have children? Can you reach your goal if you make a career change? What lifestyle will you need to adopt to make "Your Number" a reality? Working towards "Your Number" will require focus, sacrifice, and flexibility.

The sooner one begins working towards "Your Number," the easier it can be to have other conversations regarding money and wealth building. I think the conversation can begin as soon as a young person begins working — say that first summer job.

The first word that came to mind when I considered my relationship with money was COMPLICATED. Like most relationships, money is a very intimate matter, and people tend to keep the specifics held close. When I take the time to reflect on my relationship with money, I realize it is not only personal but it's also rooted in emotions and very psychological.

As I stated previously, I knew growing up that my family wasn't rich, but we were far from poor. My parents were working-class people who struggled to have a decent life and provide me with opportunities they weren't afforded. While there were arguments about money, I was never privy to the who, what, where, when, or why of said disagreements.

I never received an allowance, so my first introduction to money management wasn't until I went away to college. Bad mistake! I went through the money in my on-campus bank account like Grant did in Richmond. When the balance was low at the end of the first semester, I got more upon my return to school. I cannot even begin to tell you what I spent the money on — nonsense for sure.

Now I'm sure you are wondering where the money came from. I received social security benefits after my mother passed away when I was 15 years old. Until I went to college, I never had access to the money, and my aunt could save quite a nice sum for me. It wasn't until I returned home from college and started working that I began to realize how far money can or cannot actually go.

I'm neither proud nor ashamed to admit I've spent money to fill voids and ease the pain. Albeit temporary, there's something about making a purchase that can make one feel better… well, perhaps it's just me.

I joined the club for a few reasons. First, it was presented to me by Dr. Angela Reddix, and after briefly following her on social media and seeing just a fraction of what she's accomplished, I knew this was something I wanted to be a part of. The impact Dr. Angela Reddix is making in the lives of young girls and women entrepreneurs is simply amazing. Her leadership in business, as well as how she carries herself, made me want to be connected in some way to her. It's clear that Dr. Angela Reddix is a woman of faith, and I believed her to be genuine when she stated that God placed it on her heart to start this fund to help women build wealth and secure their financial future. Seeing how well she's done with her life and how she's helping others, how could I not want to be a part of this?

The second reason I joined the club was that I knew I needed to do something positive with my resources. As I mentioned on one of our first investment fund calls, I wasted and misspent more money than I care to think about, and I felt compelled to do something positive. I didn't want to miss out on what I feel is an amazing opportunity to get in on the ground floor of something that will be beneficial to those that participate.

Lastly, I took the leap and joined the club because I needed to surround myself with women doing something purposeful. There's a level of commitment and an expectation of participation that comes with being a member of this fund, and I need that in my life. I'm excited to see where being a member of this club can take me both financially and personally.

I'm not sure if it should be called an "ah-ha" because it feels more like a "well damn" moment, but being a member of the RR Fund and participating in the creation of this book, made me realize I've failed my children when it comes to teaching them about finances. Essentially, I'm repeating my family's cycle of not talking about money.

Certainly, I don't know everything about personal finances; I'm a tad confident I know a little more than my parents did at this stage, and I haven't instructed my kids on how to start managing their money is "No Bueno." The one thing I don't want my children to take from me is the poor money management habits I've adopted. I need them to exceed me in how they manage their finances and how they set about building their wealth.

Since thinking and writing my portions for this book, I've gone to my children and started a dialogue on savings and the creation of wealth. I've gotten them to think about what is "their number" and what steps can be taken towards achieving it—talking to my college student early about retirement and the importance of immediately contributing to a company-provided retirement account and telling my youngest about ways to set aside and save monies from a summer job.

It's a sobering feeling to realize you've failed the people you love the most. My "ah-ha" is forcing me to look at my financial behavior, how it ties into other areas of my life, and the need to get my financial house in order.

Based on my experiences, I would offer this advice to my younger self:

- Get a therapist! You will need it to unpack the baggage and emotions that will cause you to make some unwise financial and personal choices.

- Educate yourself on personal finances. Daddy wasn't wrong when he said, "...You need to learn how to save." Unfortunately, he just didn't have the skills to show you. There's more to saving money than his method of simply not spending it.

- Surround yourself, sooner rather than later, with people trying to make an impact. There's something about being around people doing more than just having a good time. Being around purposeful people will drive you to be more productive.

- Don't be afraid to discuss money with your spouse. Getting the hard conversations out of the way before and early on in marriage should make it less complicated as time goes on.

- Plan early for the years you can't yet see. Longevity runs on both sides of your family, and you may just be around longer than expected.

Facing a health challenge evokes many "ah-ha" moments.

Since joining the RR Fund and drafting my submission for this book, I've realized that wealth isn't a lofty or out-of-reach concept; you don't have to hit the lottery to obtain it. Creating wealth is simply a process and a journey best begun early.

I realize that my attitude regarding money and wealth creation began as far back as childhood, and it's very subjective and personal to me. One size does not fit all. Where one person may want enough resources to retire at an early age to travel the world, someone else may simply want enough to pay for care in their senior years. Yet, another individual may wish to obtain enough assets to do both.

Being part of the RR Fund has also shown me how important it is to share and seek knowledge around creating wealth.

Some actions for the reader:

1. Take time and reflect on your relationship with money.

 ○ How & why do you spend or save money?

 ○ Do you spend freely to feel good and mask pain?

 ○ Do you save money out of fear and past experiences of not having it?

2. Track your spending for 45 days, and when the time is up, assess where and how much money you have spent.

 ○ Were there any unnecessary expenditures?

 ○ Could money have been used to create or bolster savings?

 ○ If you feel you have enough savings, could the money have been put towards creating more wealth?

3. For the next 45 days, save as much of your money as possible.

 ○ Take your lunch to work; skip the dining out; pass by the sales, and at the end of the period, how much were you able to save?

4. Take inventory of all of your subscriptions and fee-based services. See how much you are spending on things you don't use.

 ○ Could the money be used to purchase a unit of stock?

5. Create a list of all of your assets.

 ○ Do you have a plan in place should you no longer be able to manage them?

6. Do you have a will or a trust?

Tara McGee

I am, Tara McGee, a 3rd generation entrepreneur passionate about helping business owners and individuals realize their organizational and employment potential. Using my experience as an operational auditor, quality assurance coordinator, and fraud investigator, I systematically identify business vulnerabilities and best business practices. Fueled by my passion for helping others I birthed Staff4U, Inc.

I hold a Bachelor's Degree in Business Administration from Jackson State University and a Master's Degree in Business Administration from Virginia Wesleyan University. I'm a firm believer in the importance of work-life balance. Of all my professional accolades, the most important of them is the personal wins I have with my family. I have a supportive husband and 3 children. I am also a cancer OVERCOMER and know the power of God's hand in my life.

I'm now on a journey of purpose, and I ensure daily that my family and team feel valued! As President of Staff4U, Inc, I am Passionate about Placing People in a Position to realize their Potential so that they may live in Prosperity!

Big Momma

I was born in the Deep South, the fifth of six children in a small town in Mississippi. I grew up in a village of family and friends who always showed me love and instilled in me that I could be or do anything I chose too. My Mom's family has always been prevalent and had a profound impact on my life. They always pushed me to excel which I could because learning was naturally easy for me. However, as I grew older, I began to rebel and not want to excel in my studies. My parents also placed restrictions on me because they were "old school" so they weren't having it. But there was a limit to my rebellion because I have always believed and known that there is a calling on my life. God has always spoken to me in my dreams, and I recall having "warning" dreams that my Big Momma would interpret.

As time went on, my spirit of discernment developed and I have learned to heed or listen to it.

With regard to money, I'm a 3rd generation entrepreneur. My Papa (my Dad's dad) began a very lucrative business that he passed on to my Dad. One of my Mom's sisters had multiple businesses, and we always saw how hard she worked and gave back in service to her family and the community. As a little girl, I have always understood wealth as not only monetary but also the importance of family. As I reflect, financially my family didn't have great wealth but there is very little that I wanted that my Mom didn't provide. We weren't what society defines as wealthy, but we had most of our needs and many of our wants met.

Most of my lessons regarding finances I learned from my Uncle T who taught me at an early age the importance of contracts and keeping your word. (Note: My Uncle T was a Chemist and an investor and would be considered financially wealthy by societal standards.)

One summer, when I was around the age of ten, I visited Uncle T's family in Michigan, and I asked him to borrow $10. His words to me were to go and get a piece of paper, and I had to write a contract that included the date, what I borrowed, repayment terms, and we both would sign it.

Of course, his lesson to me was that I asked to "borrow" money from him. If I had asked him to give me $10, he would have given it to me without any expectation of repayment.

My "silent" thoughts then were, "I wish you would have told me this before I went through all of this," while I rolled my eyes in a way he couldn't see me.

I had to repay the loan by doing chores for him. It taught me a valuable lesson about the value of my word and working to repay my debts. And also to choose my words carefully when discussing money with him. We often had conversations about finances, and he shared with me his theories which I have since shared with my children. I loved the thought of passing his financial legacy on to them and pray they continue to pass it on.

06-22-198x

I, Tara _____ borrowed ten dollars $10 from "Uncle I". I promise to pay him back.

Signed. Tara _____
"Uncle I"

"The" Contract

In my mid to late twenties, I began participating in a multi-level marketing organization. I not only learned some valuable lessons by observing all that acquired wealth, but I also learned lessons about value and spending. When I was in college, I wanted to be part of the "in crowd," so I purchased name-brand items to impress people. I did this using credit cards that I didn't have a job to pay off. While in college, you could acquire credit cards easily without understanding the impact they can have on your credit and life.

The multi-level marketing company had a huge event and of course, I wanted to dress to impress. I went to a department store and purchased two outfits for $250 each. I placed the charge on my credit card but I didn't have any real income to pay off at the end of the month.

I only wore one of the outfits once, and for the other outfit, I went to the department store shopping for another occasion and saw a similar name-brand suit for $30. Had I only planned and prepared for the occasion, I would have been able to save. I vowed not to purchase name-brand items for the sake of impressing people, and I would always look for a good bargain. And on rare occasions pay retail!

As an adult, I define wealth, not by monetary value, assets, or possessions. Wealth should not be about material possessions but about how I am able to be of service to others. It brings me joy to be able to give to others. Now, do not misunderstand, I do like and have "nice" things, but I'm much more mindful in my purchasing.

I have worked most of my life diligently and have been blessed to excel in each aspect of my career. However, I learned that there is more to life than wealth. I learned this the hard way.

My lesson began while experiencing chest pain, difficulty breathing, itching, and coughing. These symptoms had gone on for a while, but I just thought it was my allergies because I was still kind of getting adjusted to living in a new area.

We had only been living in Virginia for about a year. We moved there in 2003 and by 2004 I was diagnosed with Hodgkin's Lymphoma. I endured chemotherapy and radiation therapy and am now an *Overcomer*. I share this story to demonstrate that I have seen the hand of God move throughout my life. In 2010, I severely tore a ligament in my ankle, which after over 6 months of physical therapy, required surgery. Again, I saw the hand of God intervene as I recovered.

As God continues to move throughout my life, I understand that the true meaning of prosperity is more about health and happiness and is not merely about financial well-being. Honestly, I don't know what my numbers are as it relates to wealth goals. When considering wealth and knowing your number to maintain a lifestyle or standard of living, I don't have a number. As part of the RR Fund I am learning the importance of knowing my number. My philosophy has been that I believe God will provide, and I need only to be a good steward of what he has given me. It has become apparent to me that I have not been the best steward of God's provisions, and knowing my number and striving to achieve will lessen stress as we plan for our senior years.

As I have mentioned, money affords me the ability to be of service to others. I give to those that my spirit leads me to give too. Therefore, my relationship with money is that it is nice to have and it can provide what I consider to be some comforts in life. I don't indulge in retail therapy, anymore... But, when there are items that I want or things that I like to do I will definitely partake. For example, traveling the world is a definite perk for me. Experiencing other cultures and meeting different people, and listening to their history is amazing.

What I have learned is that I do not have to keep up with what others have. I no longer feel I need to be a part of the "in crowd." I am happy others have an abundance and I get to experience it through them without judgment. I do strive to work hard and use the talents afforded to me.

Additionally, I have tried to apply my Uncle's theory of allocating the following percentages for household income: 10% to tithes, 20% to savings, 50% to bills, the remainder to investment and/or discretionary, and any increases to savings or investments or giving. His theory was that your bills should never exceed 50% of your income. Of course, that is easier said than done. But, I believe that as long as I make strides daily I am still on the path he has shown me.

In 2016, I entered into many years of what I consider my "discovery" time. My discovery time was a time of much reflection while seeking my purpose and path. There were what I considered to be many dark days. While on this path, I continued to understand the importance of prosperity and was led to enter into Reddix Rules Fund program. I was a member of Cohort #2 in 2021 and through this program, I received an entrepreneurial grant and training. We not only received business coaching and training; we, also, received resilience training which is definitely an added value for any entrepreneur. Also, the sisterhood is phenomenal. A group of like-minded women striving to make a difference in not only our lives and legacies but, also, the lives of others in need.

Reddix Rules was an intricate part of my exiting my discovery time and building lasting relationships. When presented with the opportunity to join the Reddix Rules Fund club, my initial thought, and only thought was where can I sign up. I can get the particulars later. I now laugh at myself. I mean really, who does that?

I joined the club because life has gotten in the way of me applying my Uncle's theories. Joining the club gives me a group of like-minded women striving to do more. The avenues of investing i.e., "Angel Investing," provides an avenue for me to help others achieve their dreams. Additionally, the club has allowed me to learn more about investing and being a better steward of my finances.

My most significant "ah-ha" moment in life came this year as I was turning 50. With it, I have come to a new level of freedom and peace. I love to say that although most people say they are starting a new chapter, I have started a new volume.

The past year was so enlightening and freeing. The relationships that I have developed have propelled me to a whole new volume of freedom.

Fiercely Free

I walk in my happiness and peace. God has renewed my mind and provided me the freedom to accept myself as a whole, including what I consider areas of opportunity for improvement. He has strengthened me to see life and happiness in a new light. I strive daily to walk in inner peace and positivity. Each day I ask God to make me better today than I was yesterday. With each choice, I pray for God to be in the midst.

Regarding investments, my most significant "ah-ha" moment after joining the RR Fund club came during a meeting when our Financial Advisor was sharing insight and details about the plans for stock investments. She made it plain to understand. What had been so arduous previously was now clear, and I was amazed.

Being part of the RR Fund has helped me to learn so much about building a network of relationships that can help to propel me forward with providing avenues of service to others. It has helped me stay strong while practicing the principles that my Uncle shared. I read more about the intricacies of the financial wealth system so that I am able to make informed decisions.

For so long, because I didn't understand and "am not an avid reader," I just moved along. Now, I have relationships that hold me accountable for being a good steward and pressing forward to enhance the talents afforded me by God.

Using those talents and the knowledge afforded me by the women within this club that are not resistant to sharing their success stories and "how to" I now have a renewed vigor for learning more about finances and not just settling and that it is okay to have an abundance because out of that abundance the more I can be of service.

As I think of the clarity I have now gained, I reflect on my young self...the person who purchased clothes to be in the "in crowd" or to impress. If I could, I would tell myself to continue to stay close to God and to be a better steward of my finances because retail therapy and expensive items will not last or secure your happiness. To walk in your authentic self by embracing yourself fully and that your value is not tied to others' opinions. Additionally, please know that you will face life's challenges; however, as long as, you stand strong in your faith you are equipped to overcome.

Prosperous is the word that defines my attitude regarding wealth now. I strive more to be prosperous as opposed to wealthy. Being prosperous speaks more to me holistically and is not focused on money or possessions but rather on a state of success, including happiness, being healthy, as well as experiencing financial gain. Being prosperous provides an aspect of peace that is not usually present with wealth. As I move into a time of peace and understanding, I find that life is about prosperity and my village. I have a village of family and friends who walk with me and share my peace and happiness. We seek to lift each other and bring a positive light to our daily lives. With so many blessings and the light of God shining in my life, I strive to walk in peace.

When considering steps to move forward financially consider praying, reading, researching, and understanding any area you may choose to follow. Try to understand the importance of denying yourself some material possessions today to plan for a better future. When purchasing items on a credit card, whenever possible, plan to pay the card's balance off monthly. Consider implementing my Uncle's theory of allocating the percentages to maintain a manageable lifestyle and budget. Finally, allow peace and happiness to reign within your life. Experience the type of inner joy that comes from knowing who you are and whose you are.

Tasha Turnbull

My name is Tasha Turnbull, and 'I'm a fitness entrepreneur and fitness studio owner who resides in Norfolk, Virginia. As a small business owner for over a decade, I see the highs and lows of owning a business. There have been times when there was less than $500 combined in my business and personal bank accounts, and I 'wasn't sure how I was going to pay the rent for the studio, to times when T2 Fitness was inundated with so many new clients that the money was just pouring in like water.

I've seen it all in my time as an entrepreneur. Despite the amount of money that has been in my bank account, 'I've constantly been driven by growth, my passion for assisting people with improving their quality of life, and the unlocked potential and opportunity that has come open to me each year, allowing me to reach new heights 'I've never seen before. I'm a very passionate, internally motivated person who has not been afraid to step out into the unknown because of the possibility of change and movement into a higher unfathomable territory resulting from that calculated risk.

However, I 'wasn't always a highly motivated fitness expert who found joy in teaching people the many ways we can improve our fitness level, health, and lifestyle. I've done a complete transformation when it comes to stepping out into the unknown. Growing up, money was something that 'didn't come easily to me, and I understood the limitations in my life due to not having or being born into money. You 'didn't ask for certain clothes, shoes, trips, games, or food because you already knew what was available to you given your family's money. Truth be told, I 'wasn't concerned with keeping up with having higher-priced designer clothes and new tech toys just to say I owned them. They looked cool, and I thought it would be great to experience them, but I didn't feel like I was missing out on life. I took on the idea early on that wanting a ton of money all to yourself is a form of greed. I believed if you desired money you were vain, greedy, and shady.

My self-esteem and self-confidence were pretty low as a child and teenager. I 'didn't speak up for myself and just rolled with whatever punches swayed my way. I was utterly uncomfortable being the chubby girl at school. Because of that, I 'didn't like myself that much. To help compensate for the fact that I was overweight and unattractive, I kept my head down, did my schoolwork, and became an extremely organized person. As a young adult, I grew obsessed with being conservative with any and all money that I made. I liked the idea of being in control of money, so I tried to savor whatever funds I had. I paid all of my bills on time, never liked to borrow money from a soul, and saved as much money as I could for fear that somehow the money that I made would just magically disappear. Though I became fixated on not wanting to waste money, this actually enhanced my level of stewardship and discipline.

It was this heightened level of planning and discipline that guided me on one of my very first transformations in life; losing 100 lbs. I got to a point right after I finished my bachelor's degree that I needed to take care of my health. I was well on my way to 300 pounds at the age of 22 and I was a miserable and depressed person. I was tired of soothing myself with food but 'didn't have a soul to guide me, educate me, or motivate me to find the strength to change my life before it was too late. Once I became sick and tired of seeing myself living the same boring life day in and day out, I decided to replace my comfort food with physical movement. The goal 'wasn't to lose 100 lbs. It was to just find myself beyond the low energy, mood, and broken spirit I had been carrying for years. I gained physical and mental strength by educating myself on how to work out, properly lift weights, and develop a healthier relationship with food to fuel my body to become a leader. As a result of this lifestyle change, I naturally lost 100 lbs, with most of this weight loss occurring within the first 2 years

of starting my fitness journey. I've been maintaining most of that weight loss for the past 17 years. Little did I know that the discipline skills I amassed during those two years would assist me in becoming an entrepreneur six years later. This transformation opened my eyes to the idea that ANYTHING that you want in this world is possible, and attaining more income and wealth is actually a possibility for someone like me, who grew up in Norfolk, VA.

Before I became an entrepreneur, I never understood how everyone only had one income. That money was supposed to pay for all of your bills. Completing undergraduate (first-generation college student) and graduate schools, working a full-time job for the state government and a part-time job at Bed Bath and Beyond, and only having enough money to pay for my rent, car note, utilities, and nice meal here and there just sucked. Whose idea was it to call this living? Working for someone else allowed that person or company to decide how much money would go into my bank account on a weekly, monthly, and yearly basis, which made me uncomfortable.

This continued feeling of uneasiness persuaded me to gain control of how much money I received monthly and how often. What if I want to receive money more than just on the 1st and 15th? Who in the ham sandwich said I can only receive money twice a month? It bothered my soul that I was rationed out money twice a month, and I had to wait for what felt like forever in some months until I could receive my next payment as if I 'didn't work every day. I needed to control more of the funds coming in and the volume of funds that could come in from month to month. Therefore, starting my own business was the only solution to remedy this dilemma.

As I stepped out based on faith and opened my own business, many challenges arose as I firmly positioned myself in the entrepreneur world without a well-organized roadmap, mentor, or a friend or family member who owned a business. I created a nice 'ol business plan filled with pie charts and prediction forecasts. I even paid extra money to print the plan with colored ink. I soon discovered that implementing that plan on my own on a monthly, weekly, and daily basis is a whole other beast. But 'I've never been a person to let a lack of resources stop me from pursuing my goals. I did my research and gained experience as I went forward in my quest for financial freedom by operating a fitness studio, hosting community fitness events and workshops, speaking at different events, partnering with different national brands online to promote wellness products, writing a book about my 100 lb weight loss journey, starting a fitness clothing line, and creating a nonprofit organization whose focus is to improve the health and lifestyle of African American women who have heart disease, diabetes, and/or hypertension.

Now, as a mature adult, total wealth to me looks like someone who is not only financially wealth, but also physically, and socially wealthy. Being financially comfortable, as opposed to just being financially stable, means you are at liberty to purchase non-consumer staple goods whenever you please, year-round with actual cash, as opposed to borrowing that money (i.e., using a credit card). It also means that you can take time off from working for 1-3 months out of the year without impacting your ability to pay for or having to scale back on your basic living expenses.

Taking it a step further, being financially comfortable means having accumulated enough assets that you can distribute some of those assets in the form of cash or capital to other people, organizations, or companies, without it impacting your ability to financially take care of any of the things that you desire. To achieve financial comfort, your physical wealth must match the amount of financial wealth you seek to attain. As a fitness expert who has trained hundreds of entrepreneurs over the years, I have seen the difficulties small business owners face when their health starts to deteriorate regardless of age and what effect it has on their productivity, concentration, and ability to make well-informed decisions consistently. Our bodies are the driving force behind what goals we set out to reach, what we will attain,

and the success of our brands. We only get one body in this lifetime. To be able to obtain and sustain a significant level of financial wealth, our physical wealth plays a substantial role in how this comes to be.

Likewise, our social wealth impacts the access to resources we have to secure the capital, business partners, customers, technology, and unique infrastructure necessary to attain a high level of growth. In some instances, our social wealth could potentially reduce the physical and financial wealth needed to close on a deal to increase our wealth. Who you know, what exposure 'you've been given, what you offer to the community, and what relationships 'you've nurtured make up your social footprint and can have a favorable or stagnant effect on your total wealth. It has always been my motto to give more than what you ask for...which is why I've made a point in my career to constantly provide to my social media audience (as well as people who attend my free community talks and events) several unique and practical ways that they can lead a healthier lifestyle, given their busy schedules. I always say whatever talents you've been given and accumulated over the years; make sure you share them with your colleagues, friends, family, and acquaintances...and share them often. You never know truly know who is watching and how your good deeds can make a significant impact on someone's life and how this advice could improve your social footprint locally and in your industry as a whole.

Understanding what role my financial, physical, and social wealth plays on the amount of my total wealth has guided me to make changes in my spending, saving, and investment strategies to become what the book, *The Millionaire Next Door*, considers a prodigious accumulator of wealth. As it stands, my current net worth is average, which is a good thing considering that I never want to be a low accumulator of wealth and this allows me room to grow and improve. There is so much more that I am committed to bringing forward into the market and into communities that will make a favorable impact on the lives of thousands of people; so that desire to obtain more wealth is necessary. Knowing where I stand from a wealth-based perspective enabled me to start taking actions on a weekly and monthly basis to make my wealth goals a reality.

Since 'I've taken an active approach to improving my wealth, my relationship with money has become one that is no longer fear-based. It is now predicated upon a desire to nourish and expand. I am more comfortable speaking about money to clients, colleagues, friends, and family. I am more eager to look through my business finances monthly to assess what changes need to be made when implementing services and processing services I use to operate my business. I no longer feel that there's something wrong with wanting to obtain more money. My previous thoughts that desiring more money equated to greed, have now evolved to comfort in desiring access, affluence, and resources. Having more money not only affords me to live the lifestyle I want to live without the stress of worrying about paying for basic living expenses, as well as unexpected emergencies. It also allows me to devote time to one of my passions, which is creating programming that help to transform the health of African American women in this country.

Furthermore, 'I've learned that the more money I have for programming attracts other organizations and companies to offer me more money to enhance the scope of my service areas. As it stands, I feel optimistic about the idea that money will continue to flow to me from year to year. As I continue to use my time to develop unique services in my businesses to enhance the quality of life of high-risk individuals in this country, I know the money necessary to implement these programs will come in.

I decided to join the RR Fund because I lacked the skill and guidance necessary to accumulate wealth on my own. As I mentioned earlier, I am a first-generation college student, who had minimal guidance when it came to opening a brick-and-mortar fitness studio. Sales increase each year incrementally, but I recognized that the odds of me creating true wealth from my businesses were slim.

I was not exposed to any wealthy entrepreneurs I could converse with and learn from to transition me into a person of wealth. I am aware that a large shift in wealth is necessary to help me carry out my 'life's purpose as I see fit. I know I need to be part of something that can guide me toward the abundance I desire in life. I 'didn't come from wealth, but I have a strong work ethic and desire for the benefits of being wealthy. Therefore, I said yes without hesitation when Angela invited me to become a part of the RR Fund.

I am well aware of my strengths in these 41 years of life. One of my strengths is my ability to be a great steward over funds. From the time I was 5 years old, I could save the money I made from chores and having good grades in school for months, while my friends would spend all of their money on candy as soon as it touched their hands. I just loved when I could hold more than one dollar bill in my hand, spread the bills out like a fan, and then wave it back and forth like I was cooling myself off.

You could not tell me I 'wasn't the coolest and richest kid on the block at that time! So I would save up my money until I had 20 one-dollar bills; then I would decide what I wanted to purchase. As I got older, my saving habits continued. It is improbable for me to buy things on impulse. I would hear from my friends how they were just browsing past a store or reading an article online. Then next thing you know, they purchased three maxi dresses from an ad on the side of the page; yeah, that never happens to me. I more of a purchasing with a purpose type of person. If I don't have a specific use for the product at that moment, then I don't buy it. Now when it comes to weaknesses, investing in the right assets and creating the proper portfolio necessary to obtain growth in three, five, and ten years is not my strong suit. So leaning on the experts in the RR Fund, as well as the experts that have shared information with RR Fund members, has been an invaluable experience for me.

One of my most significant ah-ha moments I've had thus far in being a part of the RR fund is being given the opportunity to learn. My upbringing 'didn't include a lane for me to understand the value behind using your money to create money. The only tip I learned about money was the importance of saving. And boy, did I make it a priority to save what funds that I could to use at a later date. I would have funds just sitting in my savings account for years, bringing in a whopping dividend of $0.28 every 6 months, but I 'didn't know what else to do with the money. I heard of the importance of investing, but anytime I looked on the internet for articles on investing or read an article out of the *Bloomberg Report* or *the Economis*t, it was if they were talking another language and I would get frustrated. I would also get frustrated that I had no one I could call to explain these terms to me. And so, I just stuck to saving and moved on with fulfilling the other tasks I needed to reach my personal and career goals. I wouldn't have learned what unique ways I could make my money work for my community and me if I hadn't gotten the call to be a part of the RR fund. I thank God for the opportunity to connect with like-minded women who are newer to investing like myself and to connect with women who have been millionaires for years. With this wide-ranging group of highly skilled remarkable women, the possibilities are endless.

Based on what I've learned so far in being a part of the RR Fund, looking back, I would tell my 20-year-old self to become comfortable discussing money and remember your goals. Money conversations were rarely discussed in middle and high school, or even college for that matter. I knew I wanted to go to college to get a good job and make money, but there 'weren't conversations in my friends' circles, amongst family members, or in college about how to obtain wealth or the benefits of acquiring assets to obtain wealth.

Other than moaning about the money I wish I had to purchase a pair of shoes to match an outfit and complaining with friends about being broke, money was always such a taboo topic. You might discuss money problems or situations with a friend, but you 'wouldn't dare discuss how much money you make in a year. If I was a bit more comfortable discussing money, I would have had different conversations with employers, bought property at a younger age, and invested in what I could given my income at the time. But I didn't know any better, so I didn't do any better. I would have told my younger self to not be afraid to discuss money with people outside of my usual circle and be okay with starting conversations about money with people who are in positions to change your income status.

Another thing that I would have told my 20-year-old self, is to not stress over money, because the Lord will always provide a way to take care of you. As a business owner for the past 13 years, there have been plenty of high-sales months, followed by low sales months. During the low sales months, I would worry that if sales got too low that I would have to close down the studio, and I would be relegated to living on the street corner with a pair of dumbbells and a shopping cart to my name. But somehow, after a week or two of slow sales, five people

would call me out of the blue ready to work. Like clockwork, I would be jolted out of my worry spells and back in the game with many people needing assistance to improve their fitness level and health.

While I've been a go-getter all of my life, putting in 16 hour days on a regular basis, I've known for years that I have assistance from a higher power in maintaining this fitness-based business. Garnering the attention of thousands of individuals over the years to take part in fitness training with you on a weekly basis inside a boutique fitness studio, which is nowhere near the size of your big gyms and not being located in a major metropolitan city is no easy feat. But somehow, I've been successful in making that happen. So much so that people contact me with business questions that have nothing to do with fitness. My company's stability and perseverance throughout the years (and through a pandemic) is truly due to the assistance of my God.

The word that comes to mind now when I think about wealth is accessibility. Even during our current economic period marked by high inflation, high-interest rates, and a higher price of consumer goods, there seems to be many opportunities available to enhance my level of wealth. I am also a visionary; I see abundant access to capital within my reach, which is a vast difference from my upbringing.

Exposure, access, and a means of entry were not within my reach growing up and as I started my business. I remember having limited access to business loans when I started my business, even though at the time, I had an account with a banking institution and a credit union for 12 years. I ended up obtaining a business loan through another lending institution. Even though I could secure lending with a different institution, I could not understand why I wasn't able to secure a loan from either of these companies when I've been in good standing with these businesses for over ten years. Why were the doors of asset accumulation closed to me?

I recognized that even though you may appear great on paper, your social wealth, as I mentioned before, plays a prominent role in the level of wealth someone can attain. Who you know, who your family knows, and what social settings you gain access to can impact the resources you have to improve your total wealth status. My social wealth has always been limited to no one's fault. So instead of complaining about it, I would attempt to connect with other entrepreneurs via events and workshops. But no glass ceilings had ever been broken when going the networking route.

After attending RR Fund meetings, I see my network truly expanding; allowing me to interact with individuals and companies that have amassed not only wealth but also understand my purpose, vision, and ability to bring about genuine change in our community, which will bring about even more opportunities for financial growth to happen.

I've been introduced to many women business professionals who also share a growth-focused mindset. These strong women have made it a priority to increase their wealth while also making strategic decisions together to support other women-owned businesses. The community, experiences, and information shared thus far have been refreshing and invaluable. And I am eager to continue the journey towards improving my total wealth while amplifying the voices of other black and women-owned businesses in this country for years to come.

If you are newer to investing and the idea of creating long-lasting wealth for yourself, I recommend you open up to learning, which can be difficult if you are not 25 years old anymore. You have to be willing to try something new, learn the process, and be patient along the journey. Just as I had to be patient for the two years while I was on my way to losing 100 lbs., I learned then and now that success and growth do not happen overnight.

This idea of being patient totally goes against the fast-paced society that we live in. In 2022, people are buying houses, land, complete bedroom sets, and groceries on the internet, without seeing it. This type of spending would never have happened 20 years ago, but now we are in a rush to make things happen "before it's too late." When it comes to creating wealth, you may have to spend months and months learning what is the best course of action before you decide to make a move. And that is okay because we don't want to rush the outcome that will prove to be the most favorable for us in maximizing our total wealth.

Secondarily, you must be willing to ask questions to get the necessary answers. I don't have the financial bandwidth to reach my goals by myself so I have to be willing to ask questions. Everyone didn't start out inheriting millions of dollars. Plenty of millionaires started out just as I did on my weight loss journey, from ground zero. I am not afraid to start from the bottom; I started from the bottom on my weight loss journey and started from the bottom when I opened my business by myself. So instead of us looking at it as if we are starting from the bottom, let's look at it as if we are allowing ourselves to change our world.

Ti' Juana Gholson

Who am I? Ti,' Ti'-Baby, Candy, Bird, Monkey, Juana-Cake, Sis, Mommy, Nana, Beautiful, is what they call me. My government name is Ti'Juana A. Tucker-Gholson. Defining who I am would appear to be complicated; however, it's quite simple. Outside of all the titles I carry as a wife, mother, daughter, granddaughter, sister, friend, and business owner, simply lies a woman. A woman who is concerned with what concerns everyone else. A woman who cares about the quality of life, including a safe place to sleep, decent food to eat, good health, a love for family, and relationships with friends. A woman who is often defined by the roles placed on her by society or what others' expectations OR perceptions are of me. A woman who is sometimes misunderstood because of my skin color and is often expected to be strong when it's not required of others. A woman who is expected to be EXTRAordinary and not feel the pressures of life.

I am blessed to have been uniquely made by the ALL Mighty down to the date, time, and season I was born. I believe my purpose aligns with all the distinct details carefully crafted just for ME. From the year I was born, who I was born to, how I was conceived, the family structure I was born into, the country I was born in, the state, the city, even down to my sibling line-up of me being the oldest child of my mother and the first maternal grandchild. You see, these distinctions have formed the woman I am and have carved my place on the earth.

The many phases of me... wearing many hats and names.

I was also blessed to have been born at the edge of the Civil Rights Era and at a time when my great-grandparents, who were born in the early 1900s, were alive. So, the wisdom of old was passed down to me, and for that, I'm eternally grateful. I was blessed to have been born to a teenage mother, to which I accredit my good genes and being raised by "the village." I was blessed to be "that kid" that everyone in the family and our local community gravitated to and assured that I had everything I needed. I was even blessed to have naysayers who looked down on my teenage mother for my conception. You see, all these pieces have helped to form the woman in me. As one could imagine, there were challenging times that my mother had to endure as she attempted to raise me at 15 years old with limited knowledge of life herself. As one could imagine, there were some tough times in life simply because of the circumstances I was born into, coupled with my mother's age. As many did, one could guesstimate and form opinions of the child conceived of a teenage single girl would have a future of poverty, low self-esteem, learning difficulties, and other societal limitations that were statistically created during the time of my birth; however, I believe that a Greater Power had distinct plans and a purpose for me. You see, it might have *appeared* to society that my showing up in the space and time that I did was the wrong time; however, as I've continued to walk this journey and evolve into every fabric of me, I've concluded that my arrival in 1971 was necessary! It was necessary to live the life I live today.

My parents were simply conduits to bring me to the planet for this space in time. In fact, my mother would often say with pride, "I had no CLUE who I was giving birth to when God blessed me with you."

Imagine if that 15-year-old girl would have waited to have me in her 20s. I may not have the husband I have today; my children would be different, my education may not be the same, and my experiences would be different, heck, my DNA may have been different as my father may not have been *my* father. I have pondered all these things for years and have concluded that to be the *me* that I meet in the mirror every day; I needed to be here as I am and in the NOW. To even be writing this passage to share with you, I needed to be here. So, the lesson of my life has been to appreciate all the elements of me, even those not-so-favorable parts, because all parts make up the woman in me.

I tell the story often of how I gained my idea of the "look" of wealth from television.

Being raised by great grandparents in the 1970s, I had the privilege to sit and watch a black and white television. Yes, I do consider that a privilege because, believe it or not, during that time, everyone did not own a television. Anyway... My great-grandmother used to watch a very popular soap opera called The Young and The Restless. One of the show's main characters went by the name Katherine Chancellor. Note, I also tell this story in my book Girl What You Gonna DO With Your Money. I explain how I used to look at Mrs. Chancellor with amazement. As a little girl, I noticed Mrs. Chancellor's mornings looked very different from mine. I saw that when she arose for breakfast, on any given day, she would enter her dining room in a fur coat, diamond necklace, and diamond rings. She would also make a famous entrance by gliding down her lavish staircase in her beautiful mansion. I did not complain like other children about how boring the show was and wished I could watch the Flintstones (as that was my favorite cartoon). Instead, I sat thinking, "Man, how can I live like Mrs. Chancellor"... period! I knew from that picture created by that soap opera

Mommy and me. I honor that 15-year mother who chose to bring me into the world at the right moment... the right time. Thank you, Mommy!

that there was a group of people who lived very different lifestyles than what I was experiencing. I am not saying that I'm unappreciative of my beginnings because it has made me the woman I am today. However, the exposure to other possibilities allowed me to expand my vision of what my current environment was at the time. It allowed me to explore more. That little example of wealth through television drama allowed me to dream what would have appeared to be impossible for someone like me. Now, my great-grandmother hadn't a clue that I would dissect her soap opera in such a way. Her main focus was to have me "get somewhere and *sat* down"; however, it is because of her that I had that little exposure to wealth early. I am thankful for Mrs. Chancellor... I am thankful for Mrs. Tucker, my great-grandmother.

My adult definition of wealth goes far beyond a "look" or material possessions even. Wealth, for me, is personal, individualized, and defined by those who care to explore it. Wealth, for me, means something totally different from it means to another. For me, it encompasses exposure, background, and mindsets. To take it a step further, wealth, for me, includes security. I often have this conversation with my husband regarding why I do what I do and why I view money as I do. My views have historically been in direct relation to my need for security. You see, for me, wealth is foundational. I believe that once you have your foundation secured in your life and can do what you *want* to do because you've initially done what you *had* to do, you are on your way to a wealthy lifestyle. I know that may sound confusing but follow me.

Wealth for me starts with good health and doing what it takes to maintain it, so I invest in my health and well-being by eating healthy, exercising, and ensuring my health and long-term care.

I also believe that at the core of wealth is to think enough of yourself to put securities in place, such as insurance for emergencies, and to secure your family if something happens to you. Along with these insurances, I believe we should leave instructions. Leaving instructions

that will allow you to speak from the grave to continue the legacy you've spent your life building. So, have many discussions with your loved ones regarding your wishes and then discuss with your attorney about the functions of a trust. You may find it interesting. Once insurances are in place, I believe we can move towards expanding our reach in ways that will bring income even in our sleep. For example, leaving footprints on the earth through writings, talents, and gifts through trademarks, patents, and any other intellectual properties that, if established properly, will outlive you.

And most importantly, wealth is defined by the relationships and friendships built along life's journey. Not just with family, because that's easy. But with people who have come into our lives and have made an impact and vice versa.

You see, wealth is defined differently by everyone who dares to define it, and we must be respectful of each other's definition. Because the life you're called to live is uniquely different from someone else's. What's YOUR definition of wealth?

In my book Girl What You Gonna DO With Your Money, I explain the importance of "knowing what you owe." Knowing what you owe helps you to know where you want to go. WOW... That rhymed, and I wasn't even trying. This is also a discussion I have with clients as a Business & Financial Coach, especially when discussing retirement goals. When discussing "retirement," I encourage my clients to think of it more than how society describes it, more than just an age. I encourage them to look at it as "what number does it take for you to live the life you want to live," regardless of you having to punch a clock to trade time for money. What number does it take for you to make money while you sleep? To go deeper, what vehicle can you establish that would pay your living expenses if you never showed up to work again?

In my world... When you discover that, my friend, you are now "retired."

This mindset is different from the story we are told from the time we start working until thirty-five or more years later. The old idea is for a person to get a job, work thirty-five to forty years, stop working, and allow the system to pay half of their working salary to live off. The old idea was that by the time a person "retires," their expenses would be less, and the money paid into the "system" would be sufficient. Well, my friend, if you are in the golden age group as myself and you have parents alive who believed in and taught you that system, you now KNOW that that frame of thinking is outdated.

As a Business Coach, I encourage my clients to think bigger. Again, taking care of those foundational items I discussed before and then investing in a way that creates cash flow income so that if you never physically work again, your living expenses (and some) are still taken care of. This can be done in several ways depending on who you are as a person, your calling, and your risk level. A few examples that have worked for many are business ownership, real estate investing, the stock market, and intellectual property. My husband and I were blessed to start a business over 20 years ago and, as a result, earned the capital to invest in real estate, which allowed us to reach our number in our forties. We bought into the idea of incorporating the efforts of others by establishing businesses that we do not HAVE to be present in to make money from, as well as creating a real estate company that allows for monthly cash flow that takes care of our living expenses. We also have a few intellectual properties that will outlive us, allow our generations to come to know our hearts and our vision and leave instructions for our family. We never really had the risk tolerance for the stock market, but from what I hear, many are successful in that arena.

In our younger years, we worked hard doing what we HAD to do, so now... We do what we WANT to do. We faced the beast by discussing our money and wealth goals, worked on what we owed, worked towards our number, and now we live in OUR wealthy place. As I explained before, wealth is individually defined. Our mindset also fuels it. However, you as an individual must know what that means for you, define it, and work towards YOUR individual path to wealth.

My relationship with money started out with a scarcity mindset.

I didn't know it then, but in my younger years, I judged everything from the lens of not having enough. I operated as if a great depression was going to happen again. I probably drove my young husband crazy because I never wanted to spend much money. I probably sucked the fun out of spontaneity. I did things like overstocking the house. Honey, I had toilet paper and cereal for DAYS! The commissary sales were *my* holidays. This is the one thing I learned from my mother. She bulk shopped before there was a Costco or Sam's.

I used her example and then took it a step further and did things like spending our tax refund and paying our bills up for six months or more at a time because, in my scarcity, thinking, "I never wanted us to be without." I was also very judgmental of others that didn't think as

I did. As I think about how afraid I was back then regarding money, I've discovered that I must have had some sort of trauma. Those times when we had limited funds during my childhood may have supported my fear of not having enough. As I reflect further, I've had limited family conversations around money other than the typical cadences that we all probably heard if you were born in a black household. You know sayings like *"you think money grows on trees"* or *"do you think I'm made of money?"* These memories make me laugh because when I speak on money matters, I sometimes express these phrases, and the audience finishes them for me. I laugh and say, "Whew, we were raised in the same household."

I bet *you,* too, have a few familiar phrases of your own.

These phrases, also known as mindsets, shaped my earlier thinking of money. I never wanted my family to be without, so I was extreme in assuring what I thought "taking care of things" looked like. For me, if the bills were paid, the cabinets were stocked, and a couple of dollars were in the drawer, I was good. That was *my* place of wealth. As I grew not only in age but in wisdom, my relationship with money shifted. It shifted to more of a "money has a voice" type of relationship. Not loving money to the point of worship or being afraid of it keeping me in the scarcity mindset but acquiring money to give it purpose to do what I was put here to do in life. My focus is no longer on being without, but it is now more focused on vision and my purpose in life.

I am blessed to be in this club in many ways; however, my main reason for joining is to be an example that *if I can do it, so can you.* Coming from my background with what seemingly has had cards stacked against me, having to grow in my relationship with money, and building a legacy I can truly say I am proud of, I want to share this with other women. We all have a life story, a knowledge base, and an opportunity to learn from others in the club. I am happy to not only share but to be in a position to learn and expand my vision even more.

My significant ah-ah moment regarding money is my belief that for every vision, God provides provision; however, I must be positioned to carry out the mission. There, I go rhyming again. But it's true... for MY life. I was also introduced to the concept of cash flow versus having a pile of cash. For me, cash flow means many things, but the most important way it's used in my life today is passive. As explained before, my husband and I have been blessed to create vehicles that bring in cash flow based on the number *we* consider wealth. This is a significant mindset change from my 20-year-old self, who approached money with a fearful-scarcity mindset. I would tell this young lady to approach money with the mindset of purpose. If you discover your purpose, the amount of money that needs to flow through your hands will be based on it. And because purpose is driven by the vision God gives, that very vision will be provided provision to carry it out. But walk in confidence and not in fear, my love... always being a good steward.

As I close, I want to leave you with a word. You've read it several times as you've gotten through this passage. That word is *mindset.*

Be encouraged!

This is the one word that comes to mind as I explore *my* definition of wealth daily. Thinking back on who I am as a woman, where I come from, how I was raised, and where I am going. I've had to adjust, shake, and shift my mindset consistently. The more I grow in wisdom and knowledge, the more I must check my mindset. I've learned over the years that my mindset has formed and shaped my world. My mindset has allowed me to be in places I've been blessed to be in, and on the other hand, my mindset has also, at times, kept me from opportunities. I would encourage you as you journey on your road to wealth that you discover and explore your personal mindset. Take time to get to know who you are, where you've been, and what has influenced or shaped your thinking about wealth. As you explore, be reminded that your definition of wealth is defined by YOU and you only.

I see U in sUccess!

CPSIA information can be obtained
at www.ICGtesting.com
Printed in the USA
BVHW020735030323
659585BV00001B/2